Stories of Art

Stories of Art

JAMES ELKINS

Routledge
Taylor & Francis Group

NEW YORK AND LONDON

With thanks to members of the Chicago Theory Group.

Published in 2002 by
Routledge
711 Third Ave, 8th Floor
New York, NY 10017
www.routledge.com

Published in Great Britain by
Routledge
2 Park Square, Milton Park,
Abingdon, Oxon, OX14 4RN
www.routledge.co.uk

Routledge is an imprint of the Taylor & Francis Group, an informa group

Library of Congress Cataloging-in-Publication Data

Elkins, James, 1955-
 Stories of art / James Elkins.
 p. cm.
 Includes bibliographical references and index.
 Contents: Intuitive stories—Old stories—New stories—Non-European
stories—Perfect stories.
 ISBN 0-415-93942-9 (alk. paper) — ISBN 0-415-93943-7 (pbk.: alk. paper)
 1. Art—Historiography—Methodology. 2. Art criticism—Historiography—
Methodology. 3. Art—Historiography—Forecasting. I. Title.

N380.E44 2002
707'.22—dc21 2002009624

ISBN13: 978–0–415–93943–0 (pbk)

Contents

List of Illustrations *vii*

Foreword *xi*

One
Intuitive Stories *1*

Two
Old Stories *39*

Three
New Stories *57*

Four
Non-European Stories *89*

Five
Perfect Stories *117*

References and Further Reading *155*

Index *171*

Illustrations

1. The history of art imagined as a field of stars. Drawing: author.

2. The history of art imagined as a coastline. Drawing: author.

3. The history of art imagined as a map. Redrawn by author.

4. The history of art imagined as a landscape. Redrawn by author.

5. Alfred H. Barr, Jr., Diagram of the development of cubism and abstract art, 1890–1945. New York, Museum of Modern Art.

6. Alfred H. Barr., Jr., Sketch for the development of cubism and abstract art, 1890–1945. MS, no date. Pencil and ink on manila envelope. 14 ½" x 11 ½". New York, Museum of Modern Art, Alfred H. Barr, Jr., papers [AAA: 3263, 1362–1363].

7. Chinese incense burner. From the tomb of Prince Liu Sheng, king of Zhongshan, at Lingshan, Mancheng, Hebei Province. Han dynasty, 113 B.C.E. Bronze with gold inlay, height 10". Hebei Provincial Museum (*Hebei Sheng Bowuguan*), Shijiazhuang.

8. The "Picasso Madonna." Original thirteenth century, with later additions. Current location unknown. Photo from Dora Jane Hamblin, "Science Finds Way to Restore the Art Damage in Florence," *Smithsonian* 4, no. 11 (February 1974): 26–35, fig. on p. 35.

9. Piero di Cosimo (1462–1521?), *Return from the Hunt,* detail. New York, Metropolitan Museum of Art. Gift of Robert Gordon, 1875.

10. Joachim Patenier (active by 1515, d. 1524), *The Penitence of St. Jerome,* detail of central panel. New York, Metropolitan Museum of Art. Fletcher Fund, 1936.

11. The standard story of art history. Courtesy of the author.

12. Jaune Quick-to-See Smith, *Trade (Gifts for Trading Land with White People).* 1992. Oil and collage on canvas, 5' x 14'2". Norfolk, Virginia, Chrysler Museum. Courtesy of the artist.

13. The standard history of modernism (top) and the variant proposed by Robert Rosenblum (bottom). Courtesy of the author.

14. David Kroll, *Mexican Parable.* 1988. Oil on canvas, 51" x 20". Courtesy of the artist.

15. Ion Irimescu, *Young Girl with Grapes.* 1944. Bronze. Present location unknown. Photo from Alexandru Cebuc, *Irimescu* (Bucharest: Editura Meridane, 1983). Photograph by Radu Braun.

16. Figures from the Ajanta caves. 475–510 C.E., Vakataka Epoch. Ajanta, cave XVI. Borromeo/Art Resource.

17. Amrita Sher Gil, *Three Girls.* Oil on canvas, 66.5 x 92.8 cm. New Delhi, National Gallery of Modern Art, Acc. No. 982.

18. Illustration of the Story of the Squinting Prince, from Fathullah ibn Ahmad ibn Mahmud, *Treatise on Calligraphy.* Manuscript, 24.5 x 15 cm. Moscow, Museum of Oriental Cultures. Or. B 651, fol. 135.

19. Giovanni Battista Cavalcaselle, Study of Piero della Francesca, *Flagellation of Christ* (The original painting is in Urbino.) Venice, Biblioteca Marciana, f. 2038 = 12279v.

20. Time line of all art. From Helen Gardner, *Art Through the Ages*, 1st ed. (1926).

21. Bison, Altamira cave. Scala/Art Resource, NY

22. Shagodyowéhgo·wa', the Iroquois False-Face Society door-keeper. c. 1940. Photo by William Fenton. Courtesy of American Philosophical Society.

23. Michelangelo Buonarroti, *David.* 1501–1504. Marble, height 13' 5". Florence, Galleria dell'Accademia. Alinari/Art Resource, NY.

24. Village guardian, with a sacrificial dog. c. 1905. Itelmen, Kamchatka Penninsula, Russia. Photo from Waldemar Jochelson, *The Koryak,* in the series *Publications of the Jessup North Pacific Expedition,* ed. by Franz Boas, vol. 6 (Leiden: E.J. Brill, 1908), plate IX, fig. 1.

25. Robert Jacobs, *The History of Art, Third Edition,* installation view. 1992. Courtesy of the artist.

26. Robert Jacobs, *The History of Art, Third Edition,* details. 1992. Courtesy of the artist.

Foreword

In 1950, just over a half century ago, the art historian E. H. Gombrich wrote a book called *The Story of Art*. Since then it has never been out of print. Each edition is more lavish than the last, and the newest one has some of the best-quality illustrations of any art book; but the text has remained essentially unchanged. It is still, for many people, *the* story of art.

Meanwhile, in the fifty years since mid-century, the discipline of art history has grown in all sorts of new directions. Art historians are now committed to being fair to women artists and to minorities, and the newer books include more "minor" arts and non-Western cultures. What was once the single, crystal-clear *Story of Art* has become a tangle of *Stories of Art*—my subject in this book.

Gombrich's book is a brilliant answer to a long-standing problem: how to unify the threads of history into one single compelling story. When art history got under way in the Renaissance it was a complicated mixture of biographies, off-the-cuff criticism, plain old descriptions, unreliable anecdotes, and dry stuff about the artists' birthplaces and the people who employed them. It is as if the first art historian, the Italian Giorgio Vasari, was not quite sure how to write about art. He gossiped a little, and documented a little, and spent a fair amount of time just praising the artists he admired. There was no precedent to show him how a history of art ought to be written, so he made a delightful mix of other kinds of

books—family chronicles, Greek travel accounts, biographies—all bent to his project of documenting Italian art.

Four and a half centuries later, things have only gotten more confused. Now art historians write about all kinds of objects, not just the painting, sculpture, and architecture that Vasari described, and they have their choice of all sorts of theories to help them interpret what they see. Some art historians follow feminism (in any of a half-dozen variants), often combined with psychoanalysis (in another half-dozen varieties). Other art historians subscribe to semiotics, deconstruction, and even more abstruse doctrines. As the new millennium gets under way, art historians find themselves spending nearly as much time puzzling over their theories and methods as they do looking at images.

It wouldn't be possible to describe all those theories in the space of such a short book, and it probably wouldn't be helpful to try. There are many books out there that introduce theories, and some that explain them in excruciating detail. Nor could I tell the history of the discipline itself—its practitioners, its national schools, its conceptual development. That has also been done, and it takes a larger book than this to do it any sort of justice. And of course it's out of the question to recount the *actual* history of art, from the Paleolithic to Picasso, in any sensible fashion. Even Gombrich's book has a hard time doing that, and it has over four hundred illustrations.

Luckily there is a way to introduce the discipline that is both crucial to what art historians actually do and amenable to an abbreviated format. In this book I'll be looking at the *shapes* of art history that are presented in various texts—the plots, or the outlines, of the stories of art. Gombrich's *Story of Art* has an especially clear shape: essentially it starts in ancient Egypt and ends mainly in England. Any book of world art you may pick up has its shape: the author chooses some artworks and excludes others, and tries to mold them all into a satisfying pattern. The discipline of art history may be thought of as a continuous reshaping of the past, an

ongoing attempt to keep it relevant and infuse it with meaning and purpose.

This is true of all books on art history, not just the massive ones that try to put the world into an eight-pound package. A book on a specialized subject—say, a monograph on the eighteenth-century Italian painter Giambattista Tiepolo—may not offer any judgments about other artists, but it will be full of opinions about what counts as interesting eighteenth-century painting, about why Tiepolo deserves to be rethought, and about the many artists and movements who *aren't* the subject of the book. That is simply the way value judgments work: it couldn't be otherwise. The authors of a book called *Tiepolo and the Pictorial Intelligence*—if you're looking for a first book of art history, it is as close to an exemplary volume as any I can think of—are full of judgments about the way viewers have misunderstood Tiepolo. The authors say their painter "satisfies neither a taste for what is loosely but confidently referred to as pictorial unity, nor a taste for narration." They set out to restore the "truncated Tiepolo" who has been partly forgotten and misconstrued by people who didn't look hard enough at what he painted. A reader emerges with a refreshed sense of a singular artist, "accessible and easy to like," but also intellectual, "restless," with a "tart after-taste." The book concisely remakes an eighteenth-century painter for a late-twentieth-century audience, and in doing so it makes a small but distinct change in a reader's sense of the shape of all European art history. In that fashion even the most specialized book gives shape and sense to history.

It does not require advanced training to think about the shape of art history. Everyone who visits an art museum shapes history simply by walking through some galleries and avoiding others. I have seen people genuinely panicked because they had lost their way in the modern art galleries: they ask the guards how to get out, or how to get back to the Impressionists or the Rembrandt rooms. Other visitors are the opposite: they think of the old masters as mummies, preserved with misguided reverence long past

the time they should have been forgotten. Those visitors would much rather spend their time "lost" in the modern art galleries. Some viewers search for exotic art, rushing past the European paintings to the small side galleries that have odd jewelry or strange furniture. In the Art Institute of Chicago, where I work, we have a large collection of decorative glass paperweights and several dozen dollhouse miniature rooms made up in the styles of different centuries. A steady stream of visitors comes to the museum just to see those two nearly forgotten arts. So just by walking through a museum in a certain order, you build a sense of art history that seems acceptable, pleasurable, or coherent. The route you take is the precise analogue of the arrangement of chapters in a book like Gombrich's: it's a map of your interests, a strategy for experiencing the kind of cultural history that you prefer.

It can be interesting to sit down and draw a little map of the periods and artists you like best: such a picture would be your own table of contents to your sense of the past. In Chapter 1, I report on several people, students and teachers, who have made such maps. Then, in Chapter 2, I compare those impromptu maps to some major books of art history written from the Renaissance to the nineteenth century. It turns out that many people's informal sense of the shape of history corresponds very well to some of the influential books written in past centuries: in other words, the art history you imagine is your own has been invented and passed down to you largely without your knowledge.

Chapter 3 brings things up to date by considering current textbooks, the kind that are assigned in high school and freshman courses on art history. Those books try to get around the biases of the earlier scholarship by including more or less *everything* that can be stuffed into a thousand-odd pages of fine print. They teach us, in effect, that the history of art is the story of *all* art: a strange claim, and one I think it is hard to live up to or believe in.

After that I turn to books written outside Europe and America to see what art history has looked like to people who do not know

or care about European art. Non-European books can be startling and refreshing, because they show just how restricted many Western ideas about art still are. Even art historians who care a great deal about non-Western art, and about the potential equality of different cultures, continue to privilege the West. Non-European books are an excellent tonic for lingering Eurocentrism.

Even with the increasing interest in non-Western art, the discipline of art history hasn't yet produced a textbook that could be an adequate replacement for Gombrich's. In the final chapter, I imagine what such a "perfect" book of art history might look like. It would include significant amounts of art by women and minorities and art made in smaller regions and countries; and it would embrace popular arts such as advertising and decorative paperweights. For the last chapter I have invented some books, Borges-fashion, which could answer to all the demands of multiculturalism. They are far from perfect, as you'll see.

I hope these *Stories of Art* can be a kind of guide, helping you to find the shape of art history that makes most sense for you. Your sense of the past should be yours alone, not something you have memorized from someone else's book. That is the only way that art history can become more than a series of fascinating but quaint facts about the past—the only way it can grow into a subject that you really love.

Intuitive Stories

Sometimes the most difficult subjects need to begin with the simplest exercises. Einstein invented thought experiments to help him clear the thickets of equations in his new physics. His frequent antagonist Niels Bohr spent a great deal of time inventing and drawing thought experiments designed to overturn Einstein's thought experiments. Even today physicists talk about "toy systems" when they can't work with the full mathematics. Many complex enterprises begin with things so simple they seem laughable. Language textbooks are certainly like that: Mr. Smith meets Mr. Brown, and asks when they will go to the movies; they part without another word. Only after several hundred pages—and a thousand new vocabulary words—can Mr. Smith speak freely to Mr. Brown.

Let me start, then, with a simple exercise to help think about the shape of art history. It is also a thought experiment: the idea is to draw or imagine a very free and informal map of art history as it appears to you. You're to find the mental shape, the imaginative form of history, and do it by avoiding the usual straight time lines. In other words, the drawing must be a product of your own imagination, suited to your preferences, your knowledge, and your sense of the past. The map will be your working model, your "toy system." As this book moves through the influential histories of art that have been written in the past, you may discover that your

ideas have been posed and sometimes critiqued by previous gen-
erations of historians. You'll also see, I hope, that your version of
art history has a great deal to say about *you*: who you are, when you
were born, and even where you live.

Maps of Art History

For me one of the easiest pictures to draw is a constellation, where
favorite artists and artworks are loosely arranged around some
center (Plate 1). This is a drawing I made of the images that I was
thinking about in the summer of 1998; at the time I was writing
about several of them. Naturally such a drawing is very personal
and it isn't likely to correspond to anyone else's. One of the stars
is the Taï plaque, a little prehistoric piece of bone inscribed with
tiny lines; another is Duchamp, who always seems to be floating
somewhere around; a third is the "Wrangel-Schrank," a German
Renaissance cabinet with bizarre pictures done in wood inlay. A
star at the right of the moon stands for the paintings my wife
made: they aren't as well known as some of the other stars on the
chart, but for me they are nearly as important.

At the center is the moon, which I labeled "natural images:
twigs, grass, stars, sand, moths' wings." I put those things at the
center because at the time I was studying natural history as much
as I was studying art. Down near the horizon, shining faintly, are
the Dutch artist Philips de Koninck and the Czech artist Jan
Zrzavý: the one invented landscapes with low horizons, like this
one, and the other showed me just how eccentric a twentieth-cen-
tury artist can be. To most people this constellation would be fairly
meaningless or just quirky; but for me, it conjures the pattern of
history that preoccupied me at the time, and it does so surpris-
ingly strongly: as I look at it, I find myself being pulled back into
that mind-set.

When I present this thought experiment to students, I show
them a picture like this one to start off. A constellation is better
than an old-fashioned time line, and it is a good way to begin to

Plate 1. The history of art imagined as a field of stars. Drawing: author.

loosen the grip of your education and start looking for the pattern that history has for you. The star chart also has a drawback in that it doesn't show the *structure* of history. It isn't clear which artists and images are further from the center, so there is no way to tell what matters more, and what less. The stars in this picture don't fall into any order, even though they seemed ordered at the time. Nor does the picture reveal which artists and works I thought were better, and which worse.

Another option, more like the conventional time lines, is a bar chart. One student drew me one with just three bars. The last bar on the right was marked "NOW," and it was labeled with the names Blue Man Group, Laurie Anderson, Pina Bausch, Robert Wilson, Bill Viola, Stelark, Frank Stella, Andy Warhol, and Roy Lichtenstein—all things considered, a fairly unhistorical grouping. (The Blue Man Group and Laurie Anderson are successful performance artists, Pina Bausch is a choreographer, Robert Wilson designs and stages plays, Bill Viola makes experimental videos and installations, Stelark is a performance artist best known for suspending himself naked from hooks, and the last three are abstract or Pop painters.) The other two bars on the student's graph represented artists further back in time. That part was fairly empty. He picked out just a few artists by name: Pollock, Max Ernst, Oskar Schlemmer, Filippo Tommaso Marinetti, Luigi Russolo, and Rembrandt. (That's an Abstract Expressionist, a Surrealist, a producer of abstract ballets, two Italian Futurists, and a seventeenth-century Dutch painter.) It was a mighty strange graph. He admitted, too, that his choices came from art history classes that he had recently taken and that he was only just discovering art history: these were simply the artists who stuck in his mind.

Some of the most interesting mental maps of art history use landscapes. For example, imagine standing on a beach and looking out at the ocean, and say that looking out to sea is like looking into the past. The sand at your feet is whatever art you're used to,

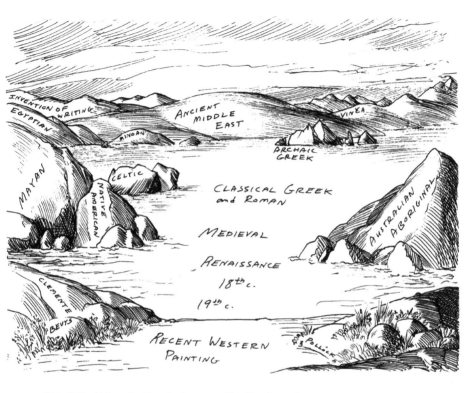

Plate 2. The history of art imagined as a coastline. Drawing: author.

and the shallow water is art of the recent past. Deep ocean water stands for art that seems very distant. What would your version of such a landscape look like? Which artists or periods would be nearby, and which would be sunk in the abyss? (One student who tried this exercise drew some strange creatures in the deep, and called them "bioluminescent non-Western art.")

My own version is shown in Plate 2; for me, the march of Western painting seems to dip under water some time in the nineteenth century and from there it just gets progressively deeper until art itself becomes invisible. I have studied the art of the Renaissance, the Middle Ages, and Rome; but for me they still seem somehow less accessible, less definitely *present*, less clear and

familiar than more recent art. Other art historians would no
doubt draw things very differently.

Erwin Panofsky, one of the preeminent twentieth-century art
historians, once remarked that everyone's knowledge is like an
archipelago—little islands drowned in a sea of ignorance. Even for
Panofsky, the history of art wasn't spread out like some geometri-
cally level salt flat, ready to be divided up into years and centuries.
Panofsky may have meant that if a person had enough time, he or
she could eventually fill in the ocean and learn everything. But
I'm not sure: there are times and places that we are prohibited
from ever understanding because our time, or place, or tempera-
ment make them in some degree inaccessible. I would rather say
that the sea of ignorance cannot be drained. In my imaginary
landscape, the ancient Middle East seems mysteriously *more* famil-
iar than classical Greek art, so I drew it as a distant headland.
These things don't always make perfect sense: I can't entirely
account for the reason that Australian Aboriginal painting (on the
right) and Mayan art (on the left) appear more solid than
medieval painting; but I know that part of my task as an art histo-
rian is to try to explain why that should be so.

I have a collection of intuitive maps drawn by students, art
instructors, and professors from all around the world. An art his-
tory graduate student in China drew a map showing five paths into
the past (Plate 3). One road, leading to the upper left, leads past
a selection of nineteenth- and twentieth-century artists back to the
Renaissance, the Middle Ages, and finally the distant hills of
Greece and Rome, prehistoric Europe, and Mesopotamia. Notice
her choice of Western artists: Moore, Maillol, Gauguin, Van Gogh,
and Matisse are commonly favored in Chinese art because the first
generations of Chinese artists who visited France in the 1920s and
1930s studied mostly conservative works and avoided Cubism,
Dada, and Surrealism. From Rodin, another Chinese favorite, she
jumps abruptly back to the Renaissance.

She puts modern Western art on an entirely separate path (at

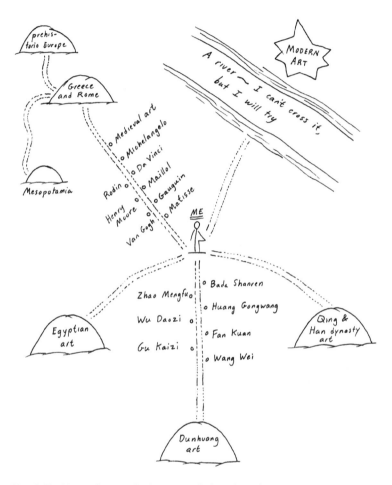

Plate 3. The history of art imagined as a map. Redrawn by author.

the upper right), and she sees it as a shining star that she can't quite reach, even though she promises "I will try." This is also a common perception among Chinese artists since the mid-1990s: contemporary Western art is an exotic challenge, one that demands an adventurous plunge into alien territory. Egyptian art is also isolated, off on a road of its own (lower left).

At the bottom and the lower right, she draws two routes into

her own Chinese past. One leads straight down, past the classic inkbrush painters to the ancient Chinese Dunhuang cave paintings (c. 750 C.E.). This road is essentially the history of Chinese painting, with some venerable forefathers who are like Michelangelo and Leonardo, and also some moderns who are like Matisse and Van Gogh. Neither road quite reaches the present, and it is telling that there is no place on her map for contemporary Chinese art as there is for modern Western art. That is partly because Chinese inkbrush painting is widely perceived to have gone into a decline in the last century or so, and partly because, for her, "modern art" includes modern Chinese art. A final road, at the lower right, leads directly to two other periods of Chinese art, one recent (the Qing dynasty, 1644–1912) and the other much older (the Han dynasty, 206 B.C.E.–220 C.E.). This is her way of pointing out another kind of Chinese tradition, which includes ceramics, bronzes, and sculpture; for her it is best captured by one very old period and one new period, the way a Westerner might pair Rome with the revival of Roman ideas in the Renaissance.

I'll reproduce one more map here to suggest the kinds of things you might draw if you try this yourself. Here is a very inventive drawing by an American undergraduate art student (Plate 4). He sees himself and his friends on a meandering path in the middle of a woods, like Dorothy on the way to Oz. The path isn't labeled, but he told me it represents Surrealism because sometimes Surrealism seems "right there," and other times it feels "far away and incomprehensible." His intuition reflects a widespread feeling that the original French Surrealist movement, which began in the 1920s and petered out in the 1940s, is really still with us, but in unexpected forms. Art historians have developed the same idea. A book called *Formless: A User's Guide,* published in 1997, tells the history of the original French movement and also updates it, expanding on the founders' ideas so they can be useful to contemporary artists and critics. Such a project, midway between art history and art criticism, makes sense for the same rea-

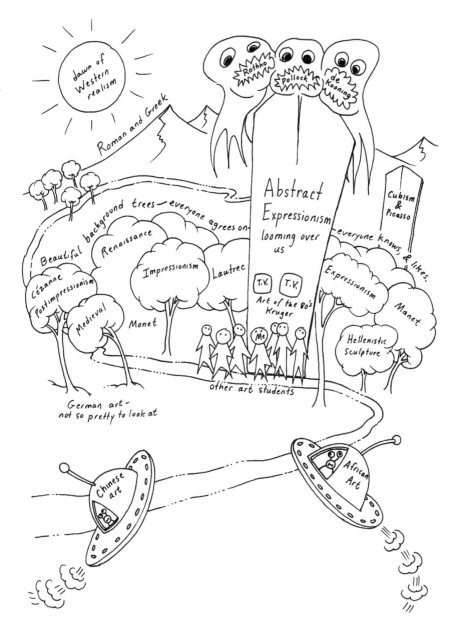

Plate 4. The history of art imagined as a landscape. Redrawn by author.

son this student's map makes sense: for many people Surrealism is at one and the same time a movement whose time has come and gone, and also a living possibility for art.

The student draws himself standing at the base of a big pillar or tombstone haunted by frightening Abstract Expressionists. In the distance is a less threatening monument to Picasso and Cubism. He feels most at home with TV and "art of the '80s," especially Barbara Kruger's media-savvy photography. Abstract Expressionism and Cubism are a different matter: they are big, serious history and not at all friendly or accessible.

All around the student and his friends is a forest, which he calls the "beautiful background trees": painting that is well known but not really engaging. In the forest is a host of periods and styles, none of them too interesting and none too difficult or distant. This is a characteristically postmodern sense of the past, where times as utterly different as the Renaissance, Hellenistic sculpture, and Postimpressionism are all equally available. Surrealism, a movement confined to the twentieth century, meanders all over his mental map, but at the same time nearly three thousand years of art is clustered conveniently around him, scrambled up in no particular order.

In the background are the Olympian mountains of Greece and Rome and the shining "dawn of Western realism." Greece and Rome are solid but far away. Many Western students and teachers who have made drawings for me do the same with Greece and Rome: it's a reflection of the idea that Classical civilization is the indispensable foundation stone of the West. The sun that illuminates the landscape is nothing other than the central theme of Gombrich's *Story of Art:* the far-reaching invention of realistic depiction.

Gombrich wouldn't have agreed with the jumbled forest or the preeminence of the Abstract Expressionists, or the TV culture, or the Yellow Brick Road of Surrealism. But he would have recognized the overwhelming Westernness of the picture. For this stu-

dent, non-Western art is literally alien: it appears as two UFOs, piloted by bug-eyed monsters. (The student who drew this apologized for his two aliens, which he said "aren't very politically correct." Yet they are honest, and that is all that matters in this exercise.)

Needless to say, drawings like these can't fully describe the shape of history. They are too simple, and besides, most of us don't normally think in diagrams. Drawings and diagrams are unfashionable in art history, because they are too neat to represent the real truth. Yet I risk showing them here because they are unguarded and informal, and that makes them tremendously valuable. The exercise is simple but it isn't simpleminded: it can help dislodge the weight of pedagogy and uncover a sense of art history that is closer to the way the past is imagined, felt, and used. I hope you are thinking of making a diagram for yourself—at least a mental one—because it will help you compare your ideas to other peoples' as we go along through this book. Once you have made such a drawing, you can begin the refining and rearranging that leads, in time, to a coherent and independent sense of what has happened to art from prehistory to the present. What counts is not the drawing itself but the insight it provides into the *necessity* of thinking about the shape of your imagination. Otherwise art history is just a parade, designed by other people, endlessly passing you by.

Periods and Megaperiods

Another way to think about art history is by considering how the periods of art should be ordered. Period names are the familiar litany of high school-level art history: Classical, Medieval, Renaissance, Baroque, Modern, Postmodern. There is no fixed number of periods, and I might as well have said Classical, Medieval, Renaissance, Baroque, Rococo, Romantic, Realist, Impressionist, Postimpressionist, Modern, Postmodern, or any number of other permutations. The more detailed the book or

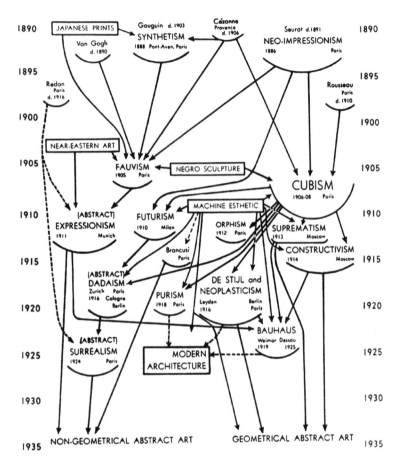

Plate 5. Alfred H. Barr, Jr., Diagram of the development of cubism and abstract art, 1890-1945. New York, Museum of Modern Art.

the course, the more periods there will be; Horst Janson's *History of Art*, one of the modern textbooks we'll be looking at in Chapter 3, has a folding time line several feet long.

If you add modern "isms" to your list, you can make it as long as you like: Orphism, Luminism, Futurism, Constructivism, Neo-Plasticism, Purism. . . . Around mid-century, at the height of international Modernism, it looked as if the twentieth century was a

cacophony of isms. Alfred Barr, who worked at the Museum of Modern Art in New York, has gone down in art history as a compulsive lister and codifier of isms; in all he counted several dozen, some of which he invented himself (Plate 5). As time passes, the many isms coalesce into major movements, but it is not yet sensible to speak of the twentieth century as a single movement with no subdivisions. Before the nineteenth century there are fewer isms but just as many periods: Ottonian, Carolingian, Romanesque, Gothic . . . and of course the names only multiply when the subject is non-Western art: in Indian art, for instance, there is Vedic art, followed by Maurya, Andhra, Kushan, and Gupta. A book could easily be filled with such names.

It is possible to go to extremes, either listing names compulsively (as Barr did) or maintaining that all periods should be gathered under one or two big headings. If all of art is one thing to you, and periods do not really matter, then you are a *monist*: you believe that a cave painting is of a piece with a painting by Pollock and ultimately there is no sense distinguishing the two. (What would count is creativity, or genius.) On the other hand, if every period name seems meaningful and every ism is worth recording, then you are an *atomist*. A fundamentalist atomist would say that isms and periods can also be divided, until art history is reduced to a sequence of individual artists. Ultimately even an artist's oeuvre can be subdivided, because each artwork is different from every other. Michelangelo's early sculpture *Bacchus,* with its precious antique looks, does not fit well with his later Florentine *Pietà,* a massive sculpture with nothing precious about it. In a sense every single artwork is a "period" unto itself. In the atomist mind-set, art history disintegrates into its component atoms, and in a monist mind-set, art history congeals into a single unworkable lump.

Most art historians behave like atomists—they study individual artists and works—but teach like moderate monists, organizing art history into a reasonable number of large periods. There have been exceptions. Gombrich once remarked that he regretted

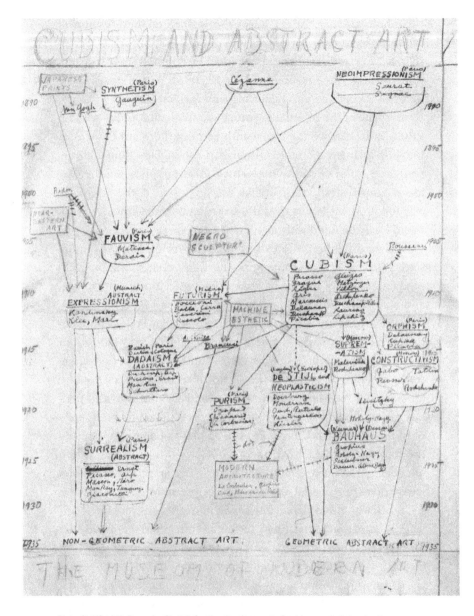

Plate 6. Alfred H. Barr., Jr., Sketch for the development of cubism and abstract art, 1890–1945. MS, no date. Pencil and ink on manila envelope. 14 ½" x 11 ½". New York, Museum of Modern Art, Alfred H. Barr, Jr., papers [AAA: 3263, 1362–1363].

never having written a monograph on an individual artist. His books tend to be on particular themes—there's a book on fresco painting, and a famous one called *Art and Illusion*—or else they are collections of essays that move through different Renaissance or modern subjects. Gombrich's work can be thought of as monist in the sense that he is attracted by ideas and less so by individual artists and periods.

The German art historian Wilhelm Pinder was drawn more to atomism: he wrote a *Problem of Generations in European Art History* (1926), proposing art be organized not by periods but according to contemporaries and near-contemporaries. Art since the Renaissance would then be a sequence of about one hundred generations rather than a half-dozen periods. If Pinder experimented with atomism, then the French art historian Pierre Daix is a specialist in subatomic particles: he made a special study of Picasso's work from 1900 to 1906, dividing it into many subperiods by season and even by month. Barr's chart is atomist, but his unpublished sketches include many more artists' names, because he was thinking initially of individuals—atomist fashion—and trying to order them as best he could—monist fashion (Plate 6). (Barr was roundly criticized for his diagram of Modern isms, and his approach helped provoke Postmodern scholarship, as we'll see later.) The majority of art historians never get as literal or inventive with the shapes of history as Pinder or Barr did: each historian negotiates the treacherous middle ground between the joy of looking at a single work and letting it pose its own unique questions, and the very different happiness of stepping back and finding at least a provisional pattern in the chaos of history.

Conversations about periods among art historians usually have to do with particular periods and transitions between them. The border between Modern art and Postmodern art is an especially contested case. Some art historians say Postmodernism began in the 1960s with Andy Warhol and Pop art. The philosopher Arthur Danto has argued that at some length, and Danto's

conclusion is implicit in work by art historians who do not stray far
back before Pop art. Art critics have also weighed in on the ques-
tion. Dave Hickey, a critic known for writing that conjures giddy
mixtures of periods and styles (his concoctions are not unrelated
to the student's drawing of the grove of trees), places the begin-
ning of Postmodernism in 1962, with the first Pop art exhibition.
Thomas McEvilley, another critic very much engaged in questions
of art history, puts it in 1961. The art historian Leo Steinberg, who
first introduced the word "postmodern" into art historical writing,
also associates the movement with Pop art, and specifically with
Rauschenberg's collages. There is a myriad of other opinions:
Rosalind Krauss and Yve-Alain Bois have argued that
Postmodernism is less a period than an ongoing resistance to
modernism; and historians such as the Belgian Thierry De Duve
have found Postmodern elements in Duchamp and Dada, back
nearly at the beginning of the century.

The same kinds of conversations are going on with respect to
the beginnings of Modern art. According to one version, it got
under way in the generation of Jacques-Louis David at the time of
the French Revolution. The art historian Michael Fried locates
some elements of Modern art in David's generation and others in
Manet's generation. Other art historians name Cézanne as the ori-
gin of Modern art, and still others begin with Cubism. (These con-
versations involve distinctions between Modernism and Modern
art, but that is not my subject here.)

Debates of this sort also go on with respect to older periods.
In the 1960s there was discussion about the span of Mannerism
and whether it should be said to begin directly after the High
Renaissance or later in the century. The first art historians who
wrote about Mannerism (in a sense they rediscovered it, as archae-
ologists find new cultures between known ones) pictured it as a
time of tortured, existential passions. In the 1960s John Shearman
wrote an influential book on the subject, redefining Mannerism as
a lighter, more intellectual pursuit and moving it away from

Florence and toward Rome. Other scholars, such as Thomas
DaCosta Kaufmann, study Mannerist developments very late in the
sixteenth century, at the court of Rudolf II in Prague. Today the
question is less often debated, but there are still at least three
viable senses of the term "Mannerism."

These questions of the times and places of isms and move-
ments are both complicated and crucial, and they cannot be
abbreviated with doing them serious injustice. Luckily there is
another question that is easier to introduce and arguably even
more fundamental: the overall sequences of *all* the periods. It
makes a world of difference to your idea of Modernism if it begins
with David, Manet, Cézanne, or Picasso; but pondering the
sequence of periods that includes Modernism raises deeper ques-
tions about the relation between Modernism and art history as a
whole.

Erwin Panofsky, who named atomism and monism, has done
some of the most sober and useful thinking on this topic. If I look
again at the list I made at first:

Classical
Medieval
Renaissance
Baroque
Modern
Postmodern

It may occur to me to lump the first two and the last three, like this:

Pre-Renaissance
 Classical
 Medieval
Renaissance
Post-Renaissance
 Baroque
 Modern
 Postmodern

Panofsky called these new headings *megaperiods:* the largest group-
ings of periods short of all of art. If this list corresponded to my
sense of history, then Pre-Renaissance, Renaissance, and Post-
Renaissance would be my three megaperiods: I would not be able
to imagine anything larger than them. A radical monist could take
the last step, compressing the three megaperiods into one huge
"period" called "art." In so doing, the monist would also collapse
the entire idea of history. That is why Panofsky's megaperiods are
so interesting: they are necessary to any sense of art history, and
they are also just one step from irrationality.

Arranging the major periods and megaperiods helps reveal
the largest units of Western art and it is also relevant to non-
Western art. Art historians tend to use words like "Baroque" and
"Classical" to describe the art of many times and places. Such
words are used, informally, to describe such things as Mayan ste-
lae, Chinese porcelain, Medieval furniture, and Thai architecture.
If I look at this incense burner (Plate 7), I may say it looks
"Baroque" even though I know the term isn't right. After all, the
object was found in a Han Dynasty tomb dated 113 B.C.E., a full
1,900 years before the European Baroque. What I mean by calling
it "Baroque" is that the burner shares some traits—superficially,
coincidentally—with a movement that is otherwise distinct. Art
historians tend to say such things offhandedly, without placing
much emphasis on them, but they are ingrained in the discipline.
The literature on non-Western art is rife with veiled and passing
references to "Classical" "Baroque," "Neoclassical," "Rococo,"
"Modern," and "Postmodern."

Notice that art historians don't casually apply non-Western
periods to Western art: it would not occur to me to try to shed light
on a Baroque sculpture by Bernini by calling it "Han-like" or try to
elucidate Brunelleschi's architecture by calling the earlier work
"Maurya" or "Andhra" and the later "Kushan" or "Gupta." That is
partly a matter of familiarity, and to a Chinese or Indian art histo-
rian such comparisons might make more sense. But it is also a tell-

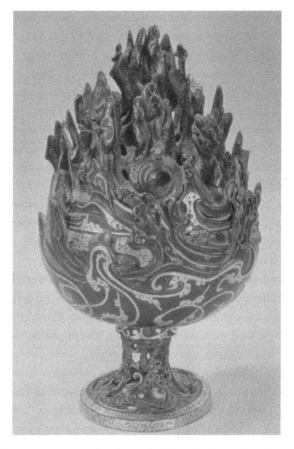

Plate 7. Chinese incense burner. From the tomb of Prince Liu Sheng, king of Zhongshan, at Lingshan, Mancheng, Hebei Province. Han dynasty, 113 B.C.E. Bronze with gold inlay, height 10". Hebei Provincial Museum (*Hebei Sheng Bowuguan*), Shijiazhuang.

tale sign of how deeply Western the discipline of art history still remains: the overwhelming majority of art historians *think* in terms of the major Western periods and megaperiods. Even if I avoid calling the burner "Baroque" and call it "curvilinear" or "dynamic" instead, I am drawing on traits that are part of the Baroque. No art history, even the practices emerging in non-

European countries, avoids this quandary. For that reason the central sequence of Western periods is relevant to the entirety of the history of art.

The large periods and megaperiods are at the heart of any historical response to artworks, even when it seems they are far from the real European Renaissance or Baroque. Here is another thought experiment that demonstrates that point. Imagine two vases, side by side on a table. Say they are in a style you have never seen before and you don't know what culture produced them. They could be tourist art made in Cairo in 1990 or ceramics fired in Sweden in 2000 B.C.E. Say one has straight lines running across it, in a simple black-and-white-stripe pattern, and the other has a gorgeous serpentine vine twirling around from the base up to the rim. Which one is older? Here you are on a par with even the most experienced art historian or archaeologist: anyone would say that one is definitely older than the other. There is no telling who might pick which vessel: I might decide the vine shows greater skill and freedom, so it must have come later; you might say the stripes are expert abstractions, the sign of a sophisticated culture. For the purposes of this thought experiment, it doesn't matter who is right: what matters is that each of us has *automatically* put the two vases in a chronological sequence. If I then add one more vase with horizontal red-and-white stripes, we would both put it in the same period as the black-and-white striped vase. We have *automatically* started arranging the unknown artifacts into periods, and those periods will almost always be influenced by Western periods from the main sequence. (Stripes look Modern to me, and vines Baroque.)

This kind of thinking was trusted from the beginnings of connoisseurship in the seventeenth century to early-modern art historians such as the German Heinrich Wölfflin; contemporary art historians call it *style analysis* and put no stock in it. Today an art historian would rather wait for some other evidence—dates, a chemical analysis, or some documents to prove the vessels' ages—

but no viewer can resist arranging artworks into periods. The more highly trained the historian, the more confidently and quickly she will make the identification—and then begin to doubt it. But the damage is done in that first half-second: periods, and the ways we conceptualize them, lead to judgments practically without our knowing it. The sequence of Western periods is central to many peoples' imagination of art history, whether they live in Europe, America, or elsewhere.

What, then, are the optimal ways of arranging the periods and megaperiods? In practice, several solutions have held sway over many possible alternatives. A person who thinks of the Renaissance as a turning point may put everything afterward in a subheading. (Megaperiods are in bold, and ordinary periods in roman typeface.)

Ancient
Classical
Medieval
Renaissance
 Baroque
 Neoclassical
 Modern
 Postmodern

This scheme has been called an *expanded Renaissance,* because it implies that in some way the Renaissance made everything else possible. It is a popular view among historians who specialize in the Renaissance, and there is strong evidence in favor of it. Art itself got under way in the Renaissance: in the Middle Ages paintings and sculptures were religious objects, not collectibles or objects of aesthetic appreciation. Along with the concept of art came a host of other terms we now find indispensable: the notion of the avant-garde, the idea that great artists are lonely geniuses, the practice of art criticism, the disciplines of aesthetics and art theory, the rise of secular art, and even the field of art history

itself. In comparison to those changes, it could be argued that the shift from Modernism to Postmodernism is relatively superficial. Panofsky himself preferred four megaperiods with period subheadings:

Classical
　　Mycenean
　　Hellenistic
Medieval
　　Carolingian
　　Gothic
Renaissance
　　Early Renaissance
　　High Renaissance
Modern

Panofsky's outline is probably the closest to a consensus of art historians' working notions. If I were to add some period subheadings under "**Modern**," such as Baroque, Romantic, Impressionist, and Postmodern, Panofsky's list would correspond fairly well to the job descriptions that universities post when they need to hire additional faculty and also to the names of different sessions in art history conferences. Probably the largest divergence of opinion is between art historians who specialize in pre-Modern art, who would subscribe to something like Panofsky's outline, and those who teach Modern and Postmodern art, who might feel more at home with an outline like this:

Premodern
　　Ancient
　　Medieval
　　Renaissance
　　Baroque
　　Romanticism
　　Realism

Modern
 Postimpressionism
 Cubism
 Abstraction
 Surrealism
 Abstract Expressionism
 Postmodernism

Art historians who work primarily with twentieth-century material tend to use less of the deeper past on average than historians who work with some period of pre-Modern history. In conferences and in the day-to-day life of art history departments, Modernists and specialists in contemporary art are less engaged with the whole range of history than pre-Modernists are engaged with recent art.

There is also the question of non-Western art, which will loom larger later in this book. A specialist in non-Western art might put all the Western periods and megaperiods under the heading **"Western,"** making the West just one culture among many. A specialist in African art might think of history this way:

African Art
 Saharan Rock Art
 Egyptian
 Nok
 Djenné
 Ife and Benin
 Colonial
 Postcolonial
European Art
Asian Art
American Art

(The African cultures and periods might still follow the *logic* of the sequence Classical-Medieval-Renaissance-Baroque, but that's another question.)

And finally, among contemporary artists, I find the working sense of art history is more centered on late capitalist America and Europe, and that the rest of history gets telescoped in a fairly drastic manner, like this:

Non-Western Art
Western Art
 Pre-Modern art
 Modern art
International Postmodern Art

Some museums also organize their collections this way, putting non-Western art in one place, "European Art" in another, and "Twentieth-Century Art" in another. Often enough those divisions also correspond to different departments in museums, each with its own budget, specialists, and subculture.

If you feel the most affinity with this last list, you are siding with the current art scene and with the globalization of all art and the compression of art history into a single pre-Modern past. In Postmodern art practice, *appropriation* is the name given to the practice of taking bits and pieces from all periods of art history and putting them into new art. Such artists are not reticent to pick and choose at will, because history itself seems to have fallen in ruins at their feet. Everything is now equally distant from the present, whether it is a prehistoric artifact or a Picasso collage. This perspective is nicely captured in the "Picasso Madonna," a Florentine restorer's joke made in the 1960s (Plate 8). It's like a postmodern map of the Renaissance: its deepest layer is a thirteenth-century painting, visible in the Madonna's right eye, her mouth, two little angels, and the infant Jesus just below the Madonna's face. Over that layer are two further layers painted in the Renaissance. (See if you can disentangle them.) The result is a playful palimpsest of at least four centuries of art, all stuck together like any Postmodern collage.

The same idea can be captured in an intuitive map like the

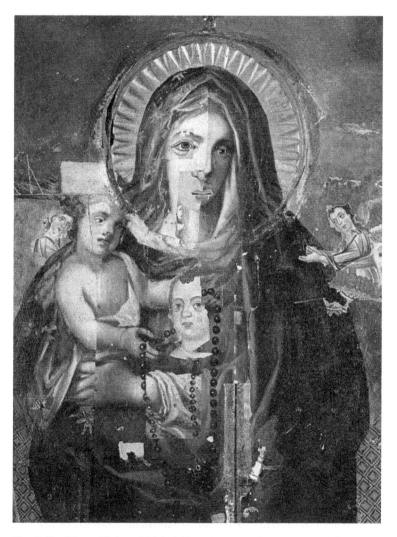

Plate 8. The "Picasso Madonna." Original thirteenth century, with later additions. Current location unknown. Photo from Dora Jane Hamblin, "Science Finds Way to Restore the Art Damage in Florence," *Smithsonian* 4, no. 11 (February 1974): 26–35, fig. on p. 35.

ones in plates 1 to 4. One artist drew a picture for me showing himself on a desert island, with all of history like a treasure trove (or a garbage pile) all around him. Nothing, he said, was more than an arm's length away. His list of periods and megaperiods might have looked like this:

Art History
 (No subdivisions)
The Present

Psychologically, such a radically collapsed sense of history is a great relief for people burdened by a nagging sense of the importance of history. Suddenly, all art is possible, and nothing needs to be studied. The first student I mentioned, who drew the bar graphs with Pina Bausch and Blue Man Group, is close to that way of thinking. Some art historians who work exclusively on contemporary art feel the same exhilaration: they can apply any theories they want, interpret in any fashion they choose, and cite or ignore precedents at will. But as Milan Kundera might say, sooner or later the apparent lightness of art history reveals itself as an "unbearable lightness," and finally as an unbearable burden.

Oscillating History

The outline lists I've given so far are the commonest models, but they are not the only ones. Wölfflin claimed there are far-reaching affinities between "Baroque" or "Classical" moments in different times and places, and he supported his contention by making elaborate analyses of the styles of selected artworks, entirely avoiding mention of their surrounding cultural contexts. (Wölfflin might have been more at ease than I would be calling the Han dynasty incense burner "Baroque.") Graduate students of art history are taught about Wölfflin, in part to help them avoid his reductive kind of style analysis. Even with that precaution, the simple fact that he continues to be taught is testimony to the seductive nature of his theories. Maybe there *is* something Baroque

about the twirling smoky shapes in the incense burner; perhaps the human eye does return to the same possibilities over and over. It is an idea that needs to be taken seriously simply because it will not go away. If I were a dyed-in-the-wool Wölfflinian, I might rewrite my initial sequence of periods like this:

Classical
Medieval (= Baroque)
Renaissance (= Classical)
Baroque
Modern (= Classical)
Postmodern (= Baroque)

Or, in simplest terms:

Classical
Baroque
Classical
Baroque
Classical
Baroque

and so on without end. No art historian would subscribe to such a list, and Wölfflin himself avoided being so explicit, but there *is* something Baroque about Medieval art, and there *is* something austere, intellectual, and Classical about Modern art.

If Wölfflin's sense of alternating periods is taken seriously, history swings back and forth like a pendulum instead of moving forward or spreading through an imaginary landscape. There are some viable models of oscillating history, and one of the most influential concerns the nature of German art. Writing about Albrecht Dürer, Germany's preeminent Renaissance artist, Panofsky said that:

> the evolution of high and post-medieval art in Western Europe might
> be compared to a great fugue in which the leading theme was taken up,
> with variations, by the different countries. The Gothic style was created

in France; the Renaissance and Baroque originated in Italy and were
perfected in co-operation wiuth the Netherlands; Rococo and nine-
teenth century Impressionism are French; and eighteenth century
Classicism and Romanticism are basically English. In this great fugue
the voice of Germany is missing. She has never brought forth one of
the universally accepted styles the names of which serve as headings for
the chapters of the History of Art.

The problem is widely debated in Germany. Has Germany
produced a characteristic kind of visual art, one that was a "lead-
ing theme" at some point in Western history? Or is it preeminently
a country of composers and poets? The question is vexed for many
reasons; after the Second World War, discussion of the
Germanness of visual art was anathema. As the German art histo-
rian Hans Belting points out, Germany did not even exist as such
after the war: Half of it (East Germany) was inaccessible to schol-
ars in the West, and it wasn't even possible to write about the
Germanic culture of northwest Poland. Nothing to do with
national art could be raised, and German critics and scholars were
relieved to be able to speak about "Occidental" or "European" art,
and even global art, rather than have to think about the
Germanness of German art. Into that vacuum stepped several gen-
erations of German artists: first Joseph Beuys, who tried to recap-
ture a viable sense of the German past by reaching back into hoary
Germanic prehistory; and then Gerhard Richter and Anselm
Kiefer, who are at one and the same time seriously involved with
issues of German history and maddeningly evasive. German art
history has yet to catch up with those new voices. With some excep-
tions, such as Belting, Karl Werkmeister, and Benjamin Buchloh,
there is little scholarly discussion of claims like Panofsky's.

Panofsky does not propose that Dürer is Germany's contribu-
tion to the "fugue" of European art; rather he says that Dürer, like
many German artists after him, fell prey to the impossible allure
of Italian art without ever fully incorporating it into a German
style. Dürer visited Italy twice to learn secrets of Italian art theory,

and he complained about the lack of theoretical training among German artists. Yet he never synthesized Italian and German art. From the art north of the Alps, Dürer inherited the Germanic qualities of attention to detail and "inwardness" (*Innerlichkeit*); from the south, he learned the Italian concern with unified, balanced, and theoretically informed pictures. Many of Dürer's pictures make use of both sources, but none, according to Panofsky, remakes them into something new. Dürer's style oscillated but did not move forward to something fundamentally new.

Traditionally artists' careers are divided into periods or phases on the model of the human life, so that there is an early period, a mature period, and a late period. If the artist is lucky, he or she will achieve a *late style*, usually conceived as a crowning synthesis. Panofsy says Dürer's oscillation prevented him from following this sequence. It is possible to tell Dürer's earlier works from his later ones, but there are no essential differences, and he never achieved a late style. (Panofsky says he only had a *last style*, meaning the style he happened to be working in when he died.)

Panofsky thinks there was "an innate conflict" in Dürer's mind, a principle of "tension" galvanizing all of his ideas and achievements. Dürer spent a few years working in an Italianate manner, then a few in a German mode, and so forth, so that his work:

> is governed by a principle of oscillation which leads to a cycle of what may be called *short periods:* and the alternation of the *short periods* overlaps the sequence of the customary three phases. The constant struggle . . . was bound to produce a certain rhythm comparable to the succession of tension, action and regression in all natural life, or to the effect of two interfering waves of light or sound in physics.

Panofsky's analysis, proposed in 1955, is one of the most lucid statements of an oscillating model of art history. He means it to apply to Dürer, but it resonates, unavoidably, with the larger question of German art.

Even though Germany is the most prominent model for this

particular historical quandary, there are many other countries and regions that have been similarly divided between two (or more) influences. Bulgarian art in the twentieth century has shifted between Soviet Socialist Realism and French Impressionism, Postimpressionism, and Surrealism. Like artists in other small countries, Bulgarian artists have tried to define the Bulgarian qualities of their work and have been acutely aware that their art is mainly a mixture of Soviet and French models. Just as the Germany of Dürer's time was polarized between north and south, Bulgarian art was polarized between east and west. (This is an overview, of course: in practice Bulgarian artists distinguish German, French, and Italian influences, as well as Russsian and other Balkan influences. Often, however, those other influences were themselves filtered through French and Russian art.) And as in the case of postwar Germany, postwar Bulgarian artists have recently suspended those these questions, turning instead to the new international art market.

Oscillating models of history permeate the discipline. Another example is Netherlandish art of the fifteenth through the seventeenth centuries, which has been described as a kind of inverse or shadow of Italian art. Just as Dürer said German art lacked Italian theory, so Dutch painters have been described as lacking Italian traits. The art historian Svetlana Alpers has proposed a model of Netherlandish painting that would free it of its traditional dependence on Italy by putting the northern achievement in positive terms. She sees Dutch painting as an "art of describing" in which Italian optical models are supplanted by a more direct, materially based way of seeing the world. Books like Alpers's are art history's best chance of escaping its traditional polarities, but some oscillations—perhaps including Germany's— have been around so long, and been tacitly accepted by so many writers, that they are built into the fabric of our understanding.

These examples (Germany, Bulgaria, the Netherlands) are all local ones, within Europe. The largest oscillations aren't north-

south or east-west: they are the huge swings that non-Western countries can feel between their own art and the art of the West. That kind of polarity can be crippling, dividing a country's sense of itself right down the middle.

Life History

Each of these models of history has its own history. Oscillating history may be a Renaissance invention, because the Renaissance itself was a renascence, a rebirth of Classical art, and therefore a revival—in other words, the beginning of an oscillation. There's also the fact that oscillations and cycles were theorized shortly after the end of the Renaissance by the historian Giambattista Vico. The divisions of history into periods and megaperiods has its origin in the universal histories of the eighteenth century, which were arrangements of all nations according to their genealogical links to Noah and his sons. By the early nineteenth century art historians were applying the same organizational methods to their more limited materials, and the notion of periods and groups of periods was routine in textbooks from the late nineteenth century onward.

A third model of history is more ancient than either oscillations or outlines: it is the *organic model*, the notion that the periods of a culture are like the periods of a person's life or the life of an animal or plant. The organic model was known to the Greeks, and it became a stock in trade of Roman historiography.

The fundamental notion is that each culture, nation, or style goes through a life cycle: first comes the rough, unstable beginnings, when the culture is "young" and no rules have been fixed. In the twentieth century, a period that has been thought of that way is Archaic Greek art (600–480 B.C.E.); under the influence of Cubism and other Modern art, Archaic vase paintings and sculptures came to be seen as the raw but honest beginnings of Greek art. Another such period, also more widely appreciated in the early twentieth century than before, is fourteenth-century Italian

painting from Giotto onward. That century, before Masaccio and the discovery of perspective, includes the first jumbled attempts to make naturalistic depictions of the world, and it appealed to twentieth-century tastes weaned on Modern art.

In the organic model, the next stage sees the end of adolescence and the beginning of maturity. In Greek sculpture that would be the Early Classical period (480–450 B.C.E.) and in Italian painting, the fifteenth century. Those periods were more fully appreciated earlier than the twentieth century; the early nineteenth-century German art historian Carl Friedrich Rumohr wrote as enthusiastically about fifteenth-century Italian art as he did about the High Renaissance.

Then follows the period of full manhood (the schema is traditionally sexist, so it isn't full womanhood). The eighteenth-century antiquarian Johann Joachim Winckelmann described Greek archaic art but preferred the perfection of Athenian art of the fifth and fourth centuries B.C.E That period, the "apogee" of Greek art, came to be known as the High Classical period. In Italian painting, the period of full maturity is the High Renaissance (beginning of the sixteenth century).

After the peak of life has passed, a man gets older, passing through middle age and beginning the slow decline toward death. In Greek art, that would be from the century before Alexander the Great, through Hellenistic art, to the rise of Rome in the first century B.C.E. Winckelmann wrote heartfelt pages on the decadence of Hellenistic art, which he saw as a model for declines in other cultures. In Italy, the decline would begin with Mannerism and academic art in the later sixteenth century, and end sometime in the seventeenth or eighteenth centuries.

Of course not all cultures die—Greece and Italy are still extant—and so the final period tends to be inconclusive. Sometimes the life-history model can become an oscillating model, as if the culture's "life" were reincarnated. Italian art is sometimes considered to have been partly revived by the nineteenth-century

landscape tradition called the *Macchiaiuoli* and then decisively by the Futurists. In other cases, the decline continued unabated for centuries. The slow death of late Roman art is a well-known example. Greek art after the first century B.C.E was also moribund. In one sense the culture changed when it became Byzantine, but in another sense modern Greece continues a nearly unimaginably long decline that began before Alexander's lifetime. These days art historians have learned not to judge so harshly, and the "decadent" late periods are studied as earnestly as classical ones. Yet these questions lurk in the background of much that is written about Greek and Italian art. Winckelmann's quandary was even greater, because he was investing so much in a culture that had no connection with Germany except that German scholars studied it and collected its masterpieces. It is as if Winckelmann were trying to recapture a full history for Germany, replete with pathos and greatness, simply by writing about it.

The schema of the life cycle was codified in ancient texts into a set sequence: *infantia, adulescentia, maturitas, senectus.* Occasionally there are five stages, and sometimes only three. Sometimes, too, the metaphors are taken from botany and not from human life, and writers speak of the "seeds" of a culture, its "blossoming," and its "withering" or "decline." Any way it's cut, the life-history model has one fatal flaw: it has to die in the end.

Paradoxical History

For many purposes these four models are sufficient (maps, periods, oscillations, life histories). They cover a large percentage of viewers' intuitive concepts of history and a surprising percentage of the serious scholarship. I will mention just one more model, much less influential and conceptually more difficult.

It is possible to imagine an art history that would work against chronology altogether. Artistic influence is normally traced from one generation to the next, so that artists in a tradition are linked by the anxiety each feels in thinking about the past. Yet it is not

entirely nonsensical to speak of influence extending backward in time, so that Picasso "influences" Rubens, or Winckelmann's eighteenth-century German classicism "influences" ancient Greece. That apparently paradoxical result is really only an image of the way that history builds meanings: as I look back *past* Picasso to see Rubens, Rubens begins to seem clunkier, more extravagant, and more unintentionally humorous than he could possibly have appeared in his own time. I see him through Picassoid glasses, as it were, tinted with the colors of Postimpressionism and Cubism. The Dutch art historian Mieke Bal has written a book about Caravaggio that says essentially the same thing: we can see Caravaggio only through the works of recent artists influenced by him—"preposterous history," she calls it. In a similar way, German scholarship in the eighteenth century did much to give us our sense of the timeless beauty of High Classical Greece. Even though Winckelmann's ideals are largely abandoned, there is still a real lingering feeling that Greece is perfect and timeless the ways the German scholars and poets hoped it was.

Paradoxical history isn't really paradoxical at all—in fact it is inescapable. How *could* I see Rubens or Caravaggio, except with the twentieth century in the back of my mind? Good scholarship suppresses the more egregious anachronisms, but it can never erase them entirely. If you are more an artist than a student of art history, then you may think of art entirely in these terms and even have a backwards time line:

Postmodernism
 Modernism
 Renaissance
 Middle Ages
 Classical Greece
 Prehistory

A few art historians other than Bal have investigated paradoxical history. At least three universities have experimented with

teaching art history backwards. (Apparently it doesn't work: influence always also goes forward, and the students become confused.) A book on Marcel Duchamp tells the story of his life starting with January 1, and under that heading the authors put whatever is known about Duchamp's activities on the first of January for every year he lived. Then they go on to January 2. When they have recounted all 365 days of the year, their "chronology" ends. It's really entirely nonsensical—no one experiences their own life that way—but it is intended to capture something real and historically true about Duchamp: his penchant for illogic and whimsy. Literary theorists have already toyed with the fabric of history in this fashion and produced results that are not at all counterintuitive. Perhaps in the future more art historians will also try their hand at such things.

Posthistory

At the end of history there is the problem of the present. If Postmodernism is our current period—and that's an assertion that is far from generally accepted—then what happens when it ends?

If Postmodernism sticks as a label for the latter portion of the twentieth century and the beginning of the twenty-first, sooner or later Postmodernism will start to appear as a period like any other. At the moment, however, it seems more like the name of something in process than a discrete period like the Baroque, with an agreed-upon beginning and end. For some, postmodernity is a condition or a mode of living rather than a period. In the 1980s art historians began speaking of the *endgame,* a term borrowed from chess and applied to the workings of historical periods. In a chess endgame, only a few pieces remain on the board, and it may not be clear whether one player can force a win or whether the play will continue indefinitely. Endgame problems are especially intractable, slow-moving, and repetitive, and chess experts have written books on the subject. In visual theory, endgame art is a postmodern condition in which little remains to be done, and yet

it is unclear whether the "game" of art can actually be ended. Endgame artists make minimal moves, trying to finesse the dying mechanisms of art a few more incremental steps.

If endgame theory captures some of the mood of Postmodernism in art history, then Postmodernism itself may not be a period with a normal ending. Instead it may continue indefinitely, until the players in the art world (the artists, their critics and historians, and the gallerists and curators) in effect agree to call a draw and start a new game. All of art history would have decisively broken with the advent of Postmodernism, because Postmodernism would be the first "period" with no determinate length. Like a course of psychoanalysis, it might continue interminably.

Alternately, the game of Western art may have already ended, and Postmodernism may be a new kind of game that starts after art. That theory, endorsed by Arthur Danto, holds that art ended when Andy Warhol made his *Brillo Boxes*. (Technically, they're handmade counterfeits of ordinary wholesale cardboard boxes holding retail Brillo boxes.) Some art historians say the same about Duchamp's *Fountain* (a porcelain urinal he bought from a catalogue and submitted to an art exhibition). If either account of the end of art becomes generally accepted—again, a far from certain outcome—then Postmodernism could be the name of something after art, just as the Middle Ages was something before art:

Before Art
> Prehistory
> Classical Greece and Rome
> Middle Ages

Art
> Renaissance
> Baroque
> Modernism

After Art
> Postmodernism

Some help in thinking about Postmodernism might come from China, because Chinese art history has also had a period with "Postmodern" qualities. From the Qing dynasty onward, Chinese painters continuously simplified their past art history, telescoping different movements into single schools. Like Western artists, they had to try ever harder to be noticed, resulting in pictures with exaggerations and eccentricities (several groups of Chinese painters are known as "eccentrics"). As in the West, artists began to develop *signature styles* and personal quirks that would make them instantly recognizable, like Damien Hirst's cows in formaldehyde or Barbara Kruger's *National Enquirer*-style photographs. Later Chinese painting evolved in a pluralist atmosphere filled with heterogeneous styles, short–lived schools, idiosyncratic works, and artists distinguished by single hypertrophied traits or monomaniacally repeated tricks—all typical traits of contemporary Western art.

Art in Qing-dynasty China has only superficial similarities to art in the West, but it is intriguing that the Chinese "Postmodernism" began about two hundred fifty years ago and showed no signs of ending when it was partly swept away in the revolution. If the parallel has any merit—and such parallels tend to fall apart as quickly as they are made—it does not bode well for our notion that Postmodernism is a period like any other. Rather it implies that Postmodernism is not a period but a state, like a coma, that might go on indefinitely. Perhaps Yve-Alain Bois said it best when he imagined the endgame as an act of mourning, in which painting slowly recognizes that its hopes for a future are not going to come true, and turns to the business of "working through the end of painting." If so, then art history doesn't have a neat tabular structure like the ones I've been proposing. Instead it "ends" with suspension points, leading away toward an indefinite future:

Normal Periods
 Classical
 Medieval

Renaissance
Baroque
Modern
Abnormal Periods
Postmodernism
. . .

Old Stories

I have let the first chapter run away a little, to give the flavor of art history's open-ended issues. Everything in that chapter is a matter for you to decide. Somewhere among the lists and maps and charts there may have been a picture that fits your intuitive sense of art history, or something close to it. In this chapter and the next, I turn back to the history of the discipline and consider what some art historians have said about the shape of art history. If you haven't found your mental map in Chapter 1, you may well find it in this chapter or the next.

Giorgio Vasari

When the Renaissance painter Giorgio Vasari sat down in his dark-paneled study to write the *Lives of the Eminent Painters, Sculptors, and Architects*—the book that eventually became a foundation stone of art history—he was not sure exactly where to begin. How did art get started? Who first made good art, and how did they know how to do it? Why did art get worse after the fall of Rome? (Why should art *ever* get worse once it's good?) In effect, Vasari says, art started with God, because God made wild nature, the human form, and all the colors. It is not entirely clear how painting and sculpture got started, and Vasari makes some strange guesses. God gave people "a bright flesh color," he says, and that

could have inspired artists to find the same colors in the earth and use them to paint.

Vasari acknowledges that his theory is not "absolutely certain" and he wonders who might have made the first artworks. He knows from the Bible that the son of Nimrod made a statue just two hundred years after the flood, and so he surmises that people had been making sculptures from the earliest times. No prehistoric sculptures were known when Vasari was writing, and he had only a sketchy notion of the period between the Flood and ancient Rome. He recalls that the Greeks said the Ethiopians invented sculpture, and the Egyptians imitated the Ethiopians. But the Bible mentions idolatrous sculptures made by the Chaldeans, and Vasari himself knew about Etruscan and other ancient sculptures that had been found in Italy itself. In the end he gives up and says that since ancient history is so poorly known, it is best to just say that God Himself, "if I may venture to say it," was the inventor of painting, sculpture, and architecture. As proof he cites the fact that "simple children, roughly brought up in the wilderness," have started to draw of their own accord, guided only by the "beautiful paintings and sculptures of Nature."

But that is not much of an argument, and with some relief he turns to things he knows better. Once, he says, Roman art was "perfect," but then it began a long, sad decline. Italian artists had to start from scratch and discover good art all over again. The word he uses to describe what they did is "rebirth" (*rinascimento*)—the literal meaning of "Renaissance." So far, so good: art history was under way. But why did art get so much worse during the centuries after Rome?

Looking at the Arch of Constantine (312–15 C.E.), Vasari notices that the best parts were filched from older monuments, and concludes that the sculptors of Constantine's day could only do "very crude" work. Since Constantine's arch was built before Rome was sacked by the Goths in 410 C.E., Vasari decides that sculpture had already begun to decline in Constantine's day.

Things only got worse when Constantine moved the seat of government to Byzantium, because he took all the best art with him; and Roman art was given its deathblows by the successive hoards of barbarians who plundered and burned the city. Like Edward Gibbon in *The Decline and Fall of the Roman Empire,* Vasari blames the Christians for zealously destroying the few remaining signs of pagan antiquity, though he also defends them, saying they didn't hate talent as such but only its use in promoting pagan values.

The odd thing about this story is the mixture of reasons Vasari gives for the fall of the arts. When the great masterpieces of painting, sculpture, and architecture had vanished from the streets of Rome, the artists could be forgiven for not knowing how to proceed; but the political ruin of Rome was not the whole story. People also got worse. They forgot about virtue and they started acting in debased and degraded ways. With no "fine spirits" or "lofty souls" remaining, there was no hope of making good art. But for Vasari, even Rome's moral decay couldn't explain why art was getting worse when times were still good. In the end he opts for a kind of fatalism to account for what happened to Rome. "When human affairs begin to decline," he says, "they grow steadily worse until the time when they can no longer deteriorate any further." Fortune likes to bring people up to the top of the wheel, he observes, and then she likes to cast them down to the very bottom—perhaps because she regrets having lifted them up or maybe just for her own amusement. Rome was once "perfect," and then its arts were completely destroyed, literally buried under the ruined city. The few artists who remained in the early Middle Ages could not make anything except "shapeless and clumsy things."

All of this happens in the brief preface. When it comes time to set up the main content of the book—the Italian Renaissance from the fourteenth century to the middle of the sixteenth—Vasari singles out a few artists who inexplicably managed to make interesting works when no one had done so for centuries. (The

Duomo in Pisa was one such work, and Vasari says it inspired many artists who saw it.) After a few good works had been made, many more were possible because people could once again distinguish good from bad and they recognized the fact that the ancient Romans were the only artists worth emulating.

A reader might be forgiven for concluding that Vasari hadn't thought much about the decline and fall of Rome, or about how good art changes into bad, or about how people living in benighted ages can suddenly figure out how to make good work again. His book is huge by modern standards (most editions are more than two volumes long), and it consists almost entirely of short, chapter-length biographies of artists. There are very few meditations on history and how it works. The book is divided into three parts for the three periods of the Renaissance (roughly the fourteenth, fifteenth, and sixteenth centuries), and Vasari does not usually stop to ponder how history is arranged on a larger scale. All the same, he knows that if he has no theory about how history works, then his *Lives* will be nothing more than "a bare narration of facts," or "a mere list of the artists with an inventory." If any history is to last, he says, and be read by later generations, then it has to do more. An historian has to think about why history changes, what motivates people, and what distinguishes good work from bad. Ultimately, a great historian "teaches men how to live, and renders them prudent." (Now there is a goal no twentieth-century art historian would endorse.) I think Vasari was partly unsure about the purposes of history, because he also says good history involves telling stories about peoples' lives—and that is what he does throughout the book, despite the fact that he acknowledges it is not enough to make good history. At any rate, the solution he proposes is famously fraught with problems.

Vasari adopts the organic model, the venerable equation between the course of art and the course of a human life. In his schema, the art of the first period (basically the fourteenth century) was like a person's childhood, full of promise but also rife

with mistakes. Art in the second period (the fifteenth century) was nearly perfect, so much so that Vasari is hard pressed to describe what the artists of the third period (the sixteenth century) could possibly contribute. He says they possess a certain freedom, a "graceful and sweet ease," charm, delicacy, and above all an almost indescribable manner (*maniera*, from which we get the word Mannerism, the period that designates Vasari's own generation).

He says nothing about what might happen in the generations after his own: he probably doesn't want to think too much about his Wheel of Fortune and how it would cast good people back down, trampling them until they can "no longer deteriorate any further." Understandably, he doesn't want to dwell on what became of ancient Rome. It is only natural that he would have thought of his own generation as perfect (it's a common notion, though most historians and critics wouldn't say it so openly), and it is in accord with his generous nature that he wants the perfection of his generation and his country to be preserved into the far distant future. Still, it's easy to imagine Vasari's first readers remembering his description of the horrible law of Fortune and wondering what might *really* happen next. If art's first period is like childhood, its second like youth, and its third like maturity, then what is left for the generation after Vasari's except old age and death? The problem is entirely insoluble, and it mixes the organic model (the life history) with the oscillating model (the Wheel of Fortune).

Vasari's inconsistencies, his convenient blind spots and about-faces, have turned into sticky problems for later generations of writers. Luckily, Vasari didn't spend much time worrying about historiography. Over 90 percent of the *Lives* is just exactly what he said he would not write: a succession of very entertaining stories. Here is brief excerpt from his biography of the painter Piero di Cosimo, to give the flavor of his book. (I've excerpted various books to demonstrate how lively these "classics" are and to avoid giving the impression that art history is nothing but theorizing

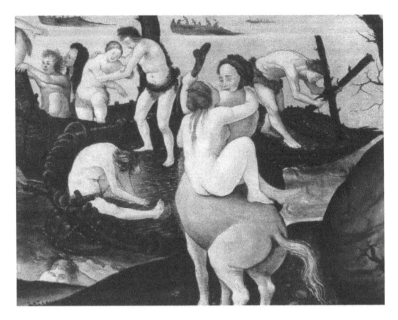

Plate 9. Piero di Cosimo (1462–1521?), *Return from the Hunt*, detail. New York, Metropolitan Museum of Art. Gift of Robert Gordon, 1875.

about how history is written. History should have the texture of what it describes and not just the restless rhetoric of modern academia.)

Piero was an eccentric artist who painted pictures representing the Dawn of Time, where human-headed animals graze placidly in rolling parklands, or battle each other with sticks and stones, or mingle with people from the Greek myths (Plate 9). Vasari does not always understand Piero's pictures but he describes them as best he can, as in the excerpt below:

[Piero di Cosimo] did some bacchanalian scenes in a chamber for Giovanni Vespucci, who lived opposite San Michele in the via de' Servi, now via di Pier Salviati, introducing curious fauns, satyrs, wood-nymphs, children and bacchantes, the diversity of creatures being marvelous, with various goatish faces, all done with grace and remarkable realism. In one scene Silenus[1] is riding an ass, with a throng of children some carrying him and some giving him drink, the general joy being ingeniously depicted.

Piero's works betray a spirit of great diversity distinct from those of others, for he was endowed with a subtlety for investigating curious matters in nature, and executed them without a thought for the time or labor, but solely for his delight and pleasure in art. It could not be otherwise, for so devoted was he to art that he neglected his material comforts, and his habitual food consisted of hard-boiled eggs, which he cooked while he was boiling his glue, to save the firing.[2] He would cook not six or eight at a time, but a good fifty, and would eat them one by one from a basket in which he kept them. He adhered so strictly to this manner of life that others seemed to him to be in slavery by comparison. The crying of babies irritated him, and so did the coughing of men, the sound of bells, and the singing of the friars. When it rained hard he loved to see the water rushing off the roofs and splashing onto the ground. He was much afraid of lightning and terrified of the thunder. He would wrap himself up in his mantle, shut up the windows and doors of the room and crouch into a corner until the fury of the storm had passed. His conversation was so various and diversified that some of his sayings made his hearers burst with laughter.

But in his old age, when eighty years old, he became so strange and eccentric that he was unbearable. He would not allow his apprentices to be about him, so that he obtained less and less assistance by his uncouthness. He wanted to work,

and not being able to on account of the paralysis, he became so enraged that he would try to force his helpless hands, while he doddered about and the brush and maul-stick fell from his grasp, a pitiful sight to behold.[3] The flies annoyed him, and he hated the dark.

Thus fallen sick of old age, he was visited by a friend who begged him to make his peace with God. But he did not think he was going to die and kept putting it off. It was not that he was bad or without faith, for though his life had been uncouth he was full of zeal. He spoke sometimes of long wasting sicknesses and gradual dying, and its wretchedness. He abused physicians and apothecaries, saying that they made their patients die of hunger, in addition to tormenting them with syrups, medicines, clysters and other tortures, such as not allowing them to sleep when drowsy.[4] He also spoke of the distress of making a will, seeing relations weep, and being in a room in the dark. He praised capital punishment, saying it was a fine thing to go to death in the open air amid a throng of people, being comforted with sweetmeats and kind words, the priest and people praying for you, and then going with the angels to Paradise, and that those were very fortunate who died suddenly. And thus he went on with these most extraordinary notions, twisting things to the strangest imaginable meanings. After such a curious life he was found dead one morning at the foot of the stairs, in 1521, and was buried in S. Pier Maggiore.

(Vasari, "Piero di Cosimo, Painter of Florence," 1568, excerpt.)

1. Bacchus' overweight, perpetually drunken companion in Greek mythology.
2. Animal glue was used in the preparation of panels and canvases, as a support for the paint.
3. The maul-stick or malstick is used to prop the painting hand against the canvas to steady it.
4. A clyster is an enema.

As you can imagine from this excerpt, Vasari is radically unreliable at times, but he is still read because of his wealth of information. He saw first-hand many of the artworks he describes and he knew many of the artists. He did not understand Piero's obscure subjects (they were identified only in the twentieth century) but his description is entirely typical of those found throughout the *Lives*. He lists the contents of the painting and praises its execution. He even calls Piero's figures graceful, one of his highest accolades, since it marks artists of the third and final period of art. It is also characteristic of Vasari to move quickly from talking about paintings to gossiping about painter's lives. Along with his half-finished theories about the progress of history, his habit of switching back and forth from praise to anecdote has intrigued and bothered generations of historians—even though his stories (*novelle*) are rich in historical meaning. There were ancient precedents for what Vasari did, but they were in separate books: Plato wrote aesthetics, Vitruvius wrote art theory, Durios of Samos wrote biographies, and Pausanius wrote travel accounts. Vasari mixed those and late medieval chronicles into a new potion recognizably his own.

When more recent art historical texts veer from descriptions to anecdotes or from praise to speculative theory, they are ultimately echoing Vasari's example. In current art-historical writing, anecdotes are more fully documented, in accord with the modern love of footnotes (they were first prominent in German historical writing in the nineteenth century), but they can still be oddly matched to the surrounding visual theories and stark documentation that comprise contemporary academic practice. Or, to put it more concisely: the incoherence that sometimes haunts art historical texts has its origins in Vasari.

Giovanni Bellori

For nearly two centuries, Vasari's *Lives* was the principal model for people who wrote art history. Some of his ideas proved difficult to accept: after all, even though he said that Italian art divided into

three neat stages, leading to a kind of static perfection, he also promoted the doctrine that history goes in cycles, with decay inevitably following perfection. It was a conundrum, and most later historians finessed the point by praising artists like Michelangelo and Raphael and saying that they "established" art, as if art could somehow remain more or less at its pinnacle even though no artists since Michelangelo had been quite as good. It was a tricky notion to uphold. Writers tried to have it both ways, putting the early sixteenth century at the apex of art, while also implying that things were still on that level. As late as 1698, nearly a hundred and fifty years after Vasari was writing, Pierre Monier argued in his *History of the Arts Related to Design* that art had declined only slightly since Raphael's time—but it wasn't an idea that could be sustained forever.

Understandably, most writers were taken by Vasari's biographies rather than his theories, and they either copied him outright or tried to emulate his expansive, friendly style. Giovanni Bellori's *Lives of the Modern Painters, Sculptors, and Architects* (1672), a very influential book, uses many of the same elements that Vasari had: brief introductions, pocket biographies larded with gossip, efficient descriptions of works, comments on style, and notes on the artists' commissions and their fame. It was a durable, if disorganized, formula to which Bellori adds a quieter historian's tone and an historian's penchant for documentation.

Bellori also knew that Vasari's three stages had come and gone, and that art was changing. He accommodated the new situation by naming several new tracks that painting was following in the mid-seventeenth century. For Bellori, Annibale Carracci, one of the founders of a conservative, classicizing school that sprang up at the end of the sixteenth century, represented a new course for art. Effectively, art had begun again after a period of decline in the mid- and late sixteenth century. Annibale had revived art by looking back to the Renaissance, just as the Renaissance painters had looked back to antiquity. That was one new possibility for art history, and another was artists who had different qualities, working in different

times and places. For Bellori, Nicolas Poussin was the preeminent artist-scholar; Rubens the preeminent court artist; Domenichino, an exemplar of artistic imagination; Lanfranco, the best follower of nature; and so on. Bellori's schemata suited his own philosophic bent and they are not followed today, but they opened a crucial new possibility for art history by implying that artists could go in different directions, at different speeds, toward different goals. In ways that would have surprised Bellori, historians could begin to think about schools, local practices, and the plurality of styles.

The effect of Bellori's revisionary history is like the spread of bicycles in the Tour de France: they start all together in a pack and gradually disperse into separate packs (*pelotons,* in the racing lingo) running at different speeds. For Bellori, as for almost every writer before the mid-nineteenth century, the race of art was just one race, begun at one time and going toward one destination, "perfection": but at the same time different schools, like pelotons, could be going at different speeds and using different strategies.

Karel Van Mander

Part of Bellori's purpose was to bring Vasari's account up to date, and other writers did the same, in effect adding supplementary volumes to the canonical set, in the way that the Apocrypha, Pseudepigrapha, and other writings were added to the Bible. Karel Van Mander's *Book of Picturing* (1603–1604) set out to do something different: in Van Mander's view, Vasari's account wasn't just out of date but fundamentally incomplete. Van Mander's project was to complement what Vasari had begun by writing the history of art north of the Alps. The *Book of Picturing* is a signal example of the oscillation between north and south that I mentioned in Chapter 1. From Van Mander's point of view, art had always had two sides, Netherlandish and Italian, and its story would be incomplete without both.

Aside from his one guiding idea, Van Mander—like Vasari—wasn't too good at historiography, and when it came to the actual writing he was even more gossipy and even less organized than Vasari. Here is part of his biography of the painter Joachim Patenier (1475–1524).

The grand, celebrated city of Antwerp, which prospers through commerce, has summoned from everywhere the most excellent in our art, who also frequently went there because art desires to be near wealth. Among others this Joachim Patenier, born in Dinant, went there too. He entered the guild and noble company of painters of the city of Antwerp in the year of Our Lord 1515. He had a certain, individual way of landscape painting—most subtle and precise, the trees somewhat stippled—in which he also painted deft little figures so that his works were much sought after, sold and exported to various countries. He had the custom of painting a little man doing his business in all his landscapes and he was therefore known as "The Shitter." Sometimes you had to search for this little shitter, as with the little owl of Hendrick met de Bles. [As Van Mander explains a little later, "This was the master of the owl who put into all his works a little owl, which is sometimes so hidden away that people allow each other a lot of time to look for it, wagering that they will not find it anyway, and thus pass their time, looking for the owl."]

This Patenier was someone who, in contradiction of his noble art, led a rowdy life. He was much inclined to drink, so that he spent entire days at the inn and wasted his earnings in excess until, forced by necessity, he had to devote himself again to the moneymaking brushes. His pupil was Frans Mostert whom, through bad temper and drunkenness, he often threw out of the door of the house but who put up with a great deal from him because he was eager to learn. When in Antwerp, Albrecht Dürer, who took much delight in Patenier's working method, portrayed him on a slate, or perhaps it was on a tablet, with a copper stylus, very excellently done.

(Van Mander, "Life of Joachim Patenier, painter of Dinant," 1603–1604, excerpt.)

I have looked for the "little man doing his business" in Patenier's paintings, and I haven't found one yet. (I have seen the owl in Hendrick met de Bles's paintings.) It's important that all these early books have no illustrations of paintings. It was assumed that you would go and see the works for yourself. (Plate 10 is a detail of one of Patenier's paintings, if you'd like to do some searching.)

Van Mander's book is remembered not so much for these colorful, informative and somewhat disorganized portraits, as it is because his is the first major effort to tell the history of European art outside Italy. Vasari had made a few gestures in the direction of northern Europe, but like Michelangelo he did not think highly of most German, French, and Flemish artists. To Vasari, art history virtually *was* Italian art history. Books like Van Mander's set out to take Vasari's mold and fill it with the art of other countries. The *Book of Picturing* includes an entire chapter taken from Vasari (modern copyright laws weren't in existence then), and Van Mander frames Vasari's material with chapters of his own on Netherlandish painters. His strategy produces curious results: reading Van Mander, it can seem as if Netherlandish art is Europe's major tradition, and Italy is somewhere off in the wings. Reading Vasari, the impression is the opposite. Readers who knew both books would then have been presented with a challenge, since they might have been led to wonder how the two are related. In logical terms, what Vasari did excludes what Van Mander did: Vasari's three stages describe *the* Renaissance of art, which was accomplished only in Italy. Other countries played marginal roles, but the classical past could only be reborn once. Implicitly, then, there is a contradiction between Van Mander's and Vasari's account—a contradiction which is merely absorbed, without much finesse, by Van Mander.

As other writers joined in the task of telling the histories of their countries' arts, the situation became even less coherent. Antonio Palomino's *Museum of Painting* (1715) has an extensive list of Spanish painters and scarcely mentions Italy. Still, the influ-

Plate 10. Joachim Patenier (active by 1515, d. 1524), *The Penitence of St. Jerome,* detail of central panel. New York, Metropolitan Museum of Art. Fletcher Fund, 1936.

ence of Vasari was subtle and pervasive: Palomino begins his chronicle in the sixteenth century because he thinks earlier Spanish painters were barbarous—a judgment that makes sense in light of Vasari's own opinions about good and bad art. Essentially Palomino is using Italian criteria of excellence and he complains that the artists he cares about died destitute or in hospices, while Italian artists became world-famous and were buried in "magnificent sepulchres." Even writers convinced of their country's importance, like the eighteenth-century French scholar André Félibien, had to acknowledge that the revival of antiquity began in Italy. And now, over four centuries after Vasari, it is still virtually impossible to write a book about these centuries that doesn't put Italy on center stage—a problem I'll take up in the next chapter.

Hegel

Because this is not a history of the discipline, I feel justified in leaping unceremoniously out of art history altogether to talk about a philosopher who has become indispensable in the later history of art. (If I were writing a history of the discipline, I would pause here to talk about Winckelmann, the defender of Classical Greek art.)

Georg Wilhelm Friedrich Hegel (1770–1831) didn't care much for visual art and did not see many works in the original. His concern was fitting art, aesthetics, and art history into larger philosophic schemes in order to reveal the essential thought that went into each. Among Hegel's many ideas about art, two have been particularly important for subsequent art history: the claim that art moves forward through time in accord with certain specifiable laws; and the claim that at any given time, all the arts of a culture are in harmony.

At first glance, there isn't anything new about the notion that art develops according to definite laws. The idea is implicit in Vasari's three periods of Italian art and in the ancient parallel between styles and the phases of a person's life. But Hegel thought in a highly abstract and systematic manner, and he proposes a definite three-stage process. History, he says, is the study of how people gradually found better ways to express the essential Spirit or Idea of culture and humanity. (Hegel's doesn't define Spirit in this way, but for my purposes it's close enough.)

In the first stage, there is no art that is up to the task of representing the Idea, and so people choose natural objects more or less at random and make them into *symbols* of the Idea. Hegel says the "early artistic pantheism of the East" is a good example, because people sometimes chose "the most worthless objects" and invested them with tremendous spiritual significance. (He may have been thinking of Hindu symbols like the elephant god Ganesha.) Symbolic artists fumbled about, trying to express themselves without being able to create forms that would harmonize with the content they had in mind.

The second stage is the *classical,* in which people—the Greeks and Romans—took the human form as their vehicle and invested it with all the aspects of the Idea. In that way Greek gods, who all had human shape, expressed the sum total of the Greeks' ideas about religion.

The third, last, and highest form of art is the *romantic,* in which natural forms are once again chosen to represent the Idea. Hegel allows that this may seem like a reversion to the primitive first stage, but what romantic art expresses is really not outward symbols but "inwardness" (*Innerlichkeit*) and subjective self-awareness. The Idea is at last free to take whatever form it will.

This is fairly typical of Hegel's way of reasoning. His works are vast, and this little outline was expanded into an encyclopedia of related ideas. (Literally so, because Hegel wrote an *Encyclopedia* as well as notes on aesthetics and art history.) It's easy to see how the triad of symbolic, classical, and romantic can also explain religion: first there were animal gods, then human ones, and now we have the incorporeal Christian God. (In a famous example, Hegel names the Sphinx as a transitional figure between symbolic and classical art: it was half animal—that is, half symbol—and half human—that is, half classical.)

Art historians have not taken the symbolic-classical-romantic sequence literally, any more than they have followed Vasari's three stages or Wölfflin's pair of Classical and Baroque. But it has proven virtually impossible *not* to think of art as progressing through time in a determinate fashion, and of all theorists of art history, Hegel has the cleanest, clearest analyses. In Hegel's view, art *progresses:* it actually moves forward rather than simply changing or wandering. His sequences are meliorist, that is, the art actually improves, because better expressions of the Idea or Spirit are to be desired over less accurate ones.

What is now often called the *diachronic* march of art through history is one of Hegel's two influential theories. The *synchronic* theory, which explains how art at any given time all hangs

together, is just as important. The example of the Sphinx shows how it works: Egyptian art and Egyptian religion worked together to express the Egyptian Idea, and the same was true of Greece. At any given time in history, *all* the products of a culture are linked by their identical relations to the Idea or Spirit, often called the Zeitgeist ("spirit of the time"). So a historian who studies the architecture of eighteenth-century England will find affinities between the painting, the furniture design, the politics, the religion, and even the state of warfare. Josiah Wedgwood's vases will fit with Robert Adam's architecture and Joseph Wright's paintings, and they will all fit together with English politics and Protestantism.

No contemporary art historian would say that Wedgewood, Adam, and Wright share a Zeitgeist; but at the same time, nearly every art historian behaves as if they do. Hegel's ideas are frustratingly tenacious. The proof is in the negative examples: art historians tend to be interested by artists who seem to stick out, who have special traits or characteristics in relation to the artists around them—what could be more natural? But then the art historian is apt to go on to write a book explaining how the artist fits into his or her time and place, and that is nothing more or less than demonstrating the Zeitgeist. The same happens with Hegel's diachronic theory. An art historian may be drawn to an artist who seems ahead of her time or curiously retrograde or to a style or a period that seems out of joint with its time. The solution is again Hegelian: the art historian examines the succession of periods and styles, and fits the artist or period back into it. Sometimes it is necessary to invent a new period, but even that expediency is fully in accord with the Hegelian mind-set. Hegel didn't say all cultures were as advanced as the Greeks, but his theory implies that all cultures eventually pass through the same stages. In my experience, these two art historical projects, mending the Zeitgeist and repairing the progress of the Idea, account for the majority of art historical writing.

Hegel is one of those insidious problems that seems easy to solve: after all, can't I just say that I will stop assuming art progresses or that all arts are tied to a central spirit? It turns out that I can say it but I cannot write that way, because the resulting lecture or book will sound *incoherent*. Listeners, viewers, and readers expect sense and structure in their art history, and so far at least the overwhelming majority of attempts to write different kinds of art history have failed.

Many fields are at work on this problem, even though (in typical fashion) Hegel isn't consistently named as the obstacle they are trying to avoid. Gombrich proposed a model based partly on the unpredictable sequence of fashion designs; the historians of science Paul Feyerabend, Karl Popper (Gombrich's longtime friend), and Thomas Kuhn all worked on questions of how science changes; and the philosopher Jacques Derrida has made concerted efforts to get past Hegel. The French art historian Hubert Damisch has tried to substitute card games and chess for Hegel's inexorable forward-marching sequences. (As if artists were playing chess or cards instead of always thinking about going *forward*.)

Many answers have emerged but so far none of them look or sound like art history. At best, they are evocative, inspiring, and challenging; at worst they sound impressionistic, ill-organized, and pointless. I'll look at some in a later chapter. For now, the moral is simple and somewhat depressing: twentieth-century theories have yet to show us how to get entirely around Hegel. The only answer is just to write art history, concentrating on the works and the ideas and not on Hegel's ghost hovering just beyond them.

New Stories

So much for illustrious confused predecessors and forbidding ghosts from the past. Twentieth-century art history, which includes the majority of *all* art history that has ever been written, has tried to go in a number of new directions. Some of the uncountable monographs and essays make their way into the teaching schedules of undergraduate classes and finally into the bulky one-volume survey texts that serve as most peoples' introduction to art history. The survey texts are simplified, compressed, conventionalized, and toned down, and so they tend to be disparaged by serious art historians. But historians still use them. Some major universities have experimented with ways of avoiding the survey texts, but the results have been less than successful. The root cause is the beginner's need for chronology, and—most essential from my standpoint—a story. In this chapter we will look at a half-dozen survey texts, starting with the one that prompted me to write this book.

E. H. Gombrich

Though it was not the first twentieth-century textbook of art history, Gombrich's *Story of Art* is the closest the century came to producing a book with clarity of purpose and a single, continuous narrative. It tells the story of art—*the* story, not just any story—with almost no distractions.

For nearly a century now (some fifty years before Gombrich crystallized it) there has been a standard way to tell the history of art. It begins with the strange and spectacular paintings of animals in French and Spanish caves, and then goes on to the ancient Middle East. The first chapters are a treasure trove of archaeological discoveries: Sumerians, Assyrians, Akkadians, Kassites, and neo-Babylonians. They are mesmerizing—the giant, bug-eyed, granite bulls, the incomprehensible gods and goddesses—but they are also a grab bag of exotic, orientalizing wonders that aren't set out in any particular order.

Once it gets under way in Egypt, art has a story to tell: it was passed from the Egyptians to the Greeks, from the Greeks to the Romans, from the Romans into the Christian Middle Ages, the Renaissance, the Baroque, and finally on to its culmination in Modernism and Postmodernism. Except for a few hitches, the story is fluent and very persuasive. It is also comforting, because it roots art in the great vanished civilizations and puts recent art at the crown of the tree of art history. Looking back, a reader can observe the triumphal succession of civilizations stretching all the way to ancient Greece and beyond. Places and times as far away and lost as Old-Kingdom Egypt are linked to art that is still being made. The vague oppression or guilt you may feel about having forgotten the great vanished civilizations is quelled by the realization that art has grown, like a giant tree, from hidden roots into leafy splendor. Even the most incomprehensible contemporary art is subtly illuminated by its place at the end of the story.

Gombrich tells this story with only a few detours. There are descriptions of Chinese art and Indian art, and some material on modern non-Western art, but mainly Gombrich recounts the development of Western *illusionism*: the increasing attention Western artists paid to the natural world and the ways of representing it. The relation between art and illusion was long Gombrich's central interest, and the *Story of Art* shows how Western art progressed from archaic symbols to highly naturalistic

styles, and then how modern artists turned away from naturalism and became skeptical of the world of appearances. It's the struggle for realism that gives the story its forward push, its drama. It may seem that realism is one of many themes that could unify a book on the history of Western art, and there are certainly other candidates. It is possible to tell the story of art as a matter of shifting political structures, or as the development of the idea of the artist as a privileged member of society, or as the rise of secularism and the gradual recession of religious art. These days it is common for art historians to write about the artist's social milieu, or the artwork's gender constructions, or the psychoanalytic theories embodied in the work. But that is all terribly recent: it dates, roughly, from the first half of the twentieth century. If you look deeper in history, you find that realism is the exclusive preoccupation. Realism has been the major theme of Western writing on art since Vasari, and before the proliferation of visual theories in the mid-twentieth century, it was virtually the only theme. For most Greek and Roman writers, there was no criterion of excellence more important than skill. So Gombrich's book is less a summing-up of his own interests than an exemplary feat that condenses the steady preoccupations of two thousand years of scattered writings into one brief book.

From Gombrich's point of view, the West is unique among cultures because it pushed toward naturalism with such vigor. Western artists invented or discovered linear perspective in the fourteenth century. They codified the rational play of light and shadow and made it into the science of chiaroscuro; they inquired into human anatomy; they developed the study of contrapposto, a set of rules for making figures look solid and weighty. After the Renaissance, Western artists made color into a science, complete with scales of chroma, value, and hue, and they studied phenomena such as simultaneous contrast and afterimages. They developed physiognomics, the academic study of human expressions. All those advances—I'm using words like "advances" and

"progress" advisedly—were made in the West, and some crucial ones, especially perspective, were made only in the West. Naturalism, in short, is *the* story of Western art.

Gombrich is a careful and eloquent writer, and he doesn't say this in so many words—it's the impression that his writing leaves: a reader finishing the *Story of Art* is conscious of having read a real story. Illusion weaves in and out of Gombrich's stories, pulling them together without being programmatic. Writing about Grünewald's grisly *Isenheim Altarpiece,* Gombrich notes that the figures are different sizes, in accord with the medieval custom of scaling figures according to their importance. At the same time, Grünewald knew the Italian Renaissance rules of perspective and scale, and used them "whenever they helped him to express what he wanted to convey." Bosch, Gombrich says, succeeded for the first time "in giving concrete and tangible shape to the fears that had haunted the minds of man in the Middle Ages." Bosch could only have done that "at this very moment," when the Renaissance had provided him with the naturalistic skill necessary to embody his inner fears. In such ways realism is blended into many of Gombrich's descriptions.

The plot has its moments of suspense—will the knowledge of the Greeks be passed on through the Middle Ages?—and its heroes—Brunelleschi and Alberti, the inventors and codifiers of perspective; Leonardo, the scientist of vision; Michelangelo, the master of anatomy. It has its villains, too, though they are almost entirely disguised by Gombrich's genuine interest and sympathy with many kinds of art. In the twentieth century, Gombrich says, artists turned away from problems of realism and began thinking only of form. "Whatever we may think of this philosophy," he writes, "it is easy to imagine a frame of mind" in which form is more important than the correspondence of the picture with reality. "Even if we do not share" the artist's interest, he concludes, "we need not scoff at his self-imposed labors." It's an open question in art history whether Gombrich really cared for some aspects of Modernism and

Postmodernism, and I don't mean to suggest that his rather skeptical tone here means he did not like abstract art. Still, any reader of the *Story of Art* will feel that he thought it missed something. Proof of the story's slightly negative ending is in the first editions of the book, where Gombrich's descriptions are occasionally more openly skeptical than in later editions. Here is an example, an account of Giacometti's very simple marble *Head* (1927) from an early edition and as he has emended it in more recent editions. Here is the description as it appears in the Fourth Edition (1951).

221

If a modern sculptor such as Giacometti (born 1901 in Switzerland) calls a mere stone cube with two dells in it a "head" he does not want to persuade us that he has ever seen such a block-head in real life. Houdon and Rodin in their wonderful portrait busts had in fact wanted to preserve for us what they had seen in the features of an inspiring head. Giacometti's purpose, like Picasso's, is entirely different. He is a sculptor who is fascinated by certain special problems of his calling and he assumes—rightly or wrongly—that we, too, share his interest. This problem, which he wants to tackle, was not invented by modern art. We remember that Michelangelo's idea of sculpture was to bring out the form that seems to slumber in the marble, to give life and movement to the figure while yet preserving the simple outline of the stone. Giacometti seems to have decided to approach the problem from the other end. He wants to try out how much the sculptor can retain of the original shape of his block while still transforming it into the suggestion of a human head. He finds that he need not even harm the surface by boring holes to represent the eyes. He just hollows out his two simple shapes and hopes that the surprising recognition of like in unlike will be more stimulating to us than the contemplation of a waxwork head, complete with eyelashes and all. And so it is, even if it might be argued that he has evaded rather than solved Michelangelo's real problem.

And this is from the Sixteenth Edition (1995).

96

One of the early members of the [Surrealists] was the young Italian-Swiss sculptor Alberto Giacometti (1901–61), whose sculpture of a head may remind us of the work of Brancusi, though what he was after was not so much simplification as the achievement of expression by minimal means. Though all that is visible on the slab are two dells, one vertical and one horizontal, it still gazes at us much as do those works of tribal art discussed in the first chapter.

Negative or not, the story has its arc, ending with a partial eclipse of illusionism. The plot is clearly theatrical, and it is even divided into different acts:

- First, the preamble in ancient Egypt and Greece, where human proportions were studied mathematically;
- Second, the near-loss of that knowledge in the Dark Ages and later;
- Third, the rediscovery of Classical knowledge in the Renaissance;
- Fourth, the elaborations of the Baroque and Rococo; and
- Fifth, the ambiguous, partly tragic ending, in which art deliberately turns against its naturalistic heritage.

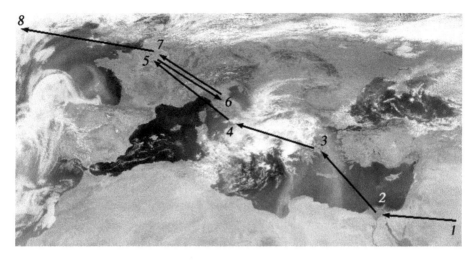

Plate 11. The standard story of art history. Courtesy of the author.

Or, if you don't like the tragic overtones of the theater metaphor, you can also picture the story as a journey. The story of art follows a well-worn path, wandering slowly westward, and finally leaping across the Atlantic (Plate 11). The trip starts in Sumer, works its way north, sometimes with a detour to Turkey for the Hittites, and then begins in earnest in Egypt. Next comes ancient Greece, number 3 on the map. There is a zigzag from Italy to France (ancient Rome, medieval France, the Italian Renaissance, nineteenth century French painting), and then eventually the path leaves Europe altogether for New York City. I don't know any tour companies that offer this itinerary, but it would be an interesting vacation: follow the advance of Western art, perhaps starting at the pyramids and ending in Manhattan in front of the Museum of Modern Art. A current version of this map would include a return to Europe for the Venice Biennale.

Let me call this the *standard story* of art history. At heart it has one message: the discovery, triumph, and abandonment of naturalistic skill. It raises a small army of philosophic problems, which I'll also list for convenience's sake.

First, it necessarily slights non-Western art. Gombrich does describe the art of Islam, India, and China, but only briefly. (Actually about 22 pages out of 637 are devoted to non-Western art.)

Second, tribal art is a special problem. Most of it is made of wood and fibers, so the preserved examples tend to be recent; by chronological criteria they should be the last chapter of the story. But that would look odd, since everyone expects art to end with Western Postmodernism. Gombrich's solution is to put tribal art in his first chapter, which he calls "Strange Beginnings: Prehistoric and Primitive Peoples; Ancient America." An earlier book, Wilhelm Hausenstein's *Art History* (1927) does the opposite, telling a standard story of Western art from Assyria onward and ending rather unfortunately with a chapter titled "Exotismus und Exoten," a mishmash of non–Western images too savage to find their places in proper art history. That sounds like orientalism, the Western fascination with all things outside itself—provided they stay outside.

Third, the story begins roughly, because prehistory and the ancient Middle East cannot be shaped into a coherent preamble to Egypt. Instead the initial scenes of the story shift wildly about, from Willendorf, Austria (where the famous little "Venus" was found) to Wiltshire, England (Stonehenge) to Boghazkeui, Turkey (the Hittite capital). Nothing before Egypt makes good narrative sense, but once Egypt is under way, so is the story.

Fourth, the standard story always needs a *starting point,* even though art rarely just starts up out of nothing. The cave at Lascaux, the *Mona Lisa,* and Cézanne's landscapes are examples of starting points. (Gombrich begins with Altamira and Lascaux.) Each object has its precedents, but telling *their* history would disrupt the histories that we expect. The *Mona Lisa*'s enigmatic smile came from Leonardo's teacher Verrocchio, and there are similar creepy smiles as far back as Greek sphinxes. Lascaux is one among many southwest European Upper and Middle Paleolothic sites. Cézanne was indebted not only to Impressionism but to his sense of Academic painting, which is normally conceived as the opposite

endeavor to his own. So what are good starting points? The art historian Whitney Davis calls this the *problem of Figure 1*: the standard story has to keep finding its initial examples, and they can never be adequately explained. Theorists call works like the "Venus" of Willendorf *myths of origin*: the statuette isn't really the beginning of anything, but it tells us where we'd like to think Paleolithic sculpture began.

These are among the salient issues of the standard story. They have prompted succeeding generations of art historians to patch the gaps in Gombrich's book, adding material and softening his special focus. But Gombrich's book is still in print because it tells its story so well: it is just a stronger book than its competitors. Today's corpulent survey texts do not erase the problems of the standard story—they only make them harder to spot. I'll try to demonstrate that by looking at two of the big survey books: one that has been in print even longer than Gombrich's (in fact, the most of the twentieth century), and another that is the latest entry in the high-stakes publishing race to provide a politically correct one-volume survey.

Helen Gardner

When it first appeared in 1926, Helen Gardner's *Art Through the Ages* was a small book. Successive editions gained in bulk and height, and a row of them together on a bookshelf looks like a staircase. In recent years Gardner's book has become the most popular one-volume survey of art: in 1994 it had 49 percent of the market share in the United States, compared to only 25 percent for Horst Janson's *History of Art*. In large universities, Janson's book is probably more popular; and another thirty-odd books, including Gombrich's *Story of Art*, compete for the remaining 26 percent of the market. Outside the United States, Gardner is hugely, unmeasurably popular. I have seen copies in China, and I have had students from Taiwan, Laos, Thailand, Korea, Columbia, Sweden, Finland, Hungary, and Romania who learned art history by reading Gardner. Gardner has been pirated and illegally

adopted and translated in an unknown number of countries. (In the next chapter we will meet one such copyright infraction in an Indian text.) All told, Gardner is one of the century's most effective emmissaries of American and European ideas on art.

In America one of the reasons for Gardner's success, I've been told, is its neutral tone. It is the product of two generations of rewriting, and these days (but not before the mid-twentieth century!) bland, noncommittal writing is at a premium because it is unlikely to offend readers. Another source of Gardner's success is its balance of Western and non-Western material. The two traits, though they may seem unrelated, go together.

As interest in multiculturalism grows, survey texts like Gardner's have to include more non-Western material even though it is not always taught in introductory courses. Contemporary publishing houses plan survey texts so that they contain enough non-Western material to satisfy teachers interested in multiculturalism; but at the same time they realize that in many schools the chapters on non-Western art may become optional reading. For that reason the non-Western material has to be easily separable from the core Western narrative, and Gardner's solution has proven to be a durable one: *Art Through the Ages* jags back and forth between the basic story of Western art and various non-Western interpolations. The idea is to keep a roughly chronological sequence while not unduly interrupting the story of Western art. Gardner's text is many times the length of Gombrich's, and it has so many "text boxes," time lines, definitions, color plates, and miscellaneous asides that the thread of the standard story is for all intents and purposes invisible. This is not unintentional: the successive editors have tried to dilute the emphasis on Western naturalism in order to make room for others kinds of information, especially on the social settings of artworks. A student who goes in order through Gardner's book will follow this zig-zag path through history (I have put the non-Western interruptions in boldface italics):

I. The Ancient World

1. The Birth of Art
2. The Ancient Near East
3. The Art of Egypt
4. The Aegean: Cycladic, Minoan, and Mycenaean Art
5. The Art of Greece
6. Etruscan and Roman Art
7. Early Christian, Byzantine, and *Islamic Art*

II. The Middle Ages

8. Early Medieval Art
9. Romanesque Art
10. Gothic Art

III. The Non-European World

11. The Art of India
12. The Art of China
13. The Art of Japan
14. The Native Arts of the Americas, Africa, and the South Pacific

IV. Renaissance, Baroque, Rococo

15. The "Proto-Renaissance" in Italy
16. Fifteenth-Century Italian Art
17. Sixteenth-Century Italian Art
18. The Renaissance Outside of Italy
19. Baroque Art
20. The Eighteenth Century: Rococo and the Birth of the Modern World

V. Modern World

21. The Nineteenth Century: Pluralism of Style
22. The Early Twentieth Century
23. The Contemporary World

Islam and the Byzantine Empire can be thought of as Eastern or Western, though in books like these Islam does not contribute at all to the narrative of Western narrative: it demands entirely new critical terms, period names, and nomenclature, and it seems entirely alien to what surrounds it in the text.

Gardner's Table of Contents is actually quite long; it stretches over eight pages. Even so, her book isn't the most complicated in this regard; Hugh Honour's and John Fleming's *The Visual Arts: A History* veers *five* times away from Europe and back:

I. Foundations of Art

1. Before History
2. The Early Civilizations
3. Developments across the Continents
4. The Greeks and their Neighbors
5. Hellenistic and Roman Art

II. Art and the World Religions

6. Buddhism and Far Eastern Art
7. Early Christian and Byzantine Art
8. Early Islamic Art

III. Sacred and Secular Art

9. Medieval Christendom
10. The Fifteenth Century in Europe
11. The Sixteenth Century in Europe
12. The Americas, Africa, and Asia
13. The Seventeenth Century in Europe
14. Enlightenment and Liberty

IV. The Making of the Modern World

15. Romanticism and Realism
16. Eastern Traditions
17. Impressionism to Post-Impressionism

*18. Indigenous Arts of Africa, the Americas, Australia, and
Oceania*

V. Twentieth-Century Art

19. Art from 1900 to 1919
20. Between the Two World Wars
21. Post-War to Post-Modern
22. Towards the Third Millenium

Notice how this goes: the authors need to talk about Buddhism early on, so it goes under heading II, "Art and the World Religions." The next few centuries saw the rise of secularism in the West but not in the East, so the authors' next heading is somewhat awkwardly called "Sacred and Secular Art." In practice, students do not pay much attention to these large categories, but they are signs of the strain that is being put on the narrative.

The quandary is nowhere more apparent than in the books' titles: Gombrich's, Gardner's, and Honour's and Fleming's books purport to tell the whole history of art, even though by rights they should be given the much less appealing title *History of Western Art.* Art historians have yet to produce a book that concentrates *mostly* on non-Western art and interpolates condensed chapters on Europe and America. In the final chapter of this book, I'll argue that such a book would not only be inappropriate for predominantly Western customers but would actually be incoherent because it would decisively remove the core Western story.

Gardner's book was one of the first attempts at a one-volume history of world art. When it was published, its competitors were German texts like Karl Woermann's *History of Art of All Periods and People* (1905), which included short introductory chapters on India and other Asian art. As Gardner's book went through successive editions and ballooned in size, the non-Western material was expanded and integrated into the surorunding text. The three excerpts below give material on "primitive" art from three different editions of the book. Each edition has a passage that jus-

tifies lumping "primitive" art into a single chapter; that passage gets more circumspect in the later editions, as the editors work to emend the prejudices embedded in Gardner's original formulation.

Here is an example from the First Edition (1926).

86

If art is great, in proportion as it reveals the experiences of life, then this Mayan art is great art. It is the profound expression of a people who were overpowered by religious problems and practices, by the fundamental questions of man, nature, and God, and by the manifestation of these in ritual and gorgeous ceremony. At first sight it appears fantastic and weird; for the subject matter, types, costumes, and apprent symbolism all seem so strange and unintelligible. Yet in many of the examples there is an unmistakable expression of intense spirituality. Ceremonial and religious intensity kept the expression formal. Symbolism controlled the motifs of decoration and the use of color. Primitive conditions of life also limited technical accomplishment. But even with these restrictions we find the people of Middle America not only untiring workers but bold decorators and skilled draughtsmen. The design and construction of their buildings are bold and massive; the carved and painted decoration, luxuriant, brilliant in color, and architecturally fitting. The minor arts too are vigorous in form and color and show the same sensitiveness to decorative design as the architecture.

From the Fourth Edition (1959).

251

Use of the word "primitive" need not imply cru-
dity or a lack of artistic quality. Works of art such as
Benin bronzes from Africa or wood carvings from
New Ireland are actually of complex design and
high technical refinement.

It has been said that primitive man generally has
a feeling for rhythm in art superior to that of other
peoples. Primitive man's attitude toward technique
is less intellectual than ours. His interests are nar-
rower, his social patterns more fixed. His art is
based directly upon the materials of use in his soci-
ety: hence the emphases upon basket-making, pot-
tery, weaving, and carving. He sees and creates in
conceptual rather than in purely visual terms, and
thus his idea of reality is often far removed from
ours. His sense of forms, with some exceptions, is
non-naturalistic, emphasizing abstract conventions
rather than ilusionistic reality. To understand the
primitive artist also requires recognition of his
rhythmical way of seeing.

From the Tenth Edition (1996).

52

Small-scale works of native art, easily transportable and readily accessible in exhibitions, were the first to suggest a new design. With the exception of the pre-Columbian peoples of North and South America, native cultures rarely produced monumental architecture, sculpture, or painting. The native genius for design generally appeared in relatively small sculpture in stone, wood, metal, bone, and perishable materials of many kinds. Painting was done on a variety of framed and unframed surfaces and in a variety of media, and its ornamental systems were applied in ceramics, weaving, embroidery, basketry, jewelry, costume, and utensils. In this chapter we are concerned primarily with works of this kind.

A remarkable consistency is maintained throughout the many variations among styles and substyles of native art. Native artists work almost by instinct in what we call *abstract* forms—nonobjective, nonrepresentational, stylized. We also have seen such forms in early Egyptian and Mesopotamian art, in the "idols" of Crete, in Islamic art, in the art of the European migrations, in the Early Romanesque, and in the haniwa art of Japan; we shall see them presently as an enormous influence on modern art. But the art of native peoples, with a few startling exceptions, remains consistently and conservatively abstract. . . .

The consistency of style in native art finds its counterpart in the consistency of its modes of signification. Insofar as it signifies by images, native art can be said to be representational, but only to a degree strictly limited by convention (convention which, as we have noticed, largely eliminates detailed report of the optical world). Geometrical simplicity of form is best suited to the rendering of signs, symbols, and images that have unchanging attributes and general meaning, like "divinity," "royalty," and "kinship." . . .

The consistency of style and signification in native art is reinforced by their conventionality and conservatism; the three characteristics are mutually reinforcing. Native art is overwhelmingly religious, and in religious art, as in religious rite, conventional forms, established from time immemorial, are conservatively retained, with only slight change. Thus, we find little of the *historical* development of style in native art that we have traced in the art of other periods.

———————

(Excerpts on the nature of "primitive" art, from Helen Gardner et al., *Gardner's Art Through the Ages*.)

In the first edition, Gardner wrote a continuous history of Western art up to the year 1900—that is, virtually to the time she was writing. She then added a chapter called "Aboriginal American Art from the Earliest Times to the Seventeenth Century A.D.," and one chapter each on India, China, and Japan, closing with a last chapter on "Contemporary Art in Europe and America." Those extra chapters were later moved backward in the chronology, so they interrupted Western art at its mid-point just between Gothic art and the Renaissance. Her original arrangement seems unfair to non-Western cultures because they look like afterthoughts or appendices to the story of Western art. But the shape of history is virtually the same in all the later editions because they all return to contemporary Western art at the end.

As Gardner's chapter on "primitivism" grew to include Africa and Oceania, it became more difficult to define what all "primitive" art had in common and to justify lumping it in one place apart from all the rest of history. Each new edition of *Art Through the Ages* has a fresh attempt to improve on previous misconceptions and even to do away with any appearance of negative judgment.

The first edition stresses religious meanings in order to help excuse the fact that aboriginal work is "formal" in nature and "controlled" by symbolism rather than naturalistic. Later that seemed unacceptable—after all, most art made in most cultures is religious—and the editors substituted a passage on rhythm. (I wonder it it wasn't inspired by contemporaneous American discussions of rhythm in American-American and Caribbean music.) The ninth edition does away with rhythm as a criterion and puts abstraction in its place. In a sense that improves things, since "rhythm" had become a stereotyped attribute of black people, but "abstraction" is no less Western and no less powerful as a tool for distinguishing the "optical," "detailed" world of European art from the "conceptual," "abstract" world of non-Western art. The passages get longer in each edition as they grapple with the proj-

ect of corralling everything recent and non-Western into a single nonjudgmental category.

The history of nineteenth- and twentieth-century non-Western art can almost be told in terms of the words used to name it. In the editions of *Art Through the Ages,* those words are "aboriginal," "primitive," "tribal," "native," and "non-Western." Even though none of the words seems quite right, it is important to find an adeqauate term; otherwise the world's indigenous art practices will disintegrate into thousands of independent kinds of art—and thousands of individual chapters.

It takes a special reading of a book like Gardner's to find the broken strands of Gombrich's story of realism: you have to read very carefully and often between the lines. But when a writer feels the need to *explain* simplicity ("Geometrical simplicity of form is best suited to the rendering of signs, symbols, and images that have unchanging attributes") then something is clearly amiss. Illusionistic works need only to be praised, but abstract and tribal works need to be explained.

Buried beneath the surface, scattered here and there throughout the 1,135 pages of *Art Through the Ages,* is the same essential story of the progress, the drama, and the *importance* of Western art.

Marilyn Stokstad

Marilyn Stokstad's *Art History* (1995) is the most recent major one-volume history of art. It has 1,350 illustrations and 6,000 entries in its index, and can be purchased along with "slide sets, CD-ROM, videodisk, videos, a student Study Guide, and an Instructor's Resource Manual with Test Bank." Three different types of tinted boxes give additional information, and there are maps, time lines, "parallels," and "Time Scales" to help the students along.

Stokstad's book advances the problem of integrating Western and non-Western material by dividing the non-Western histories in half and putting them at two different places in the book. The

book begins with prehistory and progresses in the usual manner to Byzantine and Islamic art. (Islamic art's "alien" feel helps launch the non-Western chapters.) The story then moves to India, China, Japan, the Americas, and Africa. Each chapter takes a particular non-Western art to a convenient stopping place: "Art of India before 1100" ends just short of the rise of Islam, and "Art of the Americas before 1300" includes the Maya and Anasazi and prepares the way for the Aztecs. After that first interruption, the Western narrative resumes with early Medieval art, and continues up to the Rococo. It is then interrupted again for the second installment of non-Western art (including "Art of India after 1100" and "Art of the Americas after 1300"), after which the Western story picks up with Neoclassicism and continues to the present. All that makes for a confusing table of contents (I doubt many students get the idea at first glance), but the book is easy to use as a reference tool.

Like Gardner, Stokstad mostly does away with transitional passages. Nothing links the chapters; there is no attempt to excuse the interruptions or recall themes that had been dropped dozens or hundreds of pages before. At the end of the chapter "Art of Africa in the Modern Era," a reader learns about a contemporary African artist called Ouattara. "In his emphasis on the inherent spirituality of art," Stokstad concludes, "Ouattara voices what is most enduring about the African tradition." That is the last sentence of the chapter; on turning the page, the reader enters the world of Western Neoclassicism: "For two centuries," the book continues, "the name *Wedgwood* as been synonymous with exquisitely made English ceramics." The lack of transition wouldn't surprise a student, who will probably read the chapters in different weeks of the survey course. But it is odd for a book that aims to be something other than an encyclopedia.

Stokstad writes carefully worded descriptions, reserving judgment and usually trying for a open-minded attitude. That quality, which is most advanced in Gardner's book and intentionally

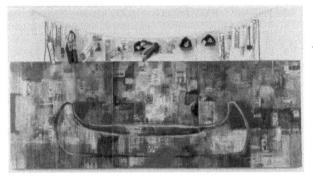

Plate 12. Jaune Quick-to-See Smith, *Trade (Gifts for Trading Land with White People)*. 1992. Oil and collage on canvas, 5' x 14'2". Norfolk, Virginia, Chrysler Museum. Courtesy of the artist.

Many Native American artists today are seeking to move beyond the occaisonally self-conscious revival of traditional forms to a broader art that acknowledges and mediates among the complex cultural forces shaping their lives. One exemplar of this trend is Jaune Quick-to-See Smith (b. 1940), who was raised on Flatrock Reservation in Montana and traces her descent to the Salish of the Northwest Coast, the Shoshone of southern California, and the Cree, a northern woodlands and plateau people. Quick-to-See Smith described the multiple influences on her work this way: "Inhabited landscape is the continuous theme in my work. Pictogram forms form Europe, the Amur, the Americas; color from beadwork, parfleches,[1] the landscape; paint application from Cobra art, New York expressionism, primitive art; composition from Kandinsky, Klee, or Byzantine art provide some of the sources for my work. Study of the wild horse ranges, western plants and animals, and ancient sites feed my imagination and dreams. This is how I reach out and strike new horizons while I reach back and forge my past."

During the United States' quincentennial celebration of Columbus's arrival in the Americas—in her words, the beginning of the "age of tourism"—Quick-to-See Smith created collages and paintings of great formal beauty that also confronted viewers with their own, perhaps unwitting, stereotypes. In *Trade (Gifts for Trading Land with White People)*, a stately canoe floats over a richly textured field, which on closer inspection proves to be a dense collage of newspaper clippings from local Native American newspapers [plate 12]. Wide swatches and rivulets of red, yellow, green, and white cascade over the newspaper collage. On a chain above the painting is a collection of both Native American cultural artifacts—tomahawks, beaded belts, feather headdresses—and American sports memorabilia for teams with names like the Atlanta Braves, the Washington Redskins, and the Cleveland Indians that many Native Americans find offensive. Surely, the painting suggests, Native Americans could trade these goods to retrieve their lost lands, just as European settlers traded trinkets with Native Americans to acquire the lands in the first place.

(Contemporary Native American Art , excerpt from Marilyn Stokstad, *Art History* (1995).)

1. A parfleche is an animal hide soaked in lye to remove the hair and mounted on a stretcher.

avoided in Gombrich's, makes Stokstad's book seem at once enlightened, multicultural, and oddly purposeless—as if art history really had no story to tell, and was just a rote chronicle of facts. On the previous page is a passage that shows the strengths and weaknesses of her ecumenical tone; it is from the end of the chapter "Art of the Americas after 1300."

This passage is the end of the chapter; the next page opens with Easter Island. The example of Jaune Quick-to-See Smith is a thoughtful way to close the account of Native American art, because it demonstrates the quandary that artists such as Smith and Ouattara face. This is where the book's neutral tone works best, because Stokstad reserves her thoughts on the success or failure of Smith's or Ouattara's heterogeneous works. It seems only appropriate to turn the page and begin reading about Easter Island. Ouattara's and Smith's kaleidoscopic arts are perfect mirrors of Stokstad's kaleidoscopic history in that each relies more on juxtaposition than synthesis.

Stokstad does have her own opinions, as when she says Native American artists are "seeking to move beyond the occasionally self-conscious revival of traditional forms." But those opinions are gentle and mainly hidden, and the avalanche of names and facts ensures that the book as a whole has no message or story line. In the absence of critical judgments, art is bathed in an eerie half-light of uniform praise. In the absence of a meaningful sequence of periods, art is strangely scattered, as if all of art history were an archaeological site strewn with random fragments. In the absence of an author who is partisan to a particular period or style, the reader begins to wonder if anything is better or more interesting than anything else. The situation is historically anomalous: before the twentieth century there were no histories of art that avoided making judgments or promoting specific historical periods. Now it seems only fair.

The history of survey texts suggests that a profound difficulty may be concealed behind the façade of multicultural equality: the

textbooks may owe their structure, their meaning, and even their existence to previous generations of books that they repudiate. Books like Janson's *History of Art*, Gardner's *Art Through the Ages*, and Stokstad's *Art History* would be unthinkable without the openly biased books that preceded them, which they implicitly reject. The lineaments of the older histories are present on every page. In Stokstad's book, a famous alabaster vase from Uruk (century 3000 B.C.E.) is described as a series of registers in low relief, aligned on groundlines (all three terms are in boldface, and are defined in a glossary); later Islamic art is introduced as "an interplay between pure abstraction and organic form" (69, 339). Those dispassionate concepts derive from impassioned discourses. The Uruk vase is a central object in claims that Mesopotamia led the way in the development of narrative art (and therefore founded Western art history); it matters to Western writers that words like "groundline" and "register" name the irreducible essentials of narrative storytelling. Calling Islamic art "abstract" or "decorative" is also a modern Western response; for many writers those words have been used to differentiate Islamic art from the West, subtly denigrating it for not grappling with naturalism. Even now, such terms require special pleading. In books like Stokstad's, words like groundline, register, abstraction, and decoration float like fragments of a shipwreck, detached from their original purposes.

The neutral tone can help correct prejudices about other periods and cultures; but it also paints an emotionally uniform picture of artworks that were never—in their maker's eyes, or in the judgments of historians—the objects of dispassionate description. A neutral, encyclopedic art history loses its impetus, the forward push that it had when it was recounted by people with a stake in art's development. Ideally, books like Stokstad's may help educate a generation of viewers to appreciate art more widely, freed of the prejudices that colored earlier accounts. But their bloodless descriptions might also promote a pallid enthusiasm where there

is no compelling reason to prefer one object over another. Instead of struggling with conflicting claims about history, students are being coached to look with equal interest on every conceivable object. There is more than a passing similarity between books like Stokstad's and the thirty-six-volume *Grove Dictionary of Art* (1996), recently completed with the help of 7,600 art historians.

It is tempting to think that art history has finally left Vasari behind. Vasari was openly, sometimes unreflectively partisan. Yet I suspect Vasari would have understood our textbooks well enough. I imagine him leafing through a copy of Gardner's *Art Through the Ages*; if he looked at the period between 1300 and 1550, he would have recognized every artist and almost every work. The descriptions of works by Michelangelo, Raphael, Bramante, Leonardo, and others would have been familiar to him because *Art Through the Ages* stresses many of the same issues that Vasari had emphasized— the artists' fame, their careers, their skill, their mythological and humanistic subject matter. (Vasari might not be happy to see that neither Stokstad nor Gardner reproduces any of his work. The ninth edition of Gardner's book calls Vasari "a versatile painter and architect" but notes that his book is "not always reliable.")

Of course many things would have surprised Vasari if he had turned to chapters other than the ones on the Italian Renaissance. He might well have found the chapters on China, America, India, and Africa unnecesary, misguided, unpatriotic, or impious (because they treat non-Christian art as if it had value equal to Christian art). But I would like to imagine that he would have had no difficulty understanding what *Art Through the Ages* is all about. After all, it is based on the same story he told in the *Lives*: it is fundamentally a history of Western art, and the heart of Western art is still the line that leads through the Italian Renaissance. All other art anticipates that sequence, develops from it, or orbits around it. I suspect Vasari would have been quite pleased to see the triumph of his history four centuries after the fact.

Competing Versions of Twentieth-Century Art

When it comes to the twentieth century, the standard story has three possible endings. In Gombrich, Modernism is the exhilirating ending of a long history, full of promise but with ambiguous undertones. In Stokstad and the recent editions of Gardner, Postmodernism is the challenging and problematic moment when the Western tradition partly dissolves into a mixture of innumerable other traditions. The third possibility is that the story has no ending one way or the other. H. H. Arnason's *History of Modern Art* begins with a summary of the standard story, concentrating on the depiction of "three-dimensional space" from Van Eyck to the invention of photography. At the end, he says that the 1990s had "no dominant style, medium, or movement," and the book closes with a list of thirty-seven recent artists in no particular order. These divergent solutions reflect the fact that the shape of the twentieth century, and to a large degree the nineteenth, are still contested by art historians and critics.

Out of the melée I'll pick just two cases.

First, the art historian and critic Robert Rosenblum has proposed a new way to think about the shape of Modernism, beginning in the early nineteenth century. In the standard story, France is talked about a lot. Most examples of prehistoric art are taken from France; France is the main example of Medieval art; France is mentioned in the chapter on the Renaissance; and France is at the center when it comes to post-Renaissance art. In histories of Modern art, France predominates until the United States takes center stage after World War II (Plate 13, top). Yet that emphasis is not entirely fair: there were Medieval styles throughout Europe, and Renaissance art was also made in Spain, Germany, England, Hungary, and elsewhere. By the nineteenth century, many countries throughout the world were participating in the fine-art enterprise. Impressionism is normally considered a French movement, but there were also Impressionism and Postimpressionism in Germany, North and South America, China, and Japan.

Rosenblum suggests an alternate story that would, as he says, "avoid Paris." It starts with German Romanticism, goes to Northern Europe, where there were expressionist artists like Nolde and Edvard Munch, and then on to New York City, the center of Abstract Expressionism (Plate 13, bottom). If you were to put Rosenblum's key artists and movements on a time line and compare it with the standard model, the result would look quite new:

French Academy		Post-Impressionism	Cubism	Abstract Expressionism
Caspar David Friedrich		Manet	Cézanne, Picasso	Jackson Pollock
1800	1850		1900	1950

Nineteenth and twentieth-century painting—the standard narrative.

German Romanticism		Expressionism	Abstract Expressionism
Caspar David Friedrich		Emil Nolde	Mark Rothko
1800	1850	1900	1950

Nineteenth- and twentieth-century painting—as proposed by Robert Rosenblum.

Rosenblum's account hasn't become the consensus, but it shows how open the field is: there is no general agreement on the shape of the last two hundred years of art.

Second, within twentieth-century art there are two major competing interpretations and several minor alternatives. The commonest version of the twentieth century stresses Cubism, Abstract Expressionism, Pop art, and Minimalism; it is opposed to an influential rival model that emphasizes photography, Surrealism, Dada, and contemporary Conceptual, feminist, and gender work.

Plate 13. The standard history of modernism (top) and the variant proposed by Robert Rosenblum (bottom). Courtesy of the author.

The standard model is largely due to several mid-century writers, including the critic Clement Greenberg and the curator Alfred Barr. Barr's chart (see Plate 5) shows Surrealism as a dead end and privileges Cubism and abstraction. Greenberg championed Abstract Expressionism and Color-Field painting. He was contemptuous of Surrealism, deeply unsure about Duchamp and Dada, and annoyed by Pop art and Minimalism. (In later years he advocated a movement called "New New Painting" that seemed to carry on the most promising line of abstraction.)

A rival model, which takes Surrealism as the century's crucial movement, has been developed by a number of contemporary critics and art historians. It is a strong position because, statistically speaking, much of contemporary art—from installation to video, from painting to performance—owes its basic strategies to Surrealism. Contemporary works that blur and question gender,

or show odd and inexplicable concatenations of unrelated objects, are, I would argue, fundamentally Surrealist. An example—from among literally millions—is David Kroll's *Mexican Parable* (1988): a dry but lovely commentary on the way the Catholic Church "fell" onto the landscape of Mexico (Plate 14).

The philosophic, historical, social, and even tempermental differences between these two approaches to the twentieth century do not begin to exhaust the conceptual disarray of writing on Modernism and Postmodernism. There are also influential theories that are largely ignored by academia: many people continue to prefer realistic paintings done with a modicum of skill; other people look willingly only at art that has a moral or social purpose. The twentieth century is a highly contested field of a half-dozen rival interpretations, and the disagreements between the art historians who privilege Modernism (including Abstract Expressionism and the primacy of painting) and those who privilege surrealism (including its explorations of gender and media outside painting) are the deepest and most interesting. Unfortunately the one-volume survey texts don't reflect these questions; instead, they try to mash as much art as they can into the chapters on Modernism and Postmodernism, making it look as if the twentieth century is just a collection of isms.

This may be a good place to insert a note on Barr's diagram and all the others in this book. Barr's and Greenberg's versions of the century have been criticized for being overconfident and too rational and abstract. At the time, Barr's chart was critiqued for omitting social context—for imagining that art begets art without its surrounding culture—and for being too wrapped up in the machismo of conflicts between faceless antagonists. Recently it has been said, particularly by historians who privilege Surrealism, that Barr's diagram is the very epitome of Modernist thinking that can never accommodate the subversive, irrational effects of movements like Surrealism. Doubtless Barr was using his diagram to consolidate his own version of the century and to put the Museum

Plate 14. David Kroll, *Mexican Parable*. 1988. Oil on canvas, 51" x 20". Courtesy of the artist.

of Modern Art, where he worked, on the international map. Yet I've used charts, maps, and other diagrams throughout this book: does that mean I am inadvertently promoting a modernist or formalist philosophy of art? I don't think so, for two reasons: first, whereas Barr was proselytizing, I am reporting (and inviting readers to make their own reports); and second, there have been many times in art history, starting with Vasari, when writers have set out the equivalent of Barr's chart. Diagrams—flawed or not, mental and otherwise—are part of our ways of coming to terms with history. What they do omit, and dangerously so, is the close-up feel of history and of a single viewer's encounter with a single work. In that sense, the text excerpts I have scattered through the book complement the diagrams by showing what they cannot be.

What Are World Art History Books *For?*

Those are a few of the endemic problems that plague current art history textbooks. There is also a larger issue that encompasses this book as well: the question of purpose. Why, exactly, do professors and parents want to teach the history of art, and why do students and readers want to learn it? What need is fulfilled by the monolithic survey texts? (And what need does *this* book answer to?)

Nominally, a book like Gombrich's is for college students, but in a wider sense it exists to promote a certain understanding of culture. It helps polish a liberal arts education by evoking the panorama of art history and it aims to enrich its readers' lives by alerting them to the place of visual art in Western culture. The bigger books, like Gardner's and Stokstad's, try to open the field of art even more and convey some of the importance and richness of *all* art, showing how it is part and parcel of the shared global culture.

The survey textbooks promote a certain kind of education. An ideal student will learn a little about many kinds of art: she'll be able to tell a High Renaissance painting from a Mannerist one, or King David from the *David*. Yet I wonder whether it is a good idea

to create a generation of people who are armchair connoisseurs of high culture, who can always be ready with a pertinent thought when they are confronted with a new artwork. Does it really matter if you can drop an intelligent line or two about the *David* at a party? Is your life really better for knowing about the Renaissance? There are even histories of art for children from kindergarten age up to high school. (Janson's *History of Art for Children* is a popular example.) But does a child have a happier life thinking about Giotto or Monet? The new texts are predicated on the idea that certain objects (like the *David*) made in distant times and places (such as Florence) are relevant for *any* full and rewarding life.

Yet this has not always been the case. The big telephone-book surveys of art are a particular invention of the mid-twentieth century, and the market for them is driven first and foremost by the common consensus that young people need to know about art. Before the early nineteenth century there were no equivalent books, and no notion that art and its history are part of any person's full education.

The goal of general cultural literacy itself is a German one, first developed in the nineteenth century under the name *Bildung*—a kind of aesthetic education that polishes a person by making him into a picture (that's the literal meaning of the German word). These days a similar kind of cultivation is called *aesthetic education,* and it is associated more with conservative intellectuals than with any broad consensus. One-volume art history survey texts are still mainly about European culture, and in that respect they are the overgrown descendents of the *ciceroni,* the nineteenth-century guidebooks for tourists making their pilgrimages to Italy.

My own sense is that art history is interesting only when it can be seen as many stories made by many people, often for contentious and partisan purposes. Art history has always been inseparable from nationalism and from anxieties about the kind of life people want to live and the values they hold most closely. Every

generation and every nation have to come to grips with the art of their past, and for that a believable art history is essential. I am deeply unconvinced about the notion that art can be taught fairly and dispassionately, and I'm deeply unsure about which individual artworks are worth mentioning. I can't imagine writing a survey textbook myself—but that's another story, which I'll take up in the final chapter. For now, I want to continue the job of this book, which is looking at the different shapes of art history.

Non-European Stories

When art historians debate the survey course, the arguments usually turn on the major textbooks by Gombrich, Gardner, Stokstad, Honour and Fleming, and Janson. The situation is a little incestuous because those books are all in the same family: they were all written in the twentieth century in Western Europe or America. It helps to look beyond those limits in order to see how art history has appeared in different times and places. To that end we turn now to several books written outside Western Europe and America: the first two by writers who knew the standard story; the third by a writer who had barely heard of the Renaissance; and the fourth by a writer who had barely heard of the West.

A Russian Universal History of Art

In 1956 the Institute for the Theory and History of the Visual Arts at the Academy of Arts in Moscow, in collaboration with about a hundred and fifty scholars throughout Russia, published a multivolume *Universal History of Art*. Nine years later it was translated into German and published in East Germany. The translator, Ullrich Kuhirt, claims it is the first comprehensive history of art that brings together the researches of the plurality of Soviet art historians. Certainly it is a massive accomplishment, comparable to the German *Propylaea of Art History* or the English *Pelican History of Art*, both multivolume series used in graduate-level research. In

the German translation, the *Universal History of Art* runs to about 6,900 pages and occupies eight heavy volumes.

The first six volumes proceed as a Western European reader might expect, beginning with Neolithic art and moving quickly through Mesopotamia, Greece, and Rome and then more slowly through Byzantine and Medieval art. Because the series was written by Soviet scholars, it is not surprising to find chapters on the Medieval art of Eastern Europe. But a reader might sense something is off kilter in the seventh volume, which treats the art of the nineteenth century. There the chapters are decidedly surprising:

French Art
Spanish Art
English Art
Art in Russia
Russian Art from the end of the eighteenth century to 1860
Russian Art from 1860 to the end of the nineteenth century
 Ukrainian Art
 Belorussian Art
 Lithuanian Art
 Latvian Art
 Estonian Art
 Georgian Art
 Armenian Art
Azerbaijanian Art
German Art
Belgian Art
Dutch Art
Art in Scandinavia
 Danish Art
 Swedish Art
 Norwegian Art
Italian Art
Austrian Art
Hungarian Art

Czech and Slovak Art
Polish Art
The Art of Yugoslavia
 Serbian Art
 Croatian Art
 Slovenian Art
Romanian Art
Bulgarian Art
Art of the United States of America
Japanese Art

It's not the preponderance of Russian art that is surprising here, because every history of art privileges what is near at hand. But the outline of chapters paints a very different nineteenth-century from the one known in the West. Virtually all European and American books on nineteenth-century art are dedicated to France, with ancillary attention to Germany, Italy, and England. (In the *Universal History* itself, smaller countries get short shrift in comparison to France, but there are still chapters for every country.)

As Rosenblum pointed out, in the Western European tradition it is special pleading even to include Scandinavia. Yet here it looks as if Russia and Central Europe had the lion's share of nineteenth-century art. America barely makes the list, alongside Japan—a country that is never included in the roster of essential developments in nineteenth-century art unless the subject is Japanese prints. No art historian I know could begin to fill in the contents of some of these chapters: it is pure terra incognita for Western art history.

At first it may look as if the authors of the *Universal History of Art* wanted to write a truly universal history and include as many countries as they could. Their real agenda does not become apparent until the final two volumes, both called *Art of the Twentieth Century*. The first looks even more catholic than the preceding volume, with an equally breathtaking table of contents:

French Art
English Art
Belgian Art
Dutch Art
German Art before 1945
Austrian Art
Art of West Germany
Art of Switzerland
Italian Art
Greek Art
Spanish Art
Art of Scandinavia
 Danish Art
 Norwegian Art
 Swedish Art
 Icelandic Art
 Finnish Art
Art of the United States of America
Canadian Art
Art of Latin America
Australian Art
Japanese Art
Indian Art
Ceylonese Art
Indonesian Art
Burmese Art
Afghan Art
Turkish Art
Art of the Arabian Countries
Ethiopian Art
The Art of West Africa

This is especially impressive when it is borne in mind that this volume, the penultimate one in the series, treats only twentieth-

century art: no other art history text that I know has separate chapters on Modern art in Indonesia or Iceland. There are more Asian countries here than in the nineteenth-century volume because the authors were not interested in traditional arts: they cared only when the countries began to adopt Western styles, whether they were taking them directly from France (for instance, Burmese artists first discovered Monet in the 1910s) or adopting the Socialist Realism favored in the Soviet Union.

The *Universal History of Art* seems to be a general history of Western-influenced art, but a small clue gives away the writers' larger purpose: Germany is divided into "German Art before 1945" and "Art of West Germany." This entire penultimate volume, in fact, collects the art of capitalist countries. The culmination of the *Universal History of Art,* and its strangest achievement, is the final volume, which is divided into the art of the U.S.S.R. and the art of all other socialist countries:

Art of the U.S.S.R.
> Russian Art from the End of the Nineteenth Century to
> the Beginning of the Twentieth
> Ukrainian, Belorussian, Latvian, Estonian, Lithuanian,
> Georgian, Armenian, and Azerbaijanian Art from
> the End of the Nineteenth Century to the Beginning
> of the Twentieth
> Soviet Art

Art of the Socialist Countries in Europe
> Art of East Germany
> Polish Art
> Czechoslovakian Art
> Hungarian Art
> Romanian Art
> Bulgarian Art
> Yugoslavian Art
> Albanian Art

Art of the Socialist Countries in Asia and Latin America
 Mongolian Art
 Chinese Art
 Art of the Korean Popular Democratic Republic [North
 Korea]
 Art of the Democratic Republic of Vietnam [North
 Vietnam]
 Cuban Art

The *Universal History of Art* is a Stalinist project, intended to prove
that Western art outside communist countries is aimless, purely
formal, and decadent. Communist art is the culmination of art his-
tory, its apotheosis. It is not accidental that Cuban art gets the last
word at the very end of this last volume, since Cuba was Russia's
showcase in the Western hemisphere.

 There is a sweep to the *Universal History of Art,* and a certainty
of purpose that is missing from most Western European and
American texts. The thousands of unfamiliar artists and works cre-
ate a strong impression, as if an alternate twentieth century might
have replaced the familiar one. An excerpt from the chapter on
twentieth-century Rumanian art, below, written by M. T. Kusmina,
gives the flavor of the book—its enthusiasm and the nationalism
that simmers under the surface.

 Over and over, individual artist's works are folded into the col-
lective or attributed to their nation's spirit, as they are in this
description of Ion Irimescu, a popular mid-century Romanian
sculptor. A Western reader might expect that the result would be
a kind of unbelievable propaganda, but the *Universal History of Art*
reads more as a celebration of socialism and nationalism. It
acknowledges the periphery of the art world in the first half of the
twentieth century more than any other survey, and the Stalinist
agenda is not a large price to pay for an introduction to several
thousand unknown artists and movements. It is easy, reading the
Universal History of Art, to imagine a different twentieth century in
which countries around the world lend their different voices to a

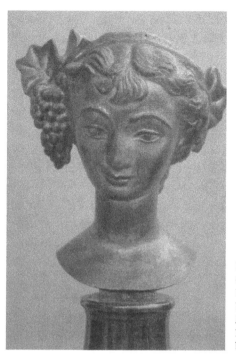

Plate 15. Ion Irimescu, *Young Girl with Grapes.* 1944. Bronze. Present location unknown. Photo from Alexandru Cebuc, *Irimescu* (Bucharest: Editura Meridane, 1983). Photograph by Radu Braun.

Ion Irimescu (b. 1903) made important works in both monumental and genre sculpture. His forms are always interesting and many-layered, whether they are lifelike portraits such as one of the painter Baba (bronze, 1946) or the art historian Oprescu (1937), or very lyric and deeply felt female figures, such as the *Young Girl with Grapes* (1944), [Plate 15], or the *Peasant Woman* (*The Flowers,* 1961). The latter is a beautiful young farm girl who holds a flower in her hand; she is the embodiment of Romanian folk art, which has always created beautiful things and always will. Irimescu also sculpted a row of worker's heads, among them the famous *Steel Caster* (1954) and the *Welder* (1962, bronze, in Bucharest). They embody the typical character of the socialist working people of Romania.

(Romanian art, excerpt from *Universal History of Art,* Moscow, 1956.)

chorus of Modernism, rather than anxiously following or deliberately ignoring the avant-garde in France, Germany, and America. The Soviet Union and other Soviet-bloc countries produced many smaller histories of art. The ones I have seen are not so much oppressive as intriguing. The best are exhilarating, full of what the composer Arnold Schönberg called "the air of other planets." One, published in 1963, was planned in three volumes: it begins with prehistory, and ends, in the second volume, with German Renaissance limewood sculpture—the rest proved problematic, possibly because it was tinged with capitalism, and the third volume never appeared. Konstantin Aleksandrovich Erberg's *History of Art* (1922) ends the sequence of Western European art with the Italian Futurist Carlo Carrà, moves east, and continues through the Polish artist Stanislaw Wyspiański, who was influenced by Symbolism and the Nabis. Another, Nikolai Malakhov's *On Modernism* (1975), is an example of a clever author outwitting the regime: Malakhov's "denunciations" of decadent Western art are full of double meanings, so that the book could be read as a sympathetic account of movements as recent as Pop, Op, and Kinetic art.

My favorite is Vladimir Semenovich Kemenov's book, subtitled *ot Leonardo da Vinchi do Rokuella Kenta* ("From Leonardo da Vinci to Rockwell Kent"). It begins with a long chapter on Leonardo, treats Baroque monumental bronze sculpture (emphasizing the French examples in Russia), continues through nineteenth–century Russian Realism (including a chapter on the sculptor Sergej Timofeevic Konenkov) and ends very satisfactorily with a pious chapter devoted to Rockwell Kent. Kent was a Soviet sympathizer, and his linear style fitted well with Soviet didactic printmaking. He wouldn't normally be a bookend for Leonardo, but in context of the book the pair seems well matched. (Kemenov was a conservative historian who championed the cause of Realism in art; he censored articles on Picasso as late as 1981.)

The shorter Russian texts tend to emphasize artists such as

Leonardo and Rembrandt whose styles make them natural
antecedents to nineteenth-century Russian Realism. The books
have lacunae in the early and High Renaissance, the Rococo (in
part because it was a deviation from the strict models of the
French Academy, which was the model for Russian academies),
Impressionism, Modernism, and Postmodernism. Those may
seem serious omissions, but Western texts have complementary
lacunae: they tend to slight nineteenth-century academic art in
France and Russia (that is, they abbreviate the very styles that were
the foundation of Soviet academic practice), and they routinely
exclude German Impressionism, Eastern European
Impressionism and Postimpressionism, and twentieth-century
Social Realism. The gaps are complementary: "our" texts, nomi-
nally unbiased, are sometimes perfect casts of Eastern molds.

One lesson I take from the *Universal History* is that Western
histories of art, from Vasari to Stokstad, have more prejudices than
are dreamt of in our Postmodern philosophies. The Russian "uni-
versal history" shows with uncanny exactitude how America's
apparently nonjudgmental survey texts not only are deeply biased
toward the West (we knew that) but are in parts virtually capitalist
manifestos, excluding each and every one of the movements that
the Russian text includes. The Russian "universal history" is a big
piece of the picture, and it fits seamlessly with Gardner and
Janson.

Egyptian, Turkish, and Iranian books

I'm imagining a jigsaw puzzle called "Perceptions of Twentieth-
Century Art." Russian and Western texts aren't the only pieces:
twentieth-century Islamic texts are another example, different
from both the socialism of the *Universal History* and the capitalism
of Gardner and Janson. Islamic textbooks tend to begin with
Egypt, Greece, and Rome, continue through the early Middle
Ages, and end with either Romanesque or Gothic before return-
ing to Islamic and Far Eastern art. I'm not sure how that tradition

began and I can't decide whether it is an attempt to avoid the Western Renaissance or to swerve toward the Middle East after the time of Muhammad.

Burhan Toprak's *Sanat Tarihi* (1960), written in Turkish, takes seventeen chapters to tell the history of art from Prehistory to the Mérode altarpiece (1425–1428), emphasizing the Hittites, the Assyrians, and Iran in separate chapters and then concluding with two chapters on Hindu art and Japan.

Ali Nagi Vaziri's *Tarikh-i umumi-i* (1959), written in Persian and published in Tehran, opens with a review of formal principles (the author credits "Helen gardener" in the notes), and then follows world art through the Gothic. The remainder of the book treats India, Africa, Mesopotamia, and the art of the Persian Gulf.

A particularly curious example is Salamah Musa's *Tarikh al-funun,* written in Arabic and published in Cairo in 1929. It is based on Sir William Orpen's history (1923) and is a collection of mostly Renaissance and Baroque portraits, but it begins with military frescoes, a painting of an army convoy, and other material of local political interest. To a larger extent than historians might want to admit, the Islamic texts are the mirror images of our Western ones: we slight Islam just as they slight the Christian West. Like the Russian *Universal History,* they fill in the negative spaces missing from the familiar Western history texts.

Edith Tömöry

Farther afield than Russia, Egypt, Turkey, and Iran are the many ex-colonies that imbibed an interest in Western art and then had to rethink it after independence. Edith Tömöry, who taught in the Department of Fine Arts in the Stella Maris College in Madras, India, wrote one such book. *A History of Fine Arts in India and the West* (1982) is a collaborative effort with faculty and students, and for economy's sake it is illustrated largely with line drawings made by three of her colleagues.

The book is divided unceremoniously down the middle, as the

title suggests: the first half, called simply *India* on a separate title page, tells the history of Indian art beginning with the "protohistoric" Indus Valley civilization (2700–1500 B.C.E.), and the second, called *The West*, recounts the history of Western art from Egypt to Barbara Hepworth, David Smith, and George Segal. The history of Western art is told in a conventional sequence of four megaperiods named Ancient, Medieval, Renissance, and "Modern Trends." Tömöry's distance from Western scholarship—both physical and metaphorical, since it is clear she did not have access to many Western texts—sometimes gives her writing an odd flavor. An "oft-recurring subject in *F. Bacon's* work," she says, referring to Francis Bacon, "is a human being imprisoned in a box by a glittering web of uncanny rays of light." A Western art historian probably wouldn't have put it that way: "glittering web" sounds almost happy, and the word *uncanny* has gotten a special resonance in Western criticism since Freud used it to describe a particular kind of modern alienation. It is as if an artist who has become history in the West were being rediscovered by an art critic in the East.

Most of the book is straightforward because Tömöry relies on a miscellany of popular sources such as Gombrich, Gardner, Sir William Orpen's *Outline of Art* (1923), Germain Bazin's *History of Art* (1959), Jose Pijoán (principal author of the *Summa artis*, a Spanish survey of art history that is currently at thirty-five volumes and growing), the *Time-Life Library of Art*, and the even-more-popular ten-volume *Teach Yourself History of Painting*. The *Time-Life Library* was a stock presence in middle-class homes when I was young; Tömöry's college may have subscribed, because she cites twenty-five volumes from *The World of Bernini* to *The World of Winslow Homer*.

Despite these unpromising sources, both halves of Tömöry's book, *India* and *The West*, take unexpected turns just at the end. She does not try to disguise her dislike of modern Western art. "In the classical tragedies," she says, "the evil powers of hate and aggression in the human psyche were overcome by heroism, which

frees the soul of the dark powers within. The modern sculptors, however, irritate and wound rather than cure and heal. For instance G. *Richier's the bat* (1952) shows a sinister natural form in the process of decay." Germaine Richier (1904–1959) was a figurative French sculptor, a minor figure, and certainly not most historians' idea of a radical modernist. Tömöry is uncomfortable with Modernism of all sorts because she feels that real art brings peace, wonder, and admiration rather than perturbation, emotion, and torment. The conclusion sounds out of place on the last page of a history of Western art.

The closing pages of the other half of the book, on India, are even more unusual. She divides her account of Indian art into three media, separating architecture, sculpture, and painting. The first two histories stop without explanation well short of the present. Architecture begins with *stambhas* (pillars, dated from the fourth century B.C.E.) and ends with Mughal buildings (sixteenth to eighteenth century); one of the last examples is the Taj Mahal. Sculpture begins with the Mauryan empire (c. 324–c. 188 B.C.E.) and ends with Chola dynasty bronzes (ninth to thirteenth century C.E.). At that point it looks as if the book is going to present Indian art as a fait accompli, something that ended with the rise of colonialism. But painting is treated quite differently: it begins with the Ajanta and Badami murals (c. 475 C.E.; see Plate 16) but ends, surprisingly, with "modern Indian painting" in the late twentieth century.

Why the difference? Why leave architecture two centuries behind the times and sculpture seven centuries behind the times, and then continue painting to the present? From Tömöry's point of view, Indian architecture and sculpture declined into empty "decadence," but painting began to revive at the end of the nineteenth century. Eighteenth- and nineteenth-century painting was at a "dead end"—it was exhausted, suffering from an "arid lack of spirit." At the close of the nineteenth century, painters such as Raja Ravi Varma (1848–1906) started to build a national style out

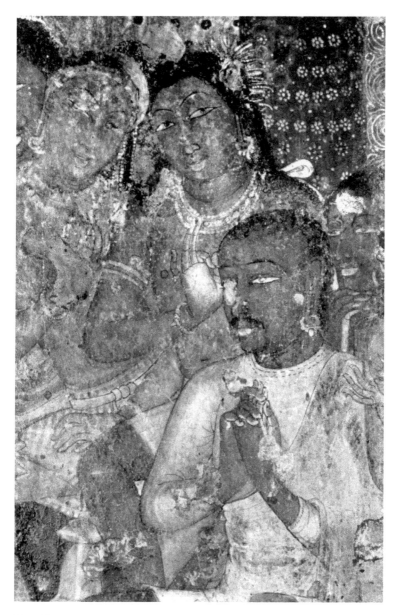

Plate 16. Figures from the Ajanta caves. 475–510 C.E., Vakataka Epoch. Ajanta, cave XVI. Borromeo/Art Resource.

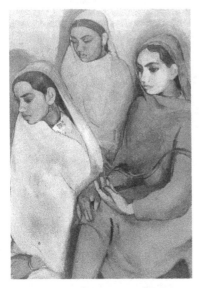

Plate 17. Amrita Sher Gil, *Three Girls*. Oil on canvas, 66.5 x 92.8 cm. New Delhi, National Gallery of Modern Art, Acc. No. 982.

Amrita Sher Gil (1913–1941) was undoubtedly the greatest among these rising young artists [Plate 17]. Of mixed Sikh-Hungarian parentage, she was trained in Paris and master therefore of Western technique. Wholly Indian in spirit, she declared on her return to India in 1934, "I realized my real artistic mission: to interpret the life of Indians and particularly the poor Indians pictorially; to paint those silent images of infinite submission and patience, . . . to reproduce on canvas the impression their sad eyes created on me."

However the artists whose work influenced her most were not Indians. From Cézanne she learnt to strive for "simplified naturalism," and from Gauguin, not his sensuality (though this has an affinity with ancient Indian art) but rather his melancholy.

Strongly reminiscent of Cézanne yet thoroughly Indian, is the *child wife,* one of her best pictures. The subject sits in the familiar Indian pose: one knee up, the other leg lying sideways, sharply bent at the knee. By elongating the limbs so that the raised knee is almost at shoulder level, the artist gives the impression of childish thinness, further accentuated by the straightness of the startlingly white blouse. The face of this child appears inexpressibly sad. The large eyes look out from under the straight long hair. The title explains the sadness. The thick lips, strongly highlighted, express an almost sulky resentment—not generally found among older women in India, accustomed as they are to have their fate decided for them by others.

Hill men, painted in 1935, shows a group whose straight vertical lines heighten the over-riding melancholy of the theme. Two turbaned men stand half facing each other, while a woman, no less melancholy, sits at their feet, the outline of arm and knee no more than suggested under the smooth clothing, just as the form of the men is merely hinted at under their enveloping shawls. Here too the artist arrests the eye by a bold use of pure white in the turban and the pyjama of the younger man, in order to relieve and at the same time to emphasize the deliberately featureless dull browns and blues of the main colour areas.

("The art of Amrita Sher Gil," excerpt from Edith Tömöry, *A History of Fine Arts in India and the West,* 1982.)

of the ruins of the tradition. (Ruined, one suspects, by the English colonization, though Tömöry does not say so.) But a trap lay in wait, because the Indian painters had to rediscover painting *through* the West: they had to find Cézanne, Picasso, and the other Modernists long after they had been assimilated by Western painters, and then they had to use them in distinctly Indian ways. The excerpt above gives a sense of the oddity of their enterprise. (The original has pen-and-ink outline drawings of the artworks; I have substituted a halftone photograph.)

From a Western standpoint it may be hard to imagine how Sher Gil could be "master" of Western technique and yet "wholly Indian in spirit," especially since her project of painting poor people corresponds to the French vogue, current when she was studying in Paris, for painting beggars, orphans, and the bohemian life. In Paris she would have been grouped with Maurice Utrillo, Amedeo Modigliani, and Georges Roualt; in India, some of what she learned in that circle becomes "wholly Indian." Even in India, the question of Sher Gil's Westernness is open to debate. A recent book on Indian art quotes one Indian scholar as saying that Sher Gil's work "smells of the west," and another as concluding that her work derives "wholly" from Gauguin. The writer, Krishna Chaitanya, decides "there is far more of Ajanta than of Gauguin in her paintings" (compare Plates 16 and 17).

Tömöry's book may not quite make the case that twentieth-century Indian painting is a "new national art," but it becomes convincing by the sheer accumulation of works that could not be presented as mid-century French paintings. In Tömöry's view, the new Indian painting is substantially better than the wrong turn taken by Modernism in the West. Hence *India*, the first half of the book, ends tentatively but happily; the second half, *The West*, ends badly. Existentialism, despair, godlessness, and moral decay have ruined the West. At least Indian painting has a chance of becoming "a continuous pledge of joy and love and peace."

A History of Fine Arts in India and the West is a schizophrenic

book: it tells two equal and opposite stories, and its two halves don't speak to one another. The one ends and the other begins: there is no explanation and no attempt to bridge the two. That, I think, is the result of Tömöry's conviction that India is the equal of the West and yet fundamentally different from it. It would not do to mix the two or to alternate them, as Gardner or Honour and Fleming do: that would imply India and the West are ultimately compatible. Tömöry's book could be convincing to a reader who already believed that twentieth-century Indian painting is the equal partner of the West (and who also held that no other nationality might come forward as a third or fourth coequal), but I suspect that for most readers the harsh division in the middle of the book will be read as a kind of legal measure, a police line ensuring that the two sides stay apart. On the one hand, Tömöry's book is irresistably reminiscent of the sad facts of colonialism and India's search for an independent modern identity; on the other, it is a model of perfect equality that no Western text can match. Just imagine if Gardner's *Art Through the Ages* were divided down the middle—567 pages of Indian art, with a sad ending, and 567 pages of Western art, with a happy ending. Surely no teacher in America or Europe would buy it.

Qāḍī Aḥmad

Now I'll go even further afield: first to a book written in nearly perfect ignorance of the Western Renaissance, and then to a book written in nearly perfect ignorance of the entire West.

Persian painting has been well studied by Western art historians, but there are relatively few histories written by Persian authors. Qāḍī Aḥmad ibn Mīr–Munshī's *Calligraphers and Painters*, a late-sixteenth-century chronicle, is an early and important example. It tells brief stories of several hundred Persian calligraphers and painters, presenting them as if they were virtually the entirety of world art. Qāḍī Aḥmad knew about Chinese painting (he praises it several times), and he had seen some Western European

painting (he calls it Frankish, *firang*); but he hardly gives painting from outside Persia the time of day, because only Persian art descends in a direct line from God.

The book is suffused with sacred purpose. In the Islamic tradition God created the *qalam* (the reed pen, or brush) before any other object, even before he proclaimed the Word that created the world. The Qur'an has a chapter called *Qalam,* and Qādī Aḥmad's book opens with a paean to the *qalam.* "Let it not be concealed," he writes, "that the first object created by the Creator, let Him be praised and exalted, was the *qalam* of marvelous writing."

This is quite different from John 1:1, "In the beginning was the Word, and the Word was with God, and the Word was God." The *qalam* draws and paints, and that means the physical form of letters or images is itself sacred. Qādī Aḥmad expands on this at some length, stressing the holiness of every written character and using it to promote the importance of painters and calligraphers. Naturally, in this scheme painting is a poor cousin to calligraphy, which uses a reed pen *qalam,* but since the *qalam* is also an "animal brush" made of animal hairs, painting becomes a holy calling in its own right. The history of art is not merely a string of biographies; it is a genealogy in which the earliest calligraphers are also the most holy because they received their styles from Muhammad, who got them from God. This conviction is fundamentally non-Western. Vasari was pious and he tells us about religious artworks, but his book is decidedly secular. For Qādī Aḥmad, what matters is the piety of the painter's hand, not the piety of his subjects.

The whole first chapter of *Calligraphers and Painters* is about the *qalam,* and Qādī Aḥmad settles in to the business of artists' biographies in the second chapter. He tends to say very little about individual paintings, concentrating instead on the artists' genealogies. The excerpt below is almost his entire account of the painter Ustad Kamaluddin Bihzād (c. 1440–1546), today one of the most highly regarded Persian painters.

Reading biographies like this, it is tempting to fill in the

After them comes the rarity of the epoch, the marvel of all the centuries, MASTER BEHZĀD OF HERAT.

Behzād is the master of the times,
He has given a full measure of mastery.
The Mother of Time has given birth to few of the rank
of Mani[1]
But, by God, Behzād is the best born (*beh-zād*) of her.

The master had lost his father and mother in his childhood and was brought up by USTĀD MĪRAK NAQQĀSH, who was librarian to the late sovereign, Sulṭān- Husayn-Mīrzā. He achieved success in a short time and so well that no one had seen an artist equal to him since the art of images came into being.

His drawing in charcoal by its fluency
Is superior to work by the brush of Māni.
Had Māni known about him,
He would have imitated his sense of proportion.
His images of birds are heart ravishing,
Like the birds of Christ, they acquire a soul.[2]

The master remained in the arena of activity from the happy time of Mīrzā Sulṭān-Ḥusayn until some time after the opening days of the reign of the late Shah Tahmāsp. Wonderful specimens of his painting are numerous. His death occurred in Herat and he was buried in the neighborhood of the Hill of Murād, within an enclosure full of paintings and ornaments.

(The biography of Master Behzād of Herat," excerpt from Qāḍī Ahmad, *Calligraphers and Painters*, 1597–1598.)

1. Mānī (d. 273 C.E.) was the founder of the Manichaean religion, and an artist; he was a figure of the ideal artist.
2. The reference is to the clay birds that flew away when the child Jesus threw them into the air.

blanks so that they seem more meaningful by Western standards. The Shah Tahmāsp (1524–1576) was a prominent patron of the arts, and the painters he supported formed a coherent group around the middle of the sixteenth century. Because the painter Bihzād was part of that group, an art historian might want to use Qādī Ahmad's story to tell the history of the patronage of Persian painting. Another historian, less interested in social contexts, might want to study Qādī Ahmad's terms of praise to see what they reveal about the painter's style. What exactly does he mean by saying Bihzād's charcoal has "fluency"? The word he uses, *mutāqarib*, means "meter," and so he might just mean "sense of proportion," as he says a few lines later. It would undoubtedly prove difficult to correlate Qādī Ahmad's somewhat generic traits with Bihzād's actual works—even his "heart ravishing" birds—and it is essential to bear in mind that Qādī Ahmad does not try. He does not illustrate his account with a copy of one of Bihzād's paintings, as Western scholars routinely do. This history of art is decidedly different from Tömöry's, or the Russian history: it begins to look truly unusable, which is to say immune from being co-opted for Western art history and apparently also immune from being understood *as* Western art history.

The manuscript of Qādī Ahmad's book is illustrated with a few miniature paintings, but they do not contribute in the way a Western reader might expect. When he introduces painting, Qādī Ahmad recounts a poem about two court painters. One was tricked by his rival into painting a portrait of their one-eyed shah—a project doomed to failure. He made a picture showing the shah sighting down the shaft of an arrow with his good eye, and in the corner of the shah's eye he painted "an angry glittering, as of a lance." With that brilliant inspiration, "the clever painter disentangled the knot in the thread of his talent"—a beautiful phrase. The poem ends:

When the shah understood his thought deep as the sea,
He gave him two kingdoms in reward for his labor,

One gift was for the shape of his mastery,
The other for the play of his imagination.
Thus the heart of the envious painter was broken;
And in despair he sat down in the corner of affliction.

It is a wonderful story, with its metaphors of blindness and
insight, but the painting that accompanies it in one manuscript
may come as a disappointment (Plate 18). There we see the shah,
with his arrow, sitting in front of a decorative screen on a hillside.
The painter is at his feet; he is talking, and his hand rests on his
painting so we can't see it. Apparently either Qāḍī Aḥmad or his
illustrator cared more about the story of treachery and inspiration
than the appearance of the painting; and from what we are told
about the shah's response, he may have felt the same way. After all,
the painter was rewarded for his clever symbolism and not the
beauty of his creation.

Calligraphers and Painters is profoundly different from Western
interests. Is it possible to imagine a contemporary Western art his-
torian taking this up as a model? Probably only if the history were
written by a devout writer whose purpose was to show how paint-
ings can be revelations of creation itself: an impossible notion in
the secular, historicized, academic world that supports art history.
If Qāḍī Aḥmad can't be read as an art-historical text, then in a real
sense he can't be understood: we have passed some border here,
beyond art history and into another sphere, where art is a branch
of religion.

Priyabala Shah

I will round out this collection with a book that is truly alien to a
student or a teacher living in America or Europe: the *Viṣṇudhar-
mottara Purāṇa,* a manual written in India in the sixth or seventh
century C.E. It gives instructions for making painting and sculpure,
and it does so from from a vantage utterly unlike the modern dis-
cipline of art history.

The title of Priyabala Shah's book is nearly untranslatable; in

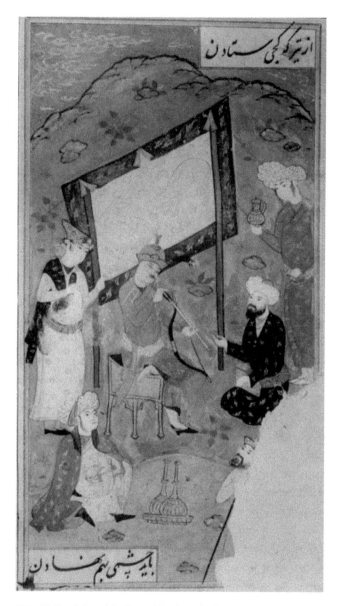

Plate 18. Illustration of the Story of the Squinting Prince, from Fathullah ibn Ahmad ibn Mahmud, *Treatise on Calligraphy*. Manuscript, 24.5 x 15 cm. Moscow, Museum of Oriental Cultures. Or. B 651, fol. 135.

Western terms, it might be rendered as *The Summa Theologica of the God Viṣṇu*. Most of the book has nothing to do with the arts, but the third part of its appendix is the earliest extant text on Indian sculpture and painting. It is set as a dialogue between a student, Vajra, and a master, Mārkaṇḍeya. At one point Vajra wants to know how to make sculptures of the gods, and Mārkaṇḍeya replies that he first has to study painting (*citrasūtram*). So Vakra asks about painting, and he is referred to "the canon of the dance," which Mārkaṇḍeya says underlies painting. As Vajra keeps asking, he keeps being referred to more fundamental arts, so that sculpture depends on painting, which comes from dancing, which relies on instrumental music, which derives from vocal music, which springs from language itself, which has to be learned through its grammar. That is why the *Viṣṇudharmottara Purāṇa* begins with lessons on grammar, metrics, syntax, kinds of argument, lexicography, rhetoric, prosody, and genres of writing. That may seem an odd starting place to learn sculpture, but in the logic of the *Viṣṇudharmottara Purāṇa* all sculpture depends on it. There are Western books that cover the same material: classical Roman texts on rhetoric and Medieval books of dialectic and grammar. But none of them pretend that the formal study of language underlies the appreciation of painting or sculpture.

To take this seriously and not just interpret the *Viṣṇudharmottara Purāṇa* as a stodgy academic manual, it is necessary to reimagine sculpture and painting as arts intimately linked to the most technical aspects of language. To a degree, that is what Renaissance humanists did when they tried to provide a theory for the visual arts by mining Medieval and Roman texts on rhetoric. Leon Battista Alberti and other fifteenth-century humanists hoped to find a Classical theory for the visual arts in the more prestigious theories of Latin writing, grammar, and speech-making. But they did not pursue the dream of founding painting on language as persistently, or as systematically, as Mārkaṇḍeya does in Priyabala Shah's book.

As the book goes on, Mārkaṇḍeya eventually gets around to problems that are necessary for the actual making of sculpture and painting, as opposed to the theoretical preparation for their making. He talks at some length about physiognomics, symbolic gestures, proportions and technique, and he gives exhaustive instructions for painting and sculpting several hundred Hindu deities. Those portions of the book resemble the Renaissance books that told artists how to depict symbols such as Fortune (a woman balancing on a ball) or Veracity (a woman holding a peach). Mārkaṇḍeya spends quite a while on such subjects—known in modern art history as iconography—and eventually both the lessons in symbolism and the opening grammar lessons are forgotten in a profusion of workshop advice. At times it sounds as if Priyabala Shah put in every scrap of information he knew; at one point he admonishes that "the ground surface for painting would have well polished space, [and] should be free from gnats and fleas." Again there are parallels to Renaissance books, this time to painter's manuals that give advice on the preparation of pigments and materials. Cennino Cennini, a late Medieval painter, says that if the painter's panel is greasy, it should be planed down until it is dry. (He doesn't mention gnats and fleas; perhaps his workshop was cleaner than Priyabala Shah's.) The excerpt below is typical of the parts of the *Viṣṇudharmottara Purāṇa* that are not lists of symbols or litanies of grammatical rules.

Priyabala Shah did not set out to make a book of art history; but it would be hasty to conclude that he *could* have or that he wouldn't have thought this book encompassed all that was worth saying about sculpture. No chronicles of sculpture or paintings have survived from this period (the post-Gupta era, sixth–mid seventh century c.e.). Yet it's entirely possible none existed; there are many cultures where technical manuals and art theory *are* the discourse on art, and history is not only unwritten, but effectively meaningless. It wouldn't be prudent to assume Priyabala Shah would have written the *History of Gupta Sculpture*, if only he'd had time.

The following are inauspicious subjects and should never be painted, except in the assembly halls of kings and in temples: bulls with their horns immersed in the sea; men under the surface of the water, but with their hands sticking out; ugly men; and people who are grief-stricken on account of death, war, or the burning ground. Paintings in residences should have auspicious subjects, such as the Vidyaharas, the nine gems, sages, Garuda, and Hanuman.[1]

Weakness or thickness in the delineation, lack of articulation, and the improper juxtaposition of colors are faults in painting. The eight good qualities of painting are proper position, proportion, spacing, gracefulness, articulation, resemblance, and foreshortening. Painting that does not have the proper positioning, is devoid of the appropriate sentiments (*rasa*), is empty to look at, hazy with darkness, or devoid of life-movement (*chetana*) is said to be inexpressive. A painting is auspicious if it seems to be dancing, or it looks frightened, or as if it is laughing, or if it looks graceful, or if it seems to be alive, as if it were breathing.

A painter should make his paintings so they have no darkness or emptiness. No one should paint a man with defective limbs, or covered all over with hair, or overwhelmed with fear because of an internal disease, or smeared with a yellow pigment. An intelligent artist paints whatever looks probable and inspires trust, and never goes beyond that bound. Paintings done by artists who are skilled and righteous and versed in the Shastras[2] bring on prosperity and quickly heal adversity. An auspicious painting cleanses the mind, relieves anxiety, improves the future, causes unparalleled pure delight, kills the evils of bad dreams, and pleases the household deity. The place where a picture is firmly placed does not look empty.

("The Kinds of Painting Suitable for Temples and the Homes of Kings," excerpt from Priyabala Shah, *Viṣṇudharmottara Purāṇa*, late sixth century.)

1. These are Hindu deities and holy figures. The nine gems are Padma, Maha Padma, Sankha, Makara, Kachchhapa, Makunda, Kunda, Nija, and Kharva.
2. The Dharma Shastras are Hindu texts on law and ethical conduct.

In this respect, Priyabala Shah's book is not entirely different from the art manuals that were written in the late Middle Ages and early Renaissance, before the early chronicles or Vasari's art history. Much of our basic understanding of Italian Renaissance painting depends on three kinds of sources: the rhetoric and grammar texts that Renaissance humanists tried to adapt to their own ends, the manuals of symbols that artists used to depict saints and moral virtues, and the handbooks that layed out the recipes and ingredients of paint. The *Viṣṇudharmottara Purāṇa* outdoes all of them. It is more intricate than the Renaissance sources, as well as more systematic and self-consistent. At the same time, it lacks an ingredient that we have come to experience as necessary: a sense of historical development. Because all painting and sculpture come from Viṣṇu (they are part of his "Summa Theologica"), there is no need to inquire into their origins or their development. There is only one correct way to depict each deity, and a painter needs only to follow the instructions. It is possible to study the *Viṣṇudharmottara Purāṇa* and use it to understand Gupta sculpture or earlier painting such as the Ajanta murals (see Plate 16). But I doubt it is possible to think of painting or sculpture as things that never change. With the *Viṣṇudharmottara Purāṇa* we have come as far as it is possible to go in studying alternate forms of history: we have gone outside chronology itself to a place where no imaginary landscape will tell the story of art because art has no story to tell.

Non-European Texts as Art History

It might seem possible to write a new history of art, using texts like these to escape from the standard story. Several cultures have left sufficient material for this purpose. China has a long-standing indigenous tradition of art history and historiography going back to the Tang dynasty. At least some of the history of Japanese art is recorded in literature produced before Western contact. Islamic art also has a well-developed historiographic tradition, though it

has more to do with calligraphy, which is usually not treated in survey textbooks, than with architecture. Other cultures, such as the Mayan, Aztec, Egyptian, and Ife left no texts on art but enough ancillary material and anthropological evidence remains to assemble a workable account.

Early Chinese painting is chronicled in a vast book by Zhang Yanyuan (ninth century), a book even larger than Vasari's and with more schools, styles, critical terms, and artists. It would seem that Zhang's book would be exactly the kind of source that could be added to Gardner's book, or to Janson's, to give them a breath of fresh air. But Zhang's book could not be used to augment the chapter on Chinese painting in Western texts because it lacks the Hegelian elements that art historians expect to find: Zhang doesn't try to gather contemporaneous artists into harmonious groups, or trace related movements through time, or find connections between artworks and their surrounding society. Like Qāḍī Aḥmad, Zhang's book is a chronicle—a listing—of artists, without the kind of historical purpose that is associated with historical writing.

In addition Zhang imagines art as an activity that serves Confucian values and promotes good fortune, and he is not interested in a secular account of "art" in the Western sense. (For the same reason, there is no history of Medieval art using only Medieval texts: art history arose only with Vasari, partly because it became possible to write about the artistic qualities of works without referring to their religious value.) The secular, aesthetic orientation is deeply ingrained in the discipline of art history, to the point where artworks cannot be considered seriously as objects of worship.

In the West, when a major artwork is damaged, restorers try not to intervene more than they have to: they patch small defects, but they won't restore the head of the Winged Victory or repaint Cimabue's *Crucifixion* (which was reduced to a ruin by a flood in the late fall of 1966). On the other hand, if a parish church in Italy

brings a damaged painting to the restorers' laboratory in Florence, they will repaint it until it looks perfect. As one of the restorers who made the "Picasso Madonna" (see Plate 8) points out: "it is not surprising that some people don't like to pray to a fragment." In the same way, the discipline of art history does not "restore" artworks to their religious uses but treats them as fragments of a precious past, and that utterly prevents their being used as religious objects. That is why religious texts like Zhang Yanyuan's or Qāḍī Aḥmad's cannot be used as art history. Non-European texts can be quoted and interpreted, but they can't usually be experienced *as* art history, only as materials *for* art history.

Books like the ones we have sampled in this chapter suggest a wonderful and troubling possibility: that some cultures have a sense of their art that will never fit with Western art history. Qāḍī Aḥmad sees art as a handmaiden of religion and thinks of art history as a matter of tracing precedents back to Muhammad and his disciples; Priyabala Shah sees art as a handmaiden of religion and does not think of history at all. It would not be fair or sensible to put those viewpoints into the relevant chapters of one of the big Western textbooks, because the surrounding chapters (on Alberti or Pollock or Wedgewood) would engulf and drown them in the ocean of the Western history of art—simply because it is a history, and theirs are not.

Perfect Stories

What would become of Western art history if it started to take the "alien" accounts in Chapter 4 with the seriousness they deserve? Would the *Story of Art* become fainter and fainter, until it got lost in a din of other voices? Or would the same familiar story keep coming back, like an old friend, giving sense and meaning to stories that would otherwise seem nearly incomprehensible? Are there, to put it more pointedly, viable alternatives to the standard story and its variants?

The principal question about the shape of art history under debate in many countries is: How is it possible to be fair to all cultures while also telling a story of art that is *our* story, fitted to our culture and our needs? I hope I have said enough to suggest that the question has no satisfactory answer, but I want to take this last chapter to try to prove it. First I'll collect and review the various requirements that are currently being made of art history textbooks. Then I'll return to the speculations of the first chapter, but in a more disciplined way, and consider a half-dozen hypothetical books that might solve the problem of fairly representing all cultures. None of them, I think, could ever be written—or if they were written, they either would not make sense as art history, or they just wouldn't sell. And finally I'll return for a last look at multiculturalism, in order to prove that it is not possible even if people actually did want it—which I doubt.

117

Current Practical Problems

Finding an acceptable history of art for any group or nation is a collective if not a democratic endeavor. Since the early 1980s there have been art history colloquia and conferences dedicated to improving the way art history is taught to undergraduates and high school students. At the sessions I have attended, teachers have mentioned at least twelve different, often mutually incompatible goals for an optimal book of art history. Such a text would:

1. reduce the emphasis on European art and acquire some principle of fair representation;
2. open the question of gender and privilege female artists where they had been omitted or marginalized;
3. speak in a responsible manner about race and minority artists;
4. avoid the emphasis on the major media of painting, sculpture, and architecture,
5. critique the canon of masterpieces;
6. find places for visual theories such as psychoanalysis, semiotics, and deconstruction;
7. escape from the history of style by telling the history of societies, patronage, and the relation between private and public life;
8. avoid the appearance of ideological neutrality by honestly praising or critiquing artworks;
9. create smoother transitions between the chronological sections of the book and also among the descriptions of technique, symbolism, style, and social meaning;
10. maximize the number of images and the amount of text that can be meaningfully compressed into a single volume;
11. efface the remains of Hegelian thinking, so that periods are not presented as links in a chain and artworks are not described as spokes in the wheel of the unified Zeitgeist; and finally

12. treat art made up to the very date of publication, instead of stopping in the late twentieth century.

There have been attempts to tackle each of these problems. I know of only one major Western text that shirks the first issue (finding space for non-Western material): the fifth edition of Janson's *History of Art* (1997). It omits non-Western material entirely in order to play to its strength, which is a detailed account of the Western tradition. That may seem reasonable, except that excluding non-Western art only defers the question of how the rest of the world should be taught (presumably in a companion course, perhaps the year after the Western survey). The simple fact is that there is no companion volume that could appear equal to Janson's, because no one knows how to write such a book. When Janson's *History of* [Western] *Art* first appeared, a smaller paperback of jettisoned non-Western material was sold shrink-wrapped with the principal volume, as if it were piggybacking on the West. The editors may have realized that was too literal a symbol of abject dependence (as if the world outside the West had to grab on to the West or be left behind). The editor, Anthony Janson, explains that "ethnographic art" is not "universal" because it has a "racial 'edge.'" It is better, he says, to concentrate on Western art even at the risk of being accused of chauvinism or "colonialist attitudes"—though it could be said that the book ended up taking the *most* "colonialist" stance possible.

Things only get worse when an author doesn't explain how she determined the fraction of the text that was to be given over to non-Western art. A collaborative work called *The Visual Arts: A World Survey from Prehistoric Times to the Present, with Special Reference to Australia and New Zealand* (1972), spends 157 of its 177 pages on art of the Northern Hemisphere and ends with four short chapters "written by dominant figures on the contemporary scene in Australia and New Zealand." But why, the reader may ask, spend only twenty pages on Australian and New Zealander art? Are they exactly one ninth as important as the rest of the world? A

Yugoslavian example of the same problem is Slavko Batusic's *Umjetnost u Slici,* which devotes 150 of its 650 pages to recent Slovenian, Macedonian, and Slavonic art. The documentation is irreplaceable, but what reasoning could lie behind the fraction (150 out of 650)? In Larry Silver's *Art in History,* five of the ten chapters (all on Western art) close with brief sections titled "View from the Outside," treating topics such as Nara Japan, Song China, Ife and Benin, "Modern Mexico," and Yoruba art. Silver is resourceful in motivating the non-Western additions, but they keep the reader wondering: How did he arrive at just that arrangement?

The second issue (the question of gender) is part of the project of gay studies and feminist art history, and it was largely successful in the last two decades of the twentieth century. A founding essay in feminist art history, Linda Nochlin's "Why Have There Been No Great Women Artists?" is now read in undergraduate classes, helping to create a generation of art historians engaged in answering the question. Feminism and gender studies have transformed the discipline in a very short period: gender has become a principal topic in new publishing, and at some art history conferences the majority of all papers are gender-related inquiries. (In 1998 one conference organizer joked that all sessions at his conference could just be called "Gender and Sexuality in X," with "X" standing for the historians' specialties. It would almost have been true if he had added "Identity Politics and X.") Even Renaissance scholarship, sometimes the last to respond to new currents, has turned to such questions as Michelangelo's sexuality, the nature of the women in Titian's life, and the place of homosexuality in Caravaggio's art.

Often scholarship that aims to create interest in women artists or gay or lesbian artists ends up depending on special arguments: the women or gay artists are said to have worked differently, chosen different subjects, or taken an ironic and distanced view of their heterosexual male contemporaries. In that way, for example,

Susan Suleiman has argued that women surrealists such as Leonora Carrington, Dorothea Tanning, and Léonor Fini were self-conscious "mimics," sly imitators, of their male counterparts. The most recent scholarship has sometimes turned away from such arguments in favor of straightforward descriptions of the work. Rosalind Krauss's *Bachelors,* a book on eight twentieth-century women artists, does away with "special pleading" by concentrating on the way Surrealism slurs genders, mixing and blurring identities. Krauss presents the woman Surrealist photographer Claude Cahun as a complement—equal and opposite—to Marcel Duchamp. Both experimented with their genders: Lucy Schob renamed herself Claude Cahun just as Marcel Duchamp renamed himself Rrose Sélavy.

Because this is not a book about art-historical theories, I won't say more about how Nochlin's question has been answered. But it is relevant that art historians interested in feminism and queer studies have not produced standard textbooks that tell the *entire* history of women artists or gay artists. Feminism has drastically altered the subjects on which art historians write and profoundly changed the content of classroom instruction and the complexion of the surveys of world art, but it has not contributed new chapters or new arrangements to the basic story of art. The older sequences of periods, cultures, and styles have remained largely intact. In the future, all that may change: art historians may find themselves studying non-Western cultures that include female artists or looking at less-well-known women artists at the expense of better-known male artists. That has happened in at least one case: the seventeenth-century painter Artemisia Gentileschi is now much more widely discussed than her father, Orazio, even though Orazio's paintings were more famous until the late twentieth century. The new writing on Artemisia has raised a number of interesting questions about what a woman's art could be in seventeenth-century Italy, but it also threatens to become anachronistic when it bypasses the work of her father; after all, from a seven-

teenth-century viewpoint it was her father's art that shaped the period, not hers. Studies that privilege Artemisia over Orazio, like studies that focus on Cellini's or Caravaggio's sexuality, risk imposing late-twentieth-century concerns on earlier material. In part that is the nature of all historical writing, but it also assumes that the remainder of art history—everything outside the current questions of gender and sexuality—can be carried along with the new concerns. I wonder if that isn't a risky notion of history; after all, the very reasons it seems important to write about Artemisia or Caravaggio are grounded in the same "old-fashioned" historical values that the new studies often repudiate. In what sense do we understand seventeenth-century Tuscan painting if Artemisia is its principal artist—given that she wasn't seen that way at the time?

It is interesting to speculate about why feminist, gay, and lesbian studies have not produced standard textbooks that might rival some of the ones I have been discussing. Rozsika Parker's and Griselda Pollock's *Old Mistresses* (1981) is certainly a start, with its chapters on medieval and premodern women artists. The authors note that histories of women artists began in the mid-nineteenth century with Ernst Guhl's *Women in Art History* (1858) and Elizabeth Ellet's *Women Artists in All Ages and Countries* (1859), but that such histories became uncommon just as feminism was becoming more widespread. Hugo Munsterberg's *History of Women Artists* (1975) is a counterexample, though it is also in the venerable tradition of books on women artists written by men. It has been suggested that it would be unfeminist in spirit to write an updated *Women Artists in All Ages and Countries,* if only because the entire project of telling the entire history of art is male. Feminist theorists such as Hélène Cixous have argued that local, personal, nonlinear writing can be construed as inherently feminine, which would mean any attempt directly to supplant the standard story would itself be a masculine desire. In addition, feminist art practice has often worked against fine-art practice—as writers from Griselda Pollock to Katy Deepwell have said. Yet I wonder if a sur-

vey of women artists might not have to be written after all, in order to intervene against the root-level story of art history. Perhaps books like the *Encyclopedia of Women's Studies* will have to serve as interim solutions.

Queer studies seems poised to produce a history of homosexual artists and art of "all ages and countries," if only because it has recently generated some of the most innovative new *kinds* of art historical interpretation. Scholars such as Gavin Butt, John Ricco, and Whitney Davis are all contributing to the new writing. Even less methodologically radical accounts such as James Saslow's can serve as histories of "all ages and countries."

The third question (concerning the representation of race) has also deeply affected the way that art history is taught, introducing new artists and compelling authors and teachers to be aware of racial themes in the central sequence of European art. There are suggestive parallels between writing on race and writing on gender. In outline, the scholarship in both has passed through three stages: the early work promoted unknown artists as representatives of their group (their gender, their sex, their racial origins); later scholarship questioned the stereotypes involved in the earlier work (such as essentialist definitions of women, gays, or racial minorities); and the most recent scholarship has tried to avoid characterizing its subjects at all (so that women artists, gay artists, or minority artists become simply artists). It is a curious development, as if the art historians are working to erase their own interests.

In the writing on race, that sequence has raised some especially thorny questions. The art historian James Smalls has argued that it is not enough to describe the styles of African-American artists or to imagine that the works simply document the conditions of African-American life. "African-American art," he says, "is partially based on pathos, self-doubt, the need to 'sell' a product (i.e., race), and classism." He concludes that scholars need to look more deeply and critically at what they are describing. In the

schema I am suggesting, Smalls's work is an example of the second stage: he questions the stereotypes that were promoted in earlier writing and advocates more careful and honest inquiries into the nature of African-American art. The third stage would then involve the questioning of *any* criteria of separateness, stereotypical or not.

An example is Kymberly Pinder's survey of the treatment of African-American artists in recent survey texts; she suggests that textbooks to some extent should dissolve African-American examples in the general mix of periods and styles. The problem with that solution, as she acknowledges, is that it pretends identity politics can disappear, and it relinquishes the possibility of affecting "supremacist and patriarchal attitudes." (Krauss's essays on women Surrealists avoids that danger by confining itself to Surrealism; in other times and places, women artists were not full participants and would therefore have to be treated differently.) At the same time, Pinder looks forward to another kind of scholarship—it would be a fourth kind—that could acknowledge that neither the critique of stereotypes (the second kind of writing) nor the avoidance of all mention of ethnic or gendered identity (the third kind) is sufficient. Art historians, in Pinder's view, should become more reflective about the impossibility of either solution; the construction of race is an impossible condition where problems can be neither forgotten nor solved.

The second ideal (fair feminism and gender studies) and the third ideal (fair racial and ethnic studies) are in the paradoxical position of being central for many art historians and yet marginal to art history's parade of cultures and periods. In literary studies, gender and race have radically altered the undergraduate curriculum for the simple reason that you can't read more than a couple of dozen books per semester, so an introductory class has to expel some classics in order to make room for works written by women and minorities. Art history has not been involved in the debates about the canon that have so inflamed academic discus-

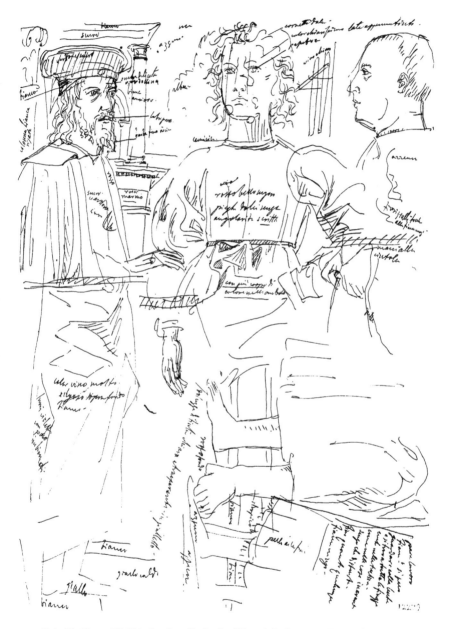

Plate 19. Giovanni Battista Cavalcaselle, Study of Piero della Francesca, *Flagellation of Christ* (The original painting is in Urbino.) Venice, Biblioteca Marciana, f. 2038 = 12279v.

sion since the 1960s because a typical first-year art history course can include a large number of women and minority artists and still have time for several thousand other artworks. (Upper-level undergraduate classes and graduate seminars are more directly affected, and faculty hiring practices have begun to change in response.)

The fourth goal (avoiding the triumvirate of painting, sculpture, and architecture) isn't as sexy, but it has had a more pronounced effect on introductory-level teaching. Arnason's *History of Modern Art* addresses the issue by adding photography as a fourth major art. More adventurously, the multivolume *Storia dell'arte italiana* includes essays on art historians, restoration and forgery, handwriting, posters, graffiti, miniatures, and postage stamps. Paola Barocchi, one of the authors of the *Storia dell'arte italiana*, illustrates a page from a sketchbook by the nineteenth-century art historian Giovanni Cavalcaselle, recording the colors of a painting by Piero della Francesca (Plate 19). Such an illustration would look entirely out of place in most textbooks, where the work of art historians takes place exclusively behind the scenes. (This picture documents a different kind of art history from back when art historians routinely sketched the artworks they wrote about. Today historians' understanding is more verbal and scholarly, and less physically engaged.)

Some one-volume survey texts consider a range of media because they are aimed at colleges that offer "art appreciation" courses before the first course on art history. Edmund Burke Feldman's *Thinking about Art* is such a book: it contains chapters on painting, sculpture, and architecture, but also "The Crafts and Design" and "Printmaking, Photography, and Film." The early editions of Karl Woermann's influential *History of Art* (1905) include a look at "the art of animals" by way of introducing "Die Kunst der Ur-, Natur-, und Halbkultur-völker" ("The Art of Primordial, Natural, and Semicultured Peoples"). Then, having dispensed with animals and primitive peoples, Woermann turns to the

canonical sequence from Egypt to Mesopotamia, Persia, and Greece. Much more could still be done to expand the discipline's roster of media. Other texts expand their subject matter by including anthropological and even biological material, but there are still very few books that venture as far as coins, crystal, or enamels, and next to none that give detailed attention to calligraphy, paper money, graphs, charts, scientific illustration, or the wider range of visual materials.

The fifth goal (adding new monuments to the canon of masterpieces) is continuously fed by feminism, gender studies, and scholarship on race, and so is the sixth goal (adding theories such as psychoanalysis, semiotics, and deconstruction). There is really no limit to either ideal, because they depend on what the market—especially the more conservative readers who constitute the majority of the buyers of survey texts—will bear. Specialized scholarship is continuously coming up with new candidates for the fifth goal (I put several on my picture of the constellation, Plate 1), and there is no lack of books with titles like *Critical Terms for Art History, Visual Theory, Visual Culture,* and *The Language of Art History* to supply the sixth goal.

The seventh goal, avoiding style history, has been a major concern of postwar art historians because the analysis of the style of artworks is so firmly (though largely erroneously) identified with early twentieth-century writing by historians such as Wölfflin. There are some interesting exceptions, however, including the *Neuer Belser Stilgeschichte,* a major initiative in German publishing that has also revived the traditional stylistic art history and the division into sculpture, painting, and architecture. (It is one of the most beautifully produced projects in recent publishing.) The editors modify the purity of style analysis, however, by introducing politics and culture as parallel developments. Some texts escape from style history by aligning themselves with sociology, cultural history, economics, or anthropology. The first volume of Jose Pijoán's *Summa artis,* the multivolume Spanish-language art his-

tory, begins with children's drawings and includes ethnographic photographs to illustrate the general setting of art-making. But style is insidious, and I have not yet seen any texts that dispose of the traditional period and style names or manage not to depend on style.

Writers who set out to achieve the eighth goal, avoiding the appearance of neutrality, sometimes become stridently enthusiastic or critical. Feldman's *Thinking about Art* is such a book, rife with exclamation marks and apostrophes to the reader. One of the most entertaining examples is Pierre Francastel's *Histoire de l'art, instrument de la propagande germanique,* published in 1945, with chapter headings such as "Art roman, génie germanique et sang barbare." The major publishing houses avoid such books and aim at the calm, authoritative, but unthreatening voice that appeals most widely.

The ninth goal, making effective transitions between chapters and between different kinds of description, is a special problem for books that are both introductory histories of art and "art appreciation" textbooks. Julio Martinez Santa-Olalla's *Historia del arte y de la cultura* explains the concept of style and then its embodiment in history, dividing the book in half. The *Storia dell'arte italiana* tells the history of art in the second of its three parts. The first is "Materials and Issues," and the third "Situations, Moments, and Research." The reader is not given an explanation for the editor's decision to sequester history from media. Elie Fauré's popular *Histoire de l'art* appeared as four chronological volumes, but Fauré's American publisher added one of Fauré's other works to make an anomalous fifth volume on *The Spirit of the Forms.* That is a delightful and quirky book—an Aztec sculpture is captioned "Feverish Surroundings"—but it has no clear connection with the chronological histories that precede it.

The tenth goal—enlarging the text, but keeping it within a single volume—may soon be solved by necessity, because books such as Gardner's and Janson's retail for around $75 and weigh up

to eight pounds. (That is heavier than the combined White and Yellow Pages of the Chicago phone book.) There are attractive alternates such as CD-ROM, DVD, inexpensive "packets" and paperback "modules," and multivolume histories. Before Gardner, art histories were often more than one volume. The *Pelican History of Art* and its more detailed German counterpart, the *Propylaen Kunstgeschichte,* are the modern descendants of smaller nineteenth-century multivolume histories. Among the current possibilities, digital media are the clearest way to solve the problem of the disparity between the 3,000 or so slides in a year-long lecture course in art history, and the large accompanying textbook, which may have only half that number.

I have suggested that the eleventh goal (the erasure of Hegelian ideas) is unattainable, because the narrative of art history is bound up with Hegelian thinking. Contemporary art historians may hesitate to write books with openly Hegelian titles, like Jens Thiis's *Fra nilen til seinen* (*From the Nile to the Seine*), but wariness and circumspection are not enough to vitiate Hegelianism. Contemporary survey texts are especially deceptive in this regard, because they make it look as if narratives of any sort have been left behind.

The twelfth goal, the up-to-the-minute developments and the welter of current art, is not unrelated to academia's inherent conservatism. A few authors include contemporary art in their histories: I have mentioned Arnason's *History of Modern Art,* which prudently declines to put recent art in any order. Things are not as good with contemporary non-Western art: I know of no textbook of world art that systematically treats non-European art after 1980. Most best-selling texts do substantially worse: Gombrich ends his chapter on Chinese art in the thirteenth century, and even Sherman E. Lee's specialized *History of Far Eastern Art* (revised in 1994) has little to say about Chinese art after the eighteenth century.

These twelve points (and others I haven't listed) have pro-

duced a moral, educational, disciplinary, and political morass. The single story of art is too flawed to function as the repository for the current sense of art history. It will continue, as ingrained practices do, while the more vigilant and reflective writers steer increasingly wide paths around it. Already the major art historians keep a mile away from survey texts: such books are written, with a couple of exceptions (Gombrich's book, Honours and Fleming's, Janson's, and Silver's), by minor art historians who are more involved in teaching than in shaping the discipline. (In the 1920s Gardner was a teacher at the School of the Art Institute, where I work.)

The problems that attend survey textbooks are widely debated, but the colloquia devoted to the first-year survey are typically attended by overworked teachers rather than the active historiographers or theorists of the discipline. One of the consequences is a growing disparity between what the survey texts teach and what the teachers of the courses may write, as part of their professional work, for other art historians. Many art historians who are active in writing and research disparage or avoid the survey texts, even though though these texts provide the basic framework for the discipline itself. As of this writing, I know only two well-known art historians, John Onians and David Summers, who are trying to "put the world in a book" (as Onians says). It's a risky business with the weight of opinion against it. In the current climate of multiculturalism, postcolonial studies, pluralism, and relativism, it seems inadvisable to speak about everything with a single voice, no matter how carefully that voice is pitched.

With that I will leave the question of the current state of scholarship and turn instead to what might be done to change it. From here to the end of the book my examples are all thought experiments, as in Chapter 1. They are intended to show what might happen if the survey text was entirely recast with the aim of solving at least a few of the twelve problems.

First Perfect Story:
Avoiding All Stories

Because the chronology of art poses such problems for books like Gardner's, what if a book of art history could be written without telling any story whatsoever? There is such a book, Janson's *Key Monuments in the History of Art: A Visual Survey.* It is comprised almost exclusively of full-page photographs. The book demonstrates just how hopeless it is to avoid the standard story by refusing to tell it, because the only way to make sense of the book is to thumb through it with the normal style periods in mind. An earlier wordless "history," called *Kunstgeschichte in Bildern (Art History in Pictures,* 1913), looks odder simply because many of the artworks that were taught in Germany in 1913 are no longer familiar. It is easier, looking through the *Kunstgeschichte in Bildern,* to imagine new stories to go in place of the old: but at least for me, the experience is unpleasantly reminiscent of my thought experiment with the vases—I find myself filling in the gaps by inventing stories uncomfortably like the old ones.

Even the German art historian Aby Warburg, who conceived the eccentric project of telling the history of certain images on folding partitions hung with postcards, depended on the presence of recognizable narratives. The installation, called *Mnemosyne* after the muse of memory, can't be interpreted without prior knowledge of art history and its standard story: it is, in effect, a sophisticated *answer* to that story. Warburg's work was at cross-purposes to the usual disciplinary divisions and the standard story, and it is one of the principal inspirations for younger scholars. Yet it's telling that no contemporary art historian has tried to make another *Mnemosyne.* In that respect Warburg is studied and admired, but not emulated. (Alois Riegl, another historian who is often paired with Warburg, expanded the discipline of art history in part by studying provincial, "decadent," "decorative" arts such as late Roman buckles, pins, and furniture designs. He is increasingly cited as a formative influence but also seldom followed. If a sig-

nificant number of art historians had taken Riegl's lead and turned to such things as Roman buckles, art history would look entirely different.)

Recently several universities, including Harvard, Stanford, and Northwestern, have offered experimental first-year courses using *thematic* divisions of the material: speaking first of gender, then of semiotics, then politics, then the gaze, and so forth. Several of the courses got poor reviews from students who were perplexed at the absence of basic chronological information. I suppose that obstacle could be overcome, perhaps by offering a condensed chronology at the outset: but that's a practical problem. What matters more is that such courses and books tend not to critique the shapes of history but to avoid them. And into the vacuum steps . . . the same old story. All the unwanted Hegelian ideas about art's progress, its styles, and its Zeitgeist come along for the ride. What is needed is not another thematically organized, storyless text or course (there are plenty of adequate "concepts" courses and "art appreciation" texts), but a concerted effort to rethink the story itself.

Second Perfect Story:
Strict Chronology

In that case, what about yielding to chronology instead of trying to escape it? A book that kept to a strict time line instead of zigzagging like Gardner or Stokstad might produce interesting contrasts; for example, the rise of the Mayan civilization would be interleaved with the spread of Christianity. Most juxtapositions, however, would have no particular meaning: it is not especially illuminating to be told, as one recent book does, that the Middle Eastern epic *Gilgamesh* and the Neolithic Irish tomb of Newgrange are contemporaneous. A strictly chronological text would become utterly incomprehensible when it came to treating the last two centuries because descriptions of modern art would be frag-

mented into hundreds of brief passages in between mention of contemporaneous Amazonian, African, Mesoamerican, Asian, and Oceanic tribal art.

Curators have experimented with strict chronology, with mixed results. In the mid-1990s the Art Institute in Chicago rehung its Modern art galleries, keeping to a fairly strict chronology, which meant that the art skipped back and forth across the Atlantic, juxtaposing movements that are traditionally kept separate. Picasso was hung next to Central European surrealists; American regionalist pictures of farmers went with French Surrealist canvases and hard-edged abstractions. For people who knew the art, it was all very interesting, but I think many teachers found it unworkable: they could no longer take their students through the galleries and explain the basic movements and isms. How much more amazing it would have been if it had included twentieth-century African and Oceanic art!

Pure chronology was only possible for Vasari and other historians who set out to tell the history of a single country's art without countenancing the existence of different schools and styles within the country. In the mid-nineteenth century, art historians began describing non-Western cultures, and from that moment chronology became impossible. A.W. Becker's *Characteristic Pictures from Art History, in Chronological Order* (1862) shows the system breaking down: Becker puts "ancient" India before Babylon, even though he acknowledges that the "wonders of Ellora" are later than had been supposed. (Actually, what he calls Ellora is Ajanta [see Plate 16], dating from the fifth century C.E. and therefore a millennium and a half after the Assyrian examples that follow.) Soon after Becker, it became impossible to imagine India as part of the mysterious prehistory of European art, and the problem of placing non-Western art had begun. Today a book that followed strict chronology would be more romantic fiction than history.

Third Perfect Story:
A Really Big Time Line

What if the prejudices and predilections that are built into all histories were to be erased by imposing a simple rule: give equal space to equal time periods, no matter how important they may seem? In Gardner's text, the prehistoric material occupies fourteen out of eleven hundred pages—a little more than 1 percent. But the time period that is covered there is fifty thousand years as opposed to five thousand—about ten times as much as the sum total of historical art. A book that righted that injustice would spend its first thousand pages on prehistoric work and its last hundred on all civilizations from Sumer onward. In that scheme, according to the proportions observed in Gardner's text, twentieth-century art would occupy about ten pages: it would be squeezed into the end of the book like one of those educational time lines that compare the age of the earth to the time people have been around.

The first edition of Helen Gardner's *Art Through the Ages* (1926) includes a simple time line of world art (Plate 20). Her chart only goes back fifteen thousand years (the age of Lascaux), but even so, it seriously compresses most of world art. The central sequence from Renaissance to Modern is almost lost, and prehistoric art dominates. The chart is more or less the opposite of the arrangement of her book, where prehistoric art is compressed into a brief initial chapter and the sequence from Renaissance to Modern occupies the bulk of the text.

The production of nonutilitarian artifacts begins around 300,000 B.C.E., so a textbook the size of Stokstad's—say around a thousand pages—would have to cover three hundred years per page to get it all in. That means the period from Goya to the present would occupy a single page, and so would the span from Giotto's Arena Chapel to El Greco's *View of Toledo*. Most of the first nine hundred pages would be blank.

PREHISTORIC

EGYPTIAN

BABYLONIAN, ASSYRIAN, CHALDEAN, PERSIAN

MINOAN

GREEK

ROMAN

EARLY CHRISTIAN IN THE WEST

CHRISTIAN IN THE EAST (BYZANTINE)

MOHAMMEDAN

PERSIAN (SASSANIAN AND MOHAMMEDAN)

ROMANESQUE

GOTHIC

RENAISSANCE IN ITALY

RENAISSANCE IN NORTHERN AND WESTERN EUROPE

MODERN

ABORIGINAL AMERICAN

INDIA

CHINA

JAPAN

Plate 20. Time line of all art. From Helen Gardner, *Art Through the Ages,* 1st ed. (1926).

Or—to make things a little less implausible—imagine constructing a book based on Gardner's shorter time line, starting around 15,000 B.C.E. If such a book were a thousand pages long, each page would cover fifteen years, not at all an unreasonable amount. (If the purpose were to write a genealogy instead of a history of art, fifteen years per page would be more than enough: allowing twenty-five years per generation, we are only eight hundred generations distant from Lascaux.)

It would be wonderful to have such a book and to leaf through chapter after chapter of nearly empty pages, here and there passing the odd notched bone or cave painting. The whole first half of the book would be nearly blank. The few dated artifacts would be placed somewhat at random, because works like the paintings at Lascaux are dated only to within several thousand years. The first excerpt below gives a not-so-random page from the first half of this hypothetical book, which happens to contain the famous cave of Altamira.

| 12,000 B.C.E. | 11,995 | 11,990 | 11,895 |

Plate 21. Bison, Altamira
cave. Scala/Art Resource, NY

Imaginary book of art history that tells the history of exactly fifteen years on each page;
excerpt from the page spanning 12,000 B.C.E. to 11895 B.C.E.

| 1650 C.E. | 1655 | 1660 | 1665 |

Willem van Aelst, *Still Life*
Willem van Aelst, *Vase of Flowers*
 Willem van Aelst, *Still Life*
 Daniel de Blieck, *Interior of a Church*
Ferdinand Bol, *Portrait of an Elderly Woman*
 Ferdinand Bol, *Portrait of the Artist's Wife*
 Philippe de Champaigne, *Portrait of Jean Antoine de Mesme*
Pieter Claesz, *Large Glass* Philippe de Champaigne, *Portrait of Françaois Perrault*
Albert Cuyp, *Cock and Hen*
Albert Cuyp, *Portrait of a Woman in Black* Pieter Claesz, *Still Life with Lobster, Fish, and Cat*
Willem van Diest, *Marine Landscape*
 Gerard Dou, *Man Playing a Violin*

 Gerard Dou, *Adoration of the Magi*

Gerard Dou, *Astronomer with a Globe*
Gebrand van den Eeckhout, *Ruth and Boaz*
Gebrand van den Eeckhout, *Philosopher Reading*
Govert Flink, *Portrait of a Woman* William Ferguson, *Still Life*
 Jean Fyt, *Dead Bird*
Jan van Goyen, *Bad Weather on the Lake of Haarlem*
Jan van Goyen, *Dutch Countryside* Guercino, *St. Paul*
Jan van Goyen, *The Port of Dordrecht* Meindert Hobbema, *Thatched Cottage by a Road*
Jan van Goyen, *View of Dordrecht* Meindert Hobbema, *Landscape*
 Samuel van Hoogstraten, *Man at a Window* Abraham Hondius, *Cattle*
 Willem Kalff, *Still Life*
 Claude Lorrain, *Moses in Front of the Burning Bush*
 Frans van Mieris, *Self-Portrait*
 Gabriel Metsu, *Money Changer* Frans van Mieris, *Cuirrassier*
 Gabriel Metsu, *Music Lesson*
 Adriaen van Ostade, *The Artist's Family*
 Adriaen van Ostade, *Two Couples Dancing*
 Adriaen van Ostade, *Peasants Dancing*
 Paulus Potter, *Seven Cows* Frans Post, *Brazilian Landscape*
 Nicolas Poussin, *Achilles at Syros*
José Ribera, *The Penitent St. Jerome*
 Rembrandt van Rijn, *Woman Bathing*
 Rembrandt van Rijn, *Jan Six*
 Rembrandt van Rijn, *Old Man Reading*
 Rembrandt van Rijn, *Anatomy Lesson of Dr. Deyman*
 Rembrandt van Rijn, *Self-Portrait*
David Teniers, *Village Festival* Salomon van Ruisdael, *Landscape with Waterfall*
Gerard Terborch, *Portrait of a Man*
 Gerard Terborch, *Portrait of a Woman*
Gerard Terborch, *Portrait of a Man Forty-Two Years Old*
 Juan de Valdés Leal, *Immaculate Conception*
 Diego Velazquez, *Las Meniñas*
Willem van de Velde, *Marine Landscape*
 Emanuel de Witte, *Interior of a Church at Delft*
 Philips Wouwerman, *Hunting Party*

| 1650 c.e. | 1655 | 1660 | 1665 |

Imaginary book of art history that tells the history of exactly fifteen years on each page; excerpt from the page spanning 1650 to 1665 C.E.

About three quarters of the way through, a reader would pass page after page of potsherds and flints, finally coming upon a tangle of buildings, sculptures, and paintings in the last pages. I wish such a book existed: it would be a lovely way to meditate on the passage of time and to contemplate our irresistible attraction to the few things that are close enough to us that we can think we understand them.

The entries in the second excerpt are taken from a book called *Repertoire of Dated Paintings in the Low Countries,* compiled in 1920. The author, Isabella Errera, lists many more paintings than I have been able to fit onto this page—approximately three thousand for these years alone. Her book is two volumes long even though it is set in very fine print; if it had been illustrated, it would have occupied dozens, perhaps hundreds of volumes. Even this small extract shows the unmanageable density that could be marshalled for such a book. (In the forest of names there is one very famous picture, Velázquez's *Las Meninas,* and I tried to include mostly better-known artists. Errera lists many others who have been nearly forgotten.)

It is hard even to begin to imagine the spans of blank time that surround works like Altamira—just as hard, I think, as it is to imagine a history that could do justice to Baroque Europe, which was bursting with paintings. The amazing thing is that two spans of time this different are routinely included as parts of the history of art.

Fourth Perfect Story:
Noticing that Europe Is Small

Here is another idea along those lines: What about trying to be fair to different parts of the world by giving equal space on the page to equal spaces on the earth? That would help counteract Eurocentrism because it would result in a book that would be almost 50 percent Oceanic art. Siberian art would loom large, and

the productions of the Inuit would be unexpectedly prominent. Italian art would get the same space as, say, the art of Novaya Zemlya or art made around Lake Baikal. France, at 200,000 square miles, would get one fifth as many pages as Argentina, at 1,000,000 square miles. (A book that followed population would create other odd effects: all of Europe would get about the same number of pages as India—as in Edith Tömöry's book.)

Rock art would be especially well served by a geographic account. Rocks are fairly evenly distributed, with the exception of places like the Amazon basin. It's interesting, however, that such a book could not be written with the present state of our knowledge, because Eurocentric habits have prevented archaeologists and art historians from looking at Asian rock art with the detail they've studied Australian and Western European rock art. Robert Bednarik, an authority on rock art, has noted that some Pleistocene Asian figurines from Mal'ta, in Siberia, attracted some attention because they resemble the famous European figurines like the "Venus" from Willendorf—but otherwise very little has been documented. As the emphasis on Europe eases, the situation will improve; Bednarik could authenticate only a couple of dozen examples from all of Asia, even though it is known that China has at least ten thousand rock art sites.

Eventually it will be possible to write a book on rock art that gives equal time to equal areas of the world. Even now, it would be possible to write such a book on wooden objects, or textiles, or pottery, or tools. It would be lovely to have a book on any subject that toured the world with an even hand, picking up art wherever it happened, like the camera in some unmanned satellite. We would be lucky, I bet, if such a book included *anything* familiar.

Fifth Perfect Story:
Paying Attention to Languages

American and European art historians are notoriously inclined to study English, French, Italian, and German, and not many other languages except Greek and Latin. Americans (art historians and others) study French by preference, and German art historians learn French, English, Italian, and other languages before they learn (say) Czech, Polish, Romanian, or Croat. The preeminence of English is due more to world economics than to the history of art, but the preference for French is fed by the status of French art. (Of course, it's a circular process: art historians publish on French art, prompting the next generation of students to take up French, and so on.)

There have been several attempts to argue against this tendency. German, it is often pointed out, is the language of much of the history of the discipline, even though American art historians tend to be poorer at German than at French or Italian. A strong case can be made for Spanish—it is the language not only of one of the principal nations of the Renaissance but of much of the Western hemisphere—but art historians in America and Europe write very little on Central and South America and they tend not to read the art history that is written there. In terms of population, Chinese should be the first choice of every art historian—but Chinese art has always been a specialty, never studied in proportion to the length or complexity of its tradition.

What about a book of art history that gives equal time to different languages? It would certainly help strip art historians of their prejudice in favor of a few cultures. European art would be tiny, with its several dozen languages. The new players would be South American art, because until recently nearly a thousand languages were spoken in the Amazon basin. Other large chapters would be about Australia, which until this century had over seven hundred languages, North America, which also had over seven

hundred languages before white people arrived, and New Guinea, which still has around a thousand languages.

There is a fair amount to be said in favor of taking languages seriously as criteria for studying art. In a very real and defensible sense, a language is a culture, even though there is no one-to-one correspondence between a people's visual art and its language. There is also ample scientific evidence to help with such a survey. In recent decades geneticists have been able to determine the relationships between various tribes and populations throughout the world, and linguists have been able to discern similarities among languages that were formerly thought to be unrelated.

There is a broad accord between the linguistic and genetic lines of research. They are quite sensitive—they can address such things as whether the Finns are related to the Basques, whether the Italians are closer to the Spanish or the French—and genetic and linguistic research tends to agree. The combined results suggest that many prehistoric human populations also had distinct languages. Given that conclusion, it is only natural to ask if other properties of culture might be correlated with genetic makeup and language. Luca Cavalli-Sforza and his colleagues have made use of archaeological evidence, and so it is only a small step to the notion that ranges of visual artifacts might be correlated with languages and genes. If it is possible to link at least some genetic populations with languages and both of them with archaeological information, why not also look at art? At least we could start taking languages more seriously than we have.

Below, I have imagined such a book, arranged in good scientific fashion as an alphabetical listing of languages. The excerpt gives three entries from the middle of the book, all under the letter "I": Iroquois, Italian, and Itelmen. Irish would be just before Iroquois, and Japanese would follow Itelmen; the book could simply progress from A to Z without privileging any language family over any other.

Iroquoian. The Iroquoian language group includes Cherokee as well as Seneca, Onondaga, and Mohawk, which are parts of the Iroquois Nation. Among the principal Iroquois artifacts are pottery and masks. The Seneca word for "mask" means "face" (*gagóhsa'*), and so does the Mohawk word (*gagú'wara'*). In vernacular "reservation English," masks are called "false faces," and the group that carves and uses the masks has come to be known as the False Face Society. The masks are widely collected. They are among the few masks anywhere in the world that are asymmetric (other examples are found in Korea and Alaska). The practice appears to have arisen in western New York State in the late seventeenth century; originally, Iroquois masks may have represented ancient spirits who were thought to dwell deep in the woods, or at the rocky limits of the known earth. Later, however, they were carved in imitation of various kinds of people: young boys, angry men with broken noses, paralytics with distorted features, and toothless old men with long grey hair (Plate 22). False Face Society members (usually called "the False

Faces") performed various functions, including curing illnesses. There were two classes of masks, those representing Common Faces, and those representing "the great humpbacked doctor" (*hadu'i' go''na'* in Seneca language; *hadu'i'* is Onondaga for "mask"). The Common False Face shown in Plate 22 is a doorkeeper, taking part in a spring housecleaning ritual. He stands by a door, shaking a mud turtle rattle. William Fenton, an ethnologist who lived among the Iroquois in the 1930s, gives a vivid description of the housecleaning ritual: "In the spring and fall," he writes, "when sickness lingers in the settlements, a great company wearing both classes of medicine masks go through the houses frightening disease spirits. They scour the exterior of the house and, crawling through the door, visit every room. They haul the sick out of bed and sometimes commit indignities on lazy people." Doorkeepers like this one were stationed to prevent anyone from trying to escape, although Fenton says they could sometimes be bribed with a pinch of tobacco.

Italian. One of the Indo-European languages most closely related to Latin, Italian is the language spoken by the great artists, humanists, and patrons of the Italian Renaissance (c. 1400–1600). The Italian word for "picture" (*pittura*) descends directly from the Latin word (*pictura*), and the same is true of words for sculpture (*scultura, sculptura*) and architecture (*architettura, architectura*). The preeminence of those three arts in Renaissance Italy occasionally led to rivalries in which one art would be declared superior to the others. Leonardo da Vinci wrote such comparisons, and other artists made works intended to show the superiority of their art. Paintings were made in which figures looked in mirrors or lay near reflecting pools in order to demonstrate that painters could show their subjects from all sides just as sculptors could. Sculptors tried to capture the textures of skin, and architects added paintings and sculptures to the façades of their buildings. Each of the three arts has its preeminent example: in architecture, there is Brunelleschi's dome in Florence; in painting, Leonardo's *Mona Lisa;* and

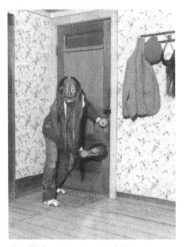

Plate 22. Shagodyowéhgo·wa', the Iroquois False-Face Society doorkeeper. c. 1940. Photo by William Fenton.

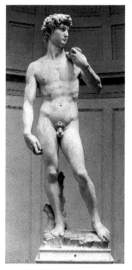

Plate 23. Michelangelo Buonarroti, *David*. 1501–1504. Marble, height 13' 5". Florence, Galleria dell'Accademia. Alinari/Art Resource, NY.

"guardians" of the culture. Also characteristic of the Koryak culture is dog sacrifice. Dogs are killed to appease mountains and the sea, to protect villages and houses, and to cure diseases. Sticks are driven into the ground, and the dead dogs are impaled on them by forcing the stick under the dogs' jaws so their muzzles point upward (Plate 24). The dogs' necks are bound with collars of grass, and grass is also laid at the bases of the sticks. Because the sacrifices are made in fall and winter, the dogs are left up until the spring, giving the settlements a striking appearance. Sometimes just dogs' heads are used; and it has also been reported that afterbirths are put in bags and hung from sticks at a distance from the houses, in order to protect newborn children.

Plate 24. Village guardian, with a sacrificial dog. c. 1905. Itelmen, Kamchatka Penninsula, Russia. Photo from Waldemar Jochelson, *The Koryak*, in the series *Publications of the Jessup North Pacific Expedition*, ed. by Franz Boas, vol. 6 (Leiden: E.J. Brill, 1908), plate IX, fig. 1.

in sculpture, Michelangelo's *David*, a forceful portrait of civic heroism that has enchanted generations of viewers (Plate 23).

Itelmen. A Paleo-Asiatic language spoken in the Koryak National District in the northern Kamchatka Peninsula, in northeastern Siberia. Traditionally, Itelmen speakers make sacred fire boards, called *gi´čgič*, which are roughly carved to resemble human figures. Eyes, mouth, and nose are chipped out of the board to give the sense of a face. The chests of the figures are provided with cupped indentations in which a drill called an "arrow" (*mā´zem*) is turned to start a fire. In the harsh climate of Siberia, the fire boards are especially important, and they are counted as sacred implements,

(An imaginary book that gives equal space to different language families; excerpt from the letter "I".)

Now here is a book worth writing. It is deeply disruptive of any number of suppositions about art, and it has the potential to be backed by a growing body of historical linguistics and genetics. It would also be able to represent prehistoric cultures; most of the populations studied by historical linguists such as Merritt Ruhlen are prehistoric, so many pages of the book would be devoted to potsherds and arrowheads. Fine art would look distinctly odd. And how sure are we, after all, that Michelangelo's *David* is more important than a frozen Koryak dog?

Sixth Perfect Story: Privileging Complex Cultures

There are other possibilities along these lines, but I would like to conclude with another that I think is a workable option. The book's table of contents, which I offer here, would divide art history according to the relative *complexity* of each culture. Such a book would have the virtue of making a theme out of the concept of history itself and it could remain basically chronological. It would also express one of art history's fondest interests by privileging artworks that are intellectually and socially complex.

The earliest cultures could be described as having been in the process of constructing the kinds of tradition that are studied mainly by art historians. The text would begin with them, stressing prehistory and including unusual media and concepts wherever possible:

Part One: Before History
 1. Paleolithic
 The inception of marking
 2. Mesolithic
 The inception of notation and representation
 3. Neolithic
 The inception of counting and new media

Part Two: The Invention of History
 4. The Ancient Near East
 The inception of visual narrative, writing, and
 artistic rules
 (Sumerian cylinder seals, tokens, and early
 writing)
 5. Mesoamerica
 Olmec iconography and principles of Maya writing
 6. India
 Symbols and figures in Harappan civilization
 and early Indian art
 7. Prehistoric China, Korea, and Japan
 Bronzes, early script, and potter's marks

That beginning would also help break down the art historical bias in favor of purely visual art, by linking visual artifacts with early writing (which was often visually oriented) and counting. The emergence of a *sense of history* would be the plot of the book. The central chapters would explore those cultures that developed indigenous historiographic traditions, narrated their own art histories, and named their own techniques, periods, and meanings. It would be interesting to take a firm position against the usual emphasis on Western art by allotting equal space to each such tradition, including the entirety of Western art:

Part Three: The Historiographic Traditions
 8. China and Related Traditions
 A detailed account of the schools and
 masters of Chinese, Korean, and Japanese
 painting
 9. Indian Traditions
 Including ritual objects in Parsee, Jain, and
 other religions, popular art, and village
 architecture before colonization

10. Islamic Traditions
 Repeating the Islamic emphasis on calligraphy,
 including the six calligraphic styles and their
 histories
11. Western Traditions
 From early Christian through Postmodernism (the
 standard story)

The book would close with a look at the entire world of visual artifacts as it has appeared in the last two centuries. Ending this way would continue and conclude the theme of history by showing how tourist art, global Modernism, and regional styles all mingle with one another. Some art practices come from historiographically developed, self-reflective traditions, and others don't, creating the kind of chafing that Stokstad describes in her account of Jaune Quick-to-See Smith:

Part Four: The Contemporary World
 12. Europe
 Emphasizing non-Western influences and stressing
 Central and Eastern Europe rather than Western
 Europe
 13. Oceania
 The current state of Polynesian, Maori, and other art
 in response to the tourist trade; the problem of
 Aboriginal art
 14. Africa and the Middle East
 Including the artifacts produced for tourists and
 those used in contemporary ritual in Islam and
 other religions
 15. Asia
 Including the effects of Western culture on Taiwan,
 Japan, Thailand, Myanmar

16. The Americas
 Stressing South American, Caribbean, and
 Mesoamerican art at the expense of North
 American art

I won't argue this plan is perfect, but I felt it was incumbent on me to think about what an acceptable account of the world's art would look like. This scheme answers the major deficiencies of Eurocentrism in a consistent and defensible manner and it is self-reflective throughout; it could include accounts of its own construction, so readers could judge the principles that went into it. It's an ad hoc solution (not like the other "perfect stories") but it's the best I could do, and it's the book I would be most interested in actually reading.

Why No One Wants the Perfect Survey Book

Now it's time for the dark conclusion. Up to this point, I have been arguing that no art history will satisfy every reader—a truism since Vasari. (The truism is still interesting because each of us has to work through the past for ourselves.) I have also suggested, at the close of Chapter 4, that there are some cultures whose idea of their own art can never fit into art history. In this last section I want to take those conclusions further by arguing three final points: first, that art historians do not really want multiculturalism; second, that multiculturalism, even in theory, is impossible anyway; and last, that art history, as an *enterprise*—an activity that generates jobs and fills seats in classrooms—is irremediably Western.

The first point is easy to make by noting the dearth of books like the ones I've been imagining or even like Tömöry's bisected history. If art historians really wanted multiculturalism, they would have taken the plunge into the ocean of non-Western thought, and tried writing books like Tömöry's (or any others). In practice, only specialists on non-Western art spend more than half their time looking at art made outside Europe and America. Most teachers and students don't want multiculturalism, or equality in

gender representation or even in race representation; otherwise the consensus would shift and art historians would stop studying, teaching, and writing about Michelangelo, David, Manet, Cézanne, Van Gogh, Picasso, and all the others, and start looking at some genuinely exotic objects instead. This goes to the question of why art history is written, and who the art historians are who write it: it's written mostly by Western Europeans and North Americans, and its root purpose is to chronicle, preserve, and sometimes promote the kind of culture that the authors find valuable. Multiculturalism is only a recent and relatively untroubling form of guilt for the choices we continue to make.

Multiculturalism is a topic that concerns art historians and students, but not enough to make the crucial changes. And even if a consensus of people interested in art history was determined to create a multicultural art history, I think that multiculturalism itself is actually impossible. There is a very clever argument to that effect constructed by the literary theorist Stanley Fish. He points out that no matter how well intentioned a person may be about understanding other cultures, there will be a point where further understanding involves giving up something essential in one's own culture. Using the example of the death sentence pronounced by the Iranian government on the writer Salman Rushdie, Fish argues that even a scholar of Islam, fully sympathetic with all other aspects of Iranian life, cannot remain a Western multiculturalist and still embrace the *fatwa*: to do so would be to embrace intolerance, which is one of the ideas rejected at ground level by Western culture. Fish astutely calls the common solution "weak" or "boutique" multiculturalism: we want to appreciate other cultures as much as we can without inconveniencing ourselves, or—to put it less uncharitably—without disorienting ourselves and risking losing our own identities. (Terry Eagleton says the same thing in a more lighthearted manner: "It is also," he writes, "rather easier to feel solidarity with 'Third World' nations which are not currently in the business of killing one's compatriots.") Fish's essay is aimed

at literary studies and political theory, but it applies to each of the non-Western texts I considered in Chapter 3.

Contemporary art historians work to achieve balanced, sympathetic understandings of other cultures, but they have to pull back when the material gets too alien. Gombrich does as much when he tries to "enter into the mentality which created [the] uncanny idols" of Aztec culture, and finds that he can at least "begin to understand" how they were using visual objects to symbolize ideas—which is exactly what Hegel said over a hundred years before. Hegel could be faulted for not trying to comprehend individual cultures other than his own, but Gombrich can't. The similarity between their conclusions points not to a correctable prejudice but to the limits that preserve a certain sense of what it is to be Western. To go further would be to give up something (who knows what?) crucial to being a modern Western viewer.

A wonderful question lurks here. It is easy to admit that Western texts are prejudiced. I doubt many people would want to claim that any Western textbooks are fairer than the Russian *Universal History* or the Islamic textbooks we considered in Chapter 4. After all, each culture has its viewpoint on the past. But could any Western historian or student *give up* Gardner, Gombrich, or any Western book of art history in favor of the Russian *Universal History,* or Ali Nagi Vaziri's book (the Iranian text), or Salamah Musa's (the Egyptian book)? I do not think so, and the reason is just as Stanley Fish explains it. A history of art like Burhan Toprak's *Sanat Tarihi,* which includes the Parthenon but has nothing Western after the Mérode altarpiece, lacks too much of what Westerners have come to identify as their cultural identity. Much as I would love to have an English-language textbook suitable for classroom use that swerved aside after the Mérode altarpiece, I know I could only use it as a foil for a fuller history. No matter how critically I might treat Gardner or Gombrich, I can't do without them indefinitely. That is the kind of acid test that proves Fish right and shows that real-life multiculturalism is soft and not hard. Art historians love the West, and

need the West and there is no other viable history of art: my third
and last point.

There is a widespread notion that the whole problem of fresh-
man art history courses is not a pressing concern because art his-
tory's new subjects (advertising, film, video art, and so on) will
spawn new stories, competing with the older ones and eventually
supplanting them. I have never been so sure, and so far the new
stories are only new because they are about new objects. Otherwise
they are faithful to the standard story. I wonder if the new histo-
ries *can* liberate us from ideas that have been in place since Vasari.
I suspect, on the contrary, that the very idea of art history belongs
to the West from the Renaissance onward, so that every history of
a non-Western art and every history of a new subject becomes a
version, an adaptation, of the *Story of Art* and its competitors. The
half of Tömöry's book that deals with Indian art is written in
Western mode, using a succession of periods, noting affinities
between contemporary works, following the Hegelian and
Wölfflinian progression of styles, noting composition, patronage,
and provenance: all the trappings of Western art histories trans-
posed onto Indian examples.

Indian, Chinese, and southeast Asian scholars write Western-
style essays and books, adopt Western armatures for their argu-
ments, hold exhibitions and colloquia, create departments and
curricula, all in the Western manner. The discipline itself has
been exported and has found new homes, and countries such as
China and India are producing art histories compatible with
Western ones. The truly insidious nature of this unacknowledged
Westernness becomes clear whenever a historian sits down—let's
say in Bangkok, or Nanjing—to write an essay on something
entirely local and specific to her time and place. That essay, if it
is to be published in a serious art magazine or given at an inter-
national colloquium, has to fit the forms and concerns of Western
art history. This is at once trivial—a matter of earning a living—
and profound. It is the real reason why the one-volume survey

texts are so important, and why *Stories* must still depend on the one *Story*.

To many people, what I've written in these last few pages will not seem right. Art historians working in the West sometimes take it on faith that scholars in non-Western cultures have their own ways of writing art history; and art historians in China and India sometimes deny that the Westernness of their writing is relevant provided their subject matter is indigenous. Multiculturalism is taken to be transforming the discipline. I am not sanguine about those defenses, but I am optimistic about the more distant future. In the fifty years since Gombrich's *Story of Art*, the subject has become irrepressibly multiple. At the moment, it's new wine in old flasks, but the sheer number of art histories and the uncountable kinds of artworks means the discipline of art history can only become more diverse. I do not think Gombrich's story can ever be abandoned without losing the sense of art history, but its voice is growing fainter in the surrounding cacophany. It seems especially promising that recent art history has become reflective about its own purposes: we still produce survey textbooks, but they include more of the world and they are more aware of their ideological bent. Art historians, like other academics, are no longer as confident about how an aesthetic education should be accomplished or whether it's a good idea at all. To me, that's the most promising—and also the most challenging—prospect for the near future of the history of art: becoming more aware of the stories we tell and the reasons we still want to tell them. The hardest of those truths, the one multiculturalism shies from, is the possibility that the standard Western story is still the backbone of the discipline.

The contemporary artist Robert Jacobs made an artwork and a new kind of art history using Janson's *History of Art*. Jacobs bought two copies, and cut all the illustrations out. (He needed two copies to make sure he could cut out the pictures on both sides of every page.) He produced two perforated books and a collection of several thousand illustrations without captions, which

Plate 25. Robert Jacobs, *The History of Art, Third Edition,* installation view. 1992. Courtesy of the artist.

he arranged in an elaborate installation. Part is shown in Plate 25, and I've also reproduced a couple of pages from one of his twin Jansons (Plate 26).

Some of the framed pages had odd-shaped silhouettes produced when a picture had been cut out of the back of the page. On one page, the outline of an Ottonian church perforated a picture of God reproaching Adam and Eve. The empty outline of the cutout church hovered like a ghostly presence between Eve and Adam if the church were casting its shadow back over Eden, prefiguring things to come.

In effect Jacobs's work, which he called *The History of Art, Third Edition,* was a new history of art. It arranged things in a pattern no one, most especially Janson, could have imagined. It was a salutary work, even if it was literally unreadable. It demonstrated that there is no end to the invention and reinvention of the stories of art.

Plate 26. Robert Jacobs, *The History of Art, Third Edition*, details. 1992. Courtesy of the artist.

References and Further Reading

Foreword

Reference

Svetlana Alpers and Michael Baxandall, *Tiepolo and the Pictorial Intelligence* (New Haven, CT: Yale University Press, 1994), 3, 166.

Chapter 1: Intuitive Stories

References

Atomism, monism, and megaperiods: Erwin Panofsky, *Renaissance and Renascences in Western Art* (New York: Icon, 1972).

Panofsky on Dürer: *The Life and Art of Albrecht Dürer* (Princeton, NJ: Princeton University Press, 1971 [1955]), 3, 12, 14; Hans Belting, *The Germans and Their Art: A Vexed Relationship*, trans. by Scott Kleager (New Haven, CT: Yale University Press, 1998 [1993]); the English edition has a lengthy introduction absent from the German edition.

Duchamp catalog: *Marcel Duchamp, Work and Life*, ed. by Pontus Hulten, texts Jennifer Gough-Cooper and Jacques Caumont (Cambridge, MA: MIT Press, 1993).

Yve-Alain Bois on the endgame: Bois, *Painting as a Model* (Cambridge, MA: MIT Press, 1990); and the review by Akira Mizuta Lippit, *MLN* 106, no. 5 (December 1991): 1074–1078.

Further Reading

Piere Daix, *Picasso 1900–1906: Catalogue raisonné de l'oeuvre peint* (Neuchâtel, Switzerland: Éditions Ides et Calendes, 1988).

Yve-Alain Bois and Rosalind Krauss, *Formless: A User's Guide* (New York: Zone Books, 1997).

Definitions of postmodernism: see Bois and Krauss, *Formless*; and also Thomas McEvilley, "History, Quality, Globalism," in Roger Denson and Thomas McEvilley, *Capacity: History, the World, and the Self in Contemporary Art and Criticism* (New York: Gordon and Breach, 1996), 119–133.

Michael Fried's work: begin with *Absorption and Theatricality: Painting and Beholder in the Age of Diderot* (Berkeley, CA: University of California Press, 1980).

Mannerism: John Shearman, *Mannerism* (Harmondsworth, UK: Penguin, 1967); Thomas DaCosta Kaufmann, *The School of Prague: Painting at the Court of Rudolf II* (Chicago: University of Chicago Press, 1988).

Periods formed instantly by styles: my *Our Beautiful, Dry, and Distant Texts: Art History as Writing* (University Park, PA: Penn State Press, 1997), 183–188. Wilhelm Pinder, *Das Problem der Generationen in der Kunstgeschichte Europas* (Munich: F. Bruckmann, 1961). For the concept of style, see Donald Preziosi, *The Art of Art History: A Critical Anthology* (Oxford: Oxford University Press, 1998), 109–164, and my "Style," *Grove Dictionary of Art* (New York, Grove Dictionaries, 1996).

German critics: Werckmeister, *Linke Ikonen: Benjamin, Eisenstein, Picasso nach dem Fall des Kommunismus* (Munich: C. Hanser, 1997); *Art and Ideology*, ed. Benjamin Buchloh (New York: New Museum of Contemporary Art, 1984).

Panofsky's analysis of Dürer: my *Our Beautiful, Dry, and Distant Texts*, op. cit., 272–297; and Joan Hart, "Heinrich Wölfflin: An Intellectual Biography," PhD dissertation, Berkeley, CA 1981 (University Microfilms, 1981), chap. 4.

Bulgarian art: Steven Mansbach, *Modern Art in Eastern Europe:*

From the Baltic to the Balkans, ca. 1890–1939 (Cambridge, UK: Cambridge University Press, 1999).

Giambattista Vico, *The New Science of Giambattista Vico*, trans. Thomas Goddard Bergin and Max Harold Fisch (Ithaca, NY: Cornell Univeristy Press, 1948).

Johann Joachim Winckelmann, *Writings on Art*, selected by David Irwin (London: Phaidon, 1972); there are also selections in *The Art of Art History: A Critical Anthology*, ed. Donald Preziosi (Oxford: Oxford University Press, 1998), 31–39, and see Whitney Davis's essay in Ibid., 40–51.

"Paradoxical history": Michel Serres, *The Parasite*, trans. Lawrence Schehr (Baltimore, MD: Johns Hopkins University Press, 1982); Jacques Derrida, *The Post Card: From Socrates to Freud and Beyond*, trans. Alan Bass (Chicago: University of Chicago Press, 1987); Mieke Bal, *Reading "Rembrandt": Beyond the Word-Image Opposition* (New York: Cambridge University Press, 1991).

Theories of postmodernism: Arthur Danto, *Beyond the Brillo Box: The Visual Arts in Post-Historical Perspective* (New York: Farra Straus Giroux, 1992); Rosalind Krauss and Yve-Alain Bois, *Formless*, op. cit.; Thierry de Duve, *Kant after Duchamp* (Cambridge, MA: MIT Press, 1996).

The endgame: Yve-Alain Bois, in *Endgame: Reference and Simulation in Recent Painting and Sculpture* (Cambridge, MA: MIT Press, 1986); René Démoris, *Les fins de la peinture* (Paris: Editions Desjonquières, 1990), reviewed by Jacques Berne, "Comment parler de la peinture aujourd'hui?" *Critique* 47, no. 534 (November 1991): 874–881.

Chapter 2: Old Stories

References

Giorgio Vasari, *The Lives of the Eminent Painters, Sculptors, and Architects*, trans. William Gaunt (New York: Everyman's Library, 1970), vol. 1, 1, 5, 7, 8–12; on old age, 207; vol. 2, 152. Piero di Cosimo excerpt: Ibid., vol. 2, 181–182.

Patenier excerpt: Van Mander, *The Lives of the Illustrious Netherlandish and German Painters, From the First Edition of the Schilder-boeck (1603–1604)*, ed. Hessel Miedema (Doornspijk, the Netherlands: Davaco, 1994), vol. 1, 134, punctuation modified. The interpolation from the life of Hendrick met de Bles is from Ibid., 137.

Pierre Monier, *Histoire des arts qui ont rapport au dessin* (Paris, 1698); English edition (London, 1699).

Bellori: *Le vite de' pittori, scultori ed architetti moderni* (Rome, 1672); the elements of Bellori's biographies are analyzed by Giovanni Previtali, "Introduzione," in Giovan Pietro Bellori, *Le Vite de' pittori, scultori e architetti moderni*, ed. Evelina Borea (Torino, Italy: Einaudi, 1976), l; and see Julius Schlosser, *Die Kunstliteratur, Ein Handbuch zur Quellenkunde ner neueren Kunstgeschichte* (Vienna: Anton Schroll, 1985), esp. 407–462 (repr. 1st ed., 1924).

Antonio Palomino de Castro y Velasco, *El Museo Pictórico y Escala Óptica* (Madrid: M. Aguilar, 1947); partly translated by Nina Mallory as *Lives of the Eminent Spanish Painters and Sculptors* (Cambridge, UK: Cambridge University Press, 1987), xi, 3.

Félibien, *Entretiens sur les views at sur les ouvrages des plus excellens peintres anciens et modernes* (Farnborough, UK: Gregg Press, 1967), originally published 1725; end of the first *Entretien*, p. 134.

Hegel: for relevant excerpts, *The Art of Art History*, op. cit., 97–108.

Further Reading

Vasari: Paul Barolsky, "Vasari and the Historical Imagination," *Word & Image* 15 (1999): 286–291.

Piero di Cosimo: Erwin Panofsky, "The Early History of Man in Two Cycles of Paintings by Piero di Cosimo," *Studies in Iconology: Humanistic Themes in the Art of the Renaissance* (New York: Harper and Row, 1972), 61–63. The second painting is also discussed in Elkins, *Why Are Our Pictures Puzzles? On the*

Modern Origins of Pictorial Complexity (New York: Routledge, 1999), 189; and in Elkins, *Streams into Sand: On Connections between Renaissance and Modern Paintings* (New York: Gordon and Breach, forthcoming).

Ancient art texts: *Lexikon der Kunst*, v. "Kunstgeschichte" (Leipzig: E. A. Seemann, 1992), vol. 4, 128, col. B. For Bellori, see *Le Vite de' pittori, scultori, ed architetti moderni*, with an introduction by Eugenio Battisti (Genoa: Quaderni dell'Istituto di Storia dell'Arte della Università di Genova, n.d.), esp. xiii.

Van Mander: Walter Melion, *Shaping the Netherlandish Canon, Karel van Mander's* Schilder-Boeck (Chicago: University of Chicago Press, 1991), esp. chap. 6. For a German example akin to Palomino, see Joachim von Sandrart, *L'Academia Todesca della Architettura, Scultura et Pictura, oder Teutsche Academie der Edlen Bau-, Bild-, und Mahlerey-Künste* (Nürnberg, 1675), partly reprinted in *Joachim von Sandrarts Academie der Bau-, Bild-, und Mahlerey-Künste von 1675*, ed. A. R. Peltzer (Munich: G. Hirth, 1925).

Hegel in art history: E. H. Gombrich, *In Search of Cultural History* (Oxford: Clarendon Press, 1969); and my "Art History without Theory," *Critical Inquiry Critical Inquiry* 14 (1988): 354–378.

Derrida's attempt to address Hegel: *Glas*, trans. John Leavey, Jr. and Richard Rand (Lincoln, NE: University of Nebraska Press, 1986).

Damisch: "Moves: Playing Chess and Cards with the Museum," in *Moves*, exh. cat. (Rotterdam: Museum Boijmans Van Beuningen, 1997), 73–96.

Chapter 3: New Stories

References

E. H. Gombrich, *The Story of Art*, 16th ed. (Englewood Cliffs, NJ: Prentice Hall, 1995): on Grünewald, 353; on Bosch, 359; on form, 583; on Masaccio's *Trinity*, 229; excerpt on Giacometti, 592. Excerpt from the earlier edition: Gombrich, *The Story of*

Art, 4th ed. (New York: Oxford University Press, 1951), 436–437.

Wilhelm Hausenstein, *Kunstgeschichte* (Berlin: Deutsche Busch Gemeinschaft, 1927).

Problem of Figure 1: Whitney Davis, "The Origins of Art History," in *Replications: Art History, Archaeology, Psychoanalysis* (University Park, PA: Penn State Press, 1996).

Gardner's Art Through the Ages, 9th ed., edited by Horst de la Croix, et al. (Fort Worth, TX: Harcourt Brace Jovanovich, 1991).

Hugh Honour and John Fleming, *The Visual Arts: A History,* 4th ed. (Englewood Cliffs, NJ: Prentice Hall, 1995); H. W. Janson, *History of Art* (New York: Abrams, 1995), 15.

Excerpts from Gardner: *Gardner's Art Through the Ages: An Introduction to Its History and Significance* (New York: Harcourt, Brace, and Company, 1926), 399; *Helen Gardner's Art Through the Ages,* ed. Sumner Crosby (New York: Harcourt, Brace, 1959), 632; *Helen Gardner's Art Through the Ages,* ed. Horst de la Croix, et al., 9th ed. (New York: Harcourt Brace, 1991), 501–502. The second excerpt is from the opening of the chapter called simply "Primitive," and the last is from the chapter called "The Native Arts of the Americas, Africa, and the South Pacific," in a section titled "Stylistic Community of the Native Arts."

Karl Woermann, *Geschichte der Kunst aller Zeiten und Völker* (Leipzig: Bibliographisches Institut, 1905–1911).

Marilyn Stokstad, *Art History* (New York: Prentice Hall and Harry N. Abrams, 1995), 6, 15, 925, 928 (on Quattara and Wedgewood), 891 (on Quick-to-See Smith).

H. H. Arnason, Marla Prather, and Daniel Wheeler, *History of Modern Art, Painting, Sculpture, Architecture, Photography,* 4th ed. (Englewood Cliffs, NJ: Prentice Hall, 1998), 17, 766.

Barr's sketches: The Museum of Modern Art Archives: Alfred H. Barr, Jr., Papers, shelf list AAA: 3263: 1364–1366. I am

indebted to Astrit Schmidt-Burkhardt for this information; see her *Stammbäume der Kunst: Zur Genealogie der Avantgarde 1800–2000*, forthcoming. The quotations about Vasari are from *Helen Gardner's Art Through the Ages*, 9th ed., 600 n.

Further Reading

Realism, naturalism, and skill: Richard Wollheim, "What the Spectator Sees," in Michael Ann Holly, Norman Bryson, and Keith Moxey, eds., *Visual Theory* (New York, 1991), 132–133; Kendall Walton, *Mimesis as Make-Believe* (Cambridge, MA: Harvard University Press, 1990); J. J. Gibson, "The Information Available in Pictures," *Leonardo* 4, no. 1 (1971): 27–35; Margaret Hagen, *Varieties of Realism: Geometries of Representational Art* (Cambridge, UK: Cambridge University Press, 1986); Nelson Goodman, *Languages of Art*, 2nd ed. (Indianapolis: Hackett, 1976); Stephen Bann, *The True Vine, On Visual Representation and The Western Tradition* (Cambridge, UK: Cambridge University Press, 1989).

Archival certainties: *Object, Image, Inquiry: The Art Historian at Work*, ed. Elizabeth Bakewell, et al. (Santa Monica, CA: Getty Art History Information Program, 1988).

The Uruk vase: Denise Schmandt-Besserat, "Art, Writing, and Narrative in Mesopotamia," *Collectanea Orientalia* (Civilisations du Proche-Orient, series 1, Archeologie et Environnement, vol. 3, 1996), 315–321.

"Abstraction" and "ornament" in Islamic art: Oleg Grabar, *The Mediation of Ornament*. The A. W. Mellon Lectures in the Fine Arts, 1989; Bollingen Series, vol. 38 (Princeton, NJ: Princeton University Press, 1992).

The Grove Dictionary of Art Online (New York: Grove's Dictionaries, Inc., 1999–) is preferred to the printed version because it is periodically updated.

Competing versions of twentieth-century art: Robert Rosenblum, *Modern Painting and the Northern Romantic Tradition: Friedrich to*

Rothko (New York: Harper and Row, 1975); Rosalind Krauss and Yve-Alain Bois, *Formless,* op. cit; Krauss, *The Optical Unconscious* (Cambridge, MA: MIT Press, 1993); Thomas Crow, *Modern Art in the Common Culture* (New Haven: Yale University Press, 1996), 3–38; *Clement Greenberg: The Collected Essays and Criticism,* ed. John O'Brian, 4 vols. (Chicago: University of Chicago Press, 1986–).

Response to Barr's chart, see Meyer Schapiro, "The Nature of Abstract Art," in *Modern Art: Nineteenth and Twentieth Century, Selected Papers,* vol. 2 (New York: Braziller, 1978), 189 ff.; for more on modernist maps, see Robert Nelson, "The Map of Art History," *The Art Bulletin* 79, no. 1 (1997): 28–40.

Masaccio's character: Michael Baxandall, *Painting and Experience in Fifteenth Century Italy* (Oxford: Oxford University Press, 1972), 118–128.

Chapter 4: Non-European Stories

References

The Russian universal history: *Universal History of Art.* Akademiia khudozhestv SSSR. Institut teorii i istorii izobrazitel'nykh iskusstv. (Moscow: State Publisher "Art," 1956), trans. Ullrich Kuhirt as *Allgemeine Geschichte der Kunst* (Leipzig: E. A. Seemann, 1965). In accord with its socalist purpose, the *Universal History of Art* has no chief editor. The excerpt on Romanian art is by M. T. Kusmina, from *Allgemeine Geschichte,* op. cit., vol. 8, 428.

Russian text that ends with limewood sculptures: Akademia khudozhestv SSSR, Institut zhivopisi, skuptury i arkhitektury, *Istoriia iskusstva zarubezhnykh stran,* 2 vols. (Moscow: Izd–vo Akademii Khudozhestv SSSR, 1963). Konstantin Aleksandrovich Erberg [K. A. Siunnerberg], *Iskusstvo i narod* (St. Petersburg: "Kolos," 1922). Nikolai Malakhov, *On Modernism* [*O Modernizme*] (Moscow: Izobrazitelnoe Iskusstvo, 1975), was followed by Malakhov, *Modernism: A Critical Survey* [*Modernizm: Kriticheskii Ocherk*], 3 vols. (Moscow: Izobrazitelnoe

Iskusstvo, 1986). I thank Zhivka Valiavicharska for drawing my attention to these books.

Russian book that ends with Rockwell Kent: Vladimir Semenovich Kemenov, *Khudozhestvennoe nasledie i sovremennost: ot Leonardo da Vinchi do Rokuella Kenta* (Moscow: "Izobrazitelnoe iskusstvo," 1989). The essay on Picasso was written by Alexander Babin, currently conservator of European and American paintings at the Hermitage; I thank him for information on Kemenov.

Twentieth-century Islamic texts: Burhan Toprak, *Sanat Tarihi* (Istanbul: Milli Egitim Basimevi, 1960); Ali Nagi Vaziri, *Tarikh-i umumi-i* (Tehran: Danishgah-i Tehran, 1959), rep. (Tehran: Hirmand, 1984); and Salamah Musa, *Tarikh al-funun* (Cairo: al-Hilal, 1929).

Edith Tömöry, *A History of Fine Arts in India and the West* (Bombay: Orient Longman, 1982): revival of painting in the nineteenth century, 165, 279, 481; on "perturbation, emotion, and torment," 488; the excerpt is on p. 283.

Indian scholars' opinions of Sher Gil: Krishna Chaitanya, *A History of Indian Painting: The Modern Period* (New Delhi: Shakti Malik Abhinav Publications, 1994), 183, quoting Asit Haldar and Francis Newton.

Tömöry's sources: *Teach Yourself History of Painting*, ed. William Gaunt (London: English Universities Press, 1954).

Qādī Aḥmad, *Calligraphers and Painters*, trans. V. Minorsky (Washington, DC: Freer Gallery of Art, 1959), 178; "*qalam* of marvelous writing," 48; the excerpt is from 179–180, 50 n. 108, and 180 n. 629.

Priyabala Shah, *Viṣṇudharmottara Purāṇa*, Third Khanda, vol. 2, *Introduction, Appendices, Indexes*. Gaekwad's Oriental Series, ed. B. J. Sandesara, no. 137 (Baroda, India: Oriental Institute, 1961): on dance and grammar, 3; on gnats and fleas, 137. The excerpt is from *Viṣṇudharmottara*, Part III, *A Treatise on Indian Painting and Image-Making*, trans. Stella Kramrisch (Calcutta:

Calcutta University Press, 1928), chap. 43, 60–61, translation modified.

Zhang Yanyuan, *Li tai ming hua chi* is partly translated into English in *Some T'ang and pre-T'and texts on Chinese Painting*, ed. William Acker, 3 vols. (Leider: E. J. Brill, 1954–1974).

The restorer of the "Picasso Madonna": Dora Jane Hamblin, "Science Finds Way to Restore the Art Damage in Florence," *Smithsonian* 4, no. 11 (February 1974): 26–35, quotation on p. 34.

Further Reading

Germaine Richier: *Germaine Richier, rétrospective*, exh. cat. (Saint-Paul, France: Fondation Maeght, 1996).

Russian *Universal History:* it was never as popular as a shorter book; Mikhail Alpatov, *Vseobshtaia istoriia iskisstv [Short History of Art]*, 3 vol. (Moscow: Iskusstvo, 1948–1955); which was written under pressure from the Stalinist regime; Alpatov agreed to write it in order to have a vehicle for his own research on Medieval art. I thank Zhivka Valiavicharska for drawing this to my attention.

Qāḍī Aḥmad: more in my *On Pictures and the Words that Fail Them* (Cambridge, UK: Cambridge University Press, 1998), 194–200; and the *Viṣṇudharmottara Purāṇa* is discussed in Ibid., 203–208.

The painter mentioned by Qāḍī Aḥmad: R. Ettinghausen, "Bihzad," *Encyclopedia of Islam* (Leiden: E. J. Brill, 1908–1937), vol. 5, supplement, 38–40; Thomas Lentz, "Changing Worlds: Bihzad and the New Painting," in *Persian Masters, Five Centuries of Painting*, ed. Sheila R. Canby (Bombay: Marg, 1990), 39–54.

Footnotes to the excerpt of the the *Viṣṇudharmottara:* Shanti Lal Nagar, *Garuda, The Celestial Bird* (New Delhi: Book India, 1992); and K. C. Aryan, *Hanuman in Art and Mythology* (New Delhi: Rekha Prakashan, 1975); *The Sharma Shastra: Or, The Hindu Law Codes,* translated by Manmatha Nath Dutt (Varanasi, India: Chaukhamba Amarabharati Prakashan, 1977).

Chapter 5: Perfect Stories

References

Feminism: Linda Nochlin, "Why Have There Been No Great Women Artists?" in *Women, Art, and Power: And Other Essays* (New York: Harper and Row, 1988), chap. 7, 145–178; Rosalind Krauss, *Bachelors* (Cambridge, MA: MIT Press, 1999), esp. 50. An example of Deepwells's very thoughtful work is *Feminist Art Criticism: Critical Strategies*, ed. Katy Deepwell (Manchester: Manchester University Press, 1995). See also Rozsica Parker and Griselda Pollock, *Old Mistresses: Women, Art, and Ideology* (London: Routledge and Kegan Paul, 1981); and for the older literature Enrst Guhl, *Die Frauen in de Kunstgeschichte* (Berlin: J. Guttentag, 1858); Elizabeth Ellet, *Women Artists in All Ages and Countries* (London: R. Bentley, 1859); Hugo Munsterberg, A History of Women Artists (New York: C. N. Potter, 1975).

Queer studies: an example of Gavin Butt's work is: "The Greatest Homosexual? Camp Pleasure and the Performative Body of Larry Rivers," in *Performing the Body/Performing the Text*, ed. Amelia Jones and Andrew Stephenson (London: Routledge, 1999), 107–126. See also John Ricco, "Fag-o-Sites: Minor Architecture and Geopolitics of Queer Everyday Life," PhD dissertation, University of Chicago, 1998 unpublished; Whitney Davis, "Gender," in *Critical Terms for Art History*, edited by Robert Nelson and Richard Shiff (Chicago: University of Chicago Press, 1996), 220–233; James Saslow, *Pictures and Passions: A History of Homosexuality in the Visual Arts* (New York: Viking, 1999).

African-American art history: James Smalls, "A Ghost of a Chance: Invisibility and Elision in African American Art Historical Practice," *Art Documentation* (spring 1994): 3–8, quotation on p. 4; Kymberly Pinder, "Black Representation and Western Survey Textbooks," *Art Bulletin*, forthcoming. I thank Kym Pinder for sources and advice on this section.

Theory and methodology books: *Critical Terms for Art History,* ed. Robert Nelson and Richard Shiff (Chicago, IL: University of Chicago Press, 1996); *Visual Theory: Painting and Interpretation,* ed. Norman Bryson, Michael Ann Holly, and Keith Moxey (New York: HarperCollins, 1991); *Visual Culture: Images and Interpretations,* ed. Norman Bryson, Michael Ann Holly, and Keith Moxey (Hanover, NH: University Press of New England, 1994); *Language of Art History,* ed. Salim Kemal and Ivan Gaskell (Cambridge, UK: Cambridge University Press, 1991).
Books cited in the "Current practical problems" section: Gombrich, *The Story of Art,* 16th ed. (Englewood Cliffs, NJ: Prentice Hall, 1995), 53. *Storia dell'arte italiana,* 12 vols. in 3 parts, ed. Giovanni Previtali and Federico Zeri (Torino, Italy: Giulio Einaudi, 1979–); in this connection see specially part 1, vol. 2, *L'artista e il pubblico* (1979), especially Paula Barocchi's essay, "Storiografia e collezionismo dal vasari al Lanzi," pp. 4–85; part 3, vol. 2, *Scrittura, miniatura, disegno* (1980); and part 3, vol. 3, *Conservazione, falso, restauro* (1981); Feldman, *Thinking About Art* (Englewood Cliffs, NJ: Prentice-Hall, 1985); Pierre Francastel, *Histoire de l'art, instrument de la propaganda germanique* (Paris: Librairie de Médicis, 1945); Elie Fauré, *Histoire de l'art,* 4 vols. (Paris: Editions G. Crès, 1921), and *History of Art,* trans. Walter Pach, 5 vols. (New York: Harper, 1921–1930), vol. 5, fig. 55; Maurice K. Symonds, Coll Portley, Ralph E. Phillips, et al., *The Visual Arts, A World Survey* (Milton, Australia: The Jacaranda Press, 1972), vii; Slavko Batusic, *Umjetnost u slici, pregled povijesti umjetnosti,* 3rd ed. (Zagreb: Matica Hrvatska, 1967), 515–668; Larry Silver, *Art in History* (Englewood Cliffs, NJ: Prentice Hall, 1993); Karl Woermann, *Geschichte der Kunst aller Zeiten und Völker* (Leipzig: Bibliographishes Institut, 1905–1911).
Current attempts to "put the world in a book": *Raising the Eyebrow: John Onians and the World Art Studies,* ed. Lauren Golden (Oxford: Archaeopress, 2001); Summers, *The Defect of*

Distance: World Art History and the Rise of Western Modernism
(Berkeley, CA: University of California Press, forthcoming).
First perfect story: E. H. Gombrich, *Aby Warburg, an Intellectual
Biography* (London: The Warburg Institute, 1970); A. W.
Becker, *Charakterbilder aus der Kunstgeschichte in chronologischer
Folge* (Leipzig: E. A. Seemann, 1862); Margaret Olin, *Forms of
Representation in Alois Riegl's Theory of Art* (University Park, PA:
Penn State Press, 1992).
Second perfect story (comparison of Gilgamesh and
Newgrange): *Neuer Belser Stilgeschichte,* op. cit., vol. 1, 419.
Third perfect story: Isabella Errera, *Répertoire des peintures datées*
(Paris: Librairie Nationale d'Art et d'Histoire, 1920), 2 vols.
Fourth perfect story: Asian rock art: Robert Bednarik, "The
Pleistocene Art of Asia," *Journal of World Prehistory* 8, no. 4
(1994): 351–375, esp. 352; Luis Pericot-Garcia, John Galloway,
and Andreas Lommel, *Prehistoric and Primitive Art* (London:
Thames and Hudson, 1969); also published as *La preistoria e i
primitivi attuali* (Florence: Sansoni, 1967). Moritz Hoernes,
*Urgeschichte der bildenden Kunst in Europa, von den Anfangen bis
um 500 vor Christi,* 3rd ed., ed. and expanded by Oswald
Menghin (Vienna: Anton Schroll, 1925).
Fifth perfect story: William Fenton, "Masked Medicine Societies
of the Iroquois," *Annual Report of the Smithsonian Institution*
(1940): 397–429; quotation on 425–426; Waldemar Jochelson,
"Material Culture and Social Organization of the Koryak,"
Memoirs of the American Museum of Natural History 10 no. 1
(1905–1908), esp. 95.
The argument against multiculturalism: Fish, "Boutique
Multiculturalism, or Why Liberals Are Incapable of Thinking
about Hate Speech," *Critical Inquiry* 23 (Winter 1997): 378–395.

Further Reading

Books mentioned in the "Current practical problems" section:
Woermann, *Geschichte der Kunst aller Zeiten und Völker,* 6 vols,

esp. vol. 1, *Die Kunst der vor-und außerchristlichen Völker,* 2nd ed.
(Leipzig: Bibliographisches Institut, 1915); 1st ed.
(1900–1911) in 3 vols. There were translations into Spanish
(*Historia del arte en todos los tiempos y pueblos* [Madrid: Saturnino
Calleja, 1925]), Russian (*Istoria isskustva vsiekh vremen i narodov*
[Moscow, 1903–1913]), and English. Alfred Woltmann's
Geschichte der Malerei, 2 vols. (Leipzig: E. A. Seemann, 1879), is
coedited and cowritten with Karl Woermann; it was expanded
and reprinted at least twice before the turn of the century;
vol. 1, *Die Malerei des Altertums,* begins with a brief chapter on
"Die Malerei im alten Orient," including Egypt and "westasi-
atischen Völker" (chiefly Assyria), before continuing to
Greece and Rome. See also the English translation, Alfred
Woltmann and Karl Woermann, *History of Ancient, Early
Christian, and Medieval Painting,* ed. Sidney Colvin (New York:
Dodd, Mead and Company, 1880–1882) and (London: C. K.
Paul, 1880–85).

Texts that have contents other than painting, sculpture, and
architecture: André Michel's *Histoire de l'art, depuis les premiers
temps chrétiens jusqu'a nos jours,* 8 vols. (Paris: Librairie Armand
Colin, 1905–1929), contains chapters on ivories, enamels, and
coins (ibid., vol. 1, *Des Débuts de l'art chrétien à la fin de la période
Romane, 899–924*).

The German style history: *Neuer Belser Stilgeschichte,* 6 vols
(Stuttgart: Belser, 1990), especially vol. 1, *Frühgeschichte und
Hochkulturen,* ed. Christoph Wetzel and Walther Wolf, which
contains the theoretical platform of the series
("Stilgeschichte," 11–152).

Jose Pijoán, et al., *Summa artis, historia general del arte,* 2nd ed.
(Bilbao, Madrid [etc.]: Espasa-Calpe, 1944–), 1st. ed. (Bilbao,
Madrid [etc.]: Espasa-Calpe, 1931–); Pijoán wrote vols. 1–16.

Julio Martinez Santa-Olalla, *Historia del arte y de la cultura*
(Madrid: Gráficos Europa, 1978). *Propylaen Kunstgeschichte,* ed.
Kurt Bittel, et al. (Berlin: Propylaen-Verlag, 1966–1975); and

Supplementbände, ed. Beat Brink et al. (Berlin: Propylaen-Verlag, 1977–). Jens Thiis, *Fra nilen til seinen, samlede avhandlinger om fremmed kunst* (Oslo: Glydendal Norsk Verlag, 1936).

For contemporary art in surveys of art history see also Bruce Cole and Adelhard Gealt, *Art of the Western World: From Ancient Greece to Post-Modernism,* with an introduction by Michael Wood (New York: Summit, 1989). Sherman Lee, *History of Far Eastern Art,* 5th ed., ed. Naomi Noble Richard (New York: Prentice Hall, 1994). The 4th ed. (New York: Abrams, 1982), ends with Lang Shi-ning (Giuseppe Castiglione), 460. *Kunst aller Tijden, een overzicht der beeldende kunsten en de samenhang met de culturele achtergrond,* ed. V. Denis and Tj. E. de Vries, 2 vols. (Amsterdam: Elsevier, 1962); Marcel Aubert, Nouvelle histoire universelle de l'art, 2 vols. (Paris: Firmin-Didot et Cie, 1932); Aubert's text has chapters by Henri Focillon (on nineteenth-century art) and René Huyghe (on twentieth-century art), followed by four chapters on non-Western art (305–406). Wilhelm Hausenstein, *Kunstgeschichte* (Berlin: Deutsche Buch-Gemeinschaft, 1927), 495–508. Janson, *Key Monuments in the History of Art, A Visual Survey* (New York: Harry N. Abrams, 1959). *Kunstgeschichte in Bildern, Neue Bearbeitung, Systematische Darstellung der Entwicklung der bildenden Kunst vom klassischen Altertum bis zur neueren Zeit,* ed. H. Schafer, et al. Part 1, *Das Altertum,* 13 vols. (Leipzig: Alfred Kröner, 1913); I have only seen vol. 1.

Genetics and languages: Luca Cavalli-Sforza, Paolo Menotti, and Alberto Piazza, *The History and Geography of Human Genes,* abridged ed. (Princeton, NJ: Princeton University Press, 1994); Joseph Greenberg, *Language in the Americas* (Stanford, CA: Stanford University Press, 1987); Merritt Ruhlen, *The Origin of Language: Tracing the Evolution of the Mother Tongue* (New York: John Wiley & Sons, 1994).

Forms of government: Alois Dempf, *Die Unsichtbare Bilderwelt, Eine Geistesgeschichte der Kunst* (Fenseideln: Benziger, 1959).

Index

Aboriginal painting, 6
Abstraction, 73
Adam, Robert, 54
Aesthetic education, 86
African art, 23, 71, 75, 120, 133,
 146
African-American art, 123–124
Ajanta, 100, 113, 133
Akkadian art, 58
Alpers, Svetlana, 30; *Tiepolo and
 the Pictorial Intelligence*, xiii
Altamira, 134–135, 136
Anasazi art, 75
Anderson, Laurie, 4
Andhra art, 13, 18
Animals, art made by, 126
Appropriation, 24
Arch of Constantine, 40–41
Arnason, H. H., *History of
 Modern Art*, 80, 126, 129
Art, *see* Dogs, frozen, dead, on a
 stick
"art appreciation," 126, 128
Art Institute of Chicago, xiv,
 133

"art of describing," 30
Atomism, 13
Australian art, 119, 140. *See also*
 Aboriginal painting

Bada Shanren, 7
Bacon, Francis, 99
Badami, 100
Bal, Mieke, 34
Barocchi, Paola, 126
Baroque art, 18–19, 26–27
Barr, Alfred H., Jr., 13, 82–83
Batusic, Slavko, 120
Bausch, Pina, 4, 26
Baxandall, Michael, *Tiepolo and
 the Pictorial Intelligence*, xiii
Bazin, Germain, 99
Becker, A. W., 133
Bednarik, Robert, 139
Bellori, Giovanni, 46–48
Belting, Hans, 28
Beuys, Joseph, 28
Bildung, 86
Bles, Hendrick met de, 49–50
Blue Man Group, 4, 26

Bohr, Niels, 1
Bois, Yve-Alain, 16, 37
 See also Formless: A User's
 Guide
Bulgarian art, 30
Butt, Gavin, 123

Cahun, Claude, 121
Canons of art, 118, 127
Caravaggio, 34, 122
Carolingian art, 13
Carrà, Carlo, 96
Carracci, Annibale, 47
Carrington, Leonora, 121
Cavalcaselle, Giovanni, 126
Cavalli-Sforza, Luca, 141
Chaitanya, Krishna, 103
Chaldean art, 40
Chao Meng-fu, *see* Zhao Mengfu
Chicago, *see* Art Institute of
 Chicago; Chicago Theory
 Group
Chicago Theory Group, iv
Chinese art, 6–8, 18–19, 37,
 104, 140
Chinese texts, 113–115, 150
Chola dynasty, 100
Classical art, 18, 27; Hegel's
 concept of, 53
Constantine, *see* Arch of
 Constantine
Constructivism, 12

Daix, Pierre, 15
Damisch, Hubert, 55
Danto, Arthur, 15, 36
David, Jacques-Louis, 16

Davis, Whitney, 65, 123
De Duve, Thierry, 16
Deepwell, Katy, 122
Derrida, Jacques, 55
Diachronic structures, 53
Diagrams of history, 84–85
Dogs, frozen, dead, on a stick,
 143–144
Duchamp, Marcel, 35, 121
Dürer, Albrecht, 27–30, 49
Dunhuang, 8
Durios of Samos, 46
Dutch art, *see* Netherlandish art

Eagleton, Terry, 148
Eggs, 45
Egyptian art, 53–54, 62, 64
Egyptian texts, 98
Einstein, Albert, 1
Ellet, Elizabeth, 122
Endgame art, 35–38
Erberg, Konstantin,
 Alksandrovich, 96
Ernst, Max, 4
Errera, Isabella, 138
Ethiopian art, 40
Eurocentrism, xv, 138–139
Expanded Renaissance, *see*
 Renaissance

Fauré, Elie, 128
Feldman, Edmund Burke, 126,
 128
Félibien, André, 51
Feminism, 121–123
Feyerabend, Paul, 55
Fish, Stanley, 148

Fleming, John, 68–69
Flies, 45
Formless: A User's Guide, 8
Francastel, Pierre, 128
Fried, Michael, 16

Gardner, Helen, *Art Through the
 Ages*, 65–74, 78, 128, 130,
 134, 149
Gay and lesbian studies,
 121–123
Gender in art history, 120–123
Gentileschi, Artemisia, 121–122
Gentileschi, Orazio, 121–122
German art, 27–30, 93
Giacometti, Alberto, 61–62
Gibbon, Edward, 41
Gombrich, E. H., regretted not
 having written a monograph,
 13–14; *Story of Art*, xi–xii, xv,
 57–65, 129, 149, 151
Graffiti, 126
Greek art, 31–32
Greenberg, Clement, 82–83
Grove Dictionary of Art, 79
Grünewald, Matthias, 60
Gu Kaizi, 7
Guhl, Ernst, 122
Gupta art, 13, 18, 111

Hamilton, Ann, 3
Han Dynasty, 8, 18
Hausenstein, Wilhelm, 64
Hegel, Georg Wilhelm
 Friedrich, 52–55, 118, 129,
 149
Hickey, Dave, 16

Hirst, Damien, 37
History, emergence of, 39–41,
 145
Honour, Hugh, 68–69
Huang Gongwang, 7

Illusionism, 58
Indian art, 98–104, 145
Indian texts, 108–113, 150
Innerlichkeit, 29, 53
Iranian texts, 98, 104–108
Irimescu, Ion, 94–95
Iroquois art, 141–142
Islamic art, 75, 78, 146
Islamic texts, 97–98
Italian art, 141–144; *see also*
 Macchiaiuoli; Medieval art;
 Renaissance art; Vasari,
 Giorgio
Itelmen, 141, 143

Jacobs, Robert, 151–153
Janson, Horst, *History of Art*, 12,
 65, 78, 119, 128, 151–153;
 History of Art for Children, 86;
 *Key Monuments in the History
 of Art: A Visual Survey*, 131
Japanese art, 91

Kassite art, 58
Kaufmann, Thomas DaCosta,
 17
Kemenov, Vladimir
 Semenovich, 96
Kent, Rockwell, 96
Konenkov, Sergej Timofeevic,
 96

Koninck, Philips de, 2
Krauss, Rosalind, 16, 121, 124
 See also Formless: A User's
 Guide
Kroll, David, 83
Kruger, Barbara, 10, 37
Kuhirt, Ullrich, 89
Kuhn, Thomas, 55
Kundera, Milan, 26
Kunstgeschichte in Bildern, 131
Kushan art, 3, 18
Kusmina, M. T., 94
Lascaux, 134–135

Lee, Sherman E., 129
Leonardo da Vinci, 64
Lichtenstein, Roy, 4
Life history model, 31–33,
 42–43
Luminism, 12

Macchiaiuoli, 33
Malakhov, Nikolai, 96
Mander, Karel van, 48–51
Mannerism, 16–17
Maps of art history, 1–11, 84–85
Marinetti, Filippo Tommaso, 4
Masterpieces, 118, 127
Maurya art, 13, 18, 100
Mayan art, 70, 75, 114
McEvilley, Thomas, 16
Medieval art, 11, 13, 17, 21–22
Megaperiods of art, 18, 21–22
Michelangelo, *David,* 85–86,
 143–144
Modernism, 16–18, 22–23, 80,
 83, 103

Modigliani, Amedeo, 103
Monier, Pierre, 47
Monism, 13
Moore, Henry, 6–7
Multiculturalism, 147–151
Munch, Edvard, 81
Munsterberg, Hugo, 122
Musa, Salamah, 98

Native American art, 77; *see also*
 Anasazi art
Neo-Plasticism, 12
Netherlandish art, 30
 Neuer Belser Stilgeschichte, 127
New Zealand art, 119
Nochlin, Linda, 120–121
Non-Western art, 66, 119, 129,
 133, 147–151
North-South polarity, 27–31

Oceanic art, 67, 69, 73, 133
Onians, John, 130
Organic model, *see* Life history
 model
Orpen, Sir William, 98–99
Orphism, 12
Oscillating history, 26–31, 43
Ottonian art, 13
Ouattara, 75, 77

Palomino, Antonio, 50–51
Panofsky, Erwin, 6, 17, 22,
 27–29
Paradoxical history, 33–35
Parker, Roszika, 122
Patenier, Joachim, 48–50
Pausanius, 46

Pelican History of Art, 89, 129
Periods of art, 11–38
Photography, 81, 128
"Picasso Madonna," 24, 115
Piera della Francesca, 126
Piero di Cosimo, 43–46
Pijoán, Jose, 99, 127–128
Pinder, Kymberly, 124
Pinder, Wilhelm, 15
Plato, 46
Pollock, Griselda, 122
Pollock, Jackson, 4–5
Popper, Karl, 55
Posthistory, 35–38
Postmodernism, 15–17, 34–38
Poussin, Nicolas, 48
Prehistoric art, 64–65, 134–135,
 139, 144
"Primitive art," *see* Tribal art
Priyabalah Shah, 108–113, 115
Problem of Figure 1, 65
Propylaea of Art History, 89, 129
Purism, 12

Qāḍī Aḥmad ibn Mīr-Munshī,
 104–108, 115
Qing dynasty, 8
Queer studies, 123
Quick-to-See Smith, Jaune,
 76–77, 146

Race, 123–124
Rauschenberg, Robert, 16
Rembrandt, 4
Renaissance art, 16–17, 31–32;
 conservative scholarship in,
 120; expanded, 21

Ricco, John, 123
Richier, Germaine, 100
Richter, Gerhard, 28
Riegl, Alois, 131–132
Rinascimento, 40
Roman art, 40–41, 131
Romanian art, 94–95
Romanticism, 28; Hegel's idea
 of, 53
Rosenblum, Robert, 80–81, 91
Rubens, Peter Paul, 48
Rudolf II, 17
Rushdie, Salman, 148
Russian art, 89–97
Russolo, Luigi, 4

Santa-Olalla, Julio Martinez,
 128
Schlemmer, Oskar, 4
Schoenberg, Arnold, 96
Shearman, John, 16
Sher Gil, Amrita, 102–103
Silenus, 45
Silver, Larry, 120
Smalls, James, 123
Standard story of art history, 63
Steinberg, Leo, 16
Stelark, 4
Stella, Frank, 4
Stokstad, Marilyn, *Art History,*
 74–79, 146
Storia dell'arte italiana, 126
Symbolic art, Hegel's concept
 of, 52
Style analysis, 20–21, 127–128
Style, last, 29
Suleiman, Susan, 121

Sumerian art, 58
Summers, David, 130
Surrealism, 8–10, 81–83, 121
Synchronic structures, 53

Taï plaque, 2
Tiepolo, Giambattista, xiii
Time-Life Library, 99
Tömöry, Edith, 98–104, 139,
 147, 150
Toprak, Burhan, 98
Tribal art, 64, 70–74, 126
Turkish texts, 98

Universal History of Art, 89–97,
 149

Varma, Raja Ravi, 100
Vasari, Giorgio, xi-xii, 39–46, 79
Vaziri, Ali Nagi, 98
Vespucci, Giovanni, 45
Vico, Giambattista, 31
Viola, Bill, 4
*Visual Arts: A World Survey from
 Prehistoric Times to the Present*,
 119

Vitruvius, 46

Wang Wei, 7
Warburg, Aby, 131
Warhol, Andy, 4, 15, 36
Wedgwood, Josiah, 54, 75
Western art, 59–60, 74
Wilson, Robert, 4
Winckelmann, Johann Joachim,
 32
Wölfflin, Heinrich, 20, 26–27,
 53, 127
Woermann, Karl, 69, 126–127
Women artists, 118, 120–123
Wright, Joseph, 54

X-rays, 3

Yugoslavian texts, 120

Zeitgeist, 54, 132
Zhang Yanyuan, 114–115
Zhao Mengfu, 3, 7
Zrzavý, Jan, 2

Lightning Source UK Ltd.
Milton Keynes UK
UKHW02f2048031018
329976UK00008B/112/P